Lewis Carroll
Photography on the Move

Lewis Carroll
Photography on the Move

Lindsay Smith

REAKTION BOOKS

For my mother, Brenda Smith, and in memory
of my father, Weston Smith, 1928–2014.

Published by
Reaktion Books Ltd
Unit 32, Waterside
44–48 Wharf Road
London N1 7UX, UK

www.reaktionbooks.co.uk

First published 2015

The author and publishers gratefully acknowledge a grant from
the Marc Fitch Fund towards the costs of publishing this work

Printed and bound in China
by 1010 Printing International Limited

A catalogue record for this book is available from the British Library

ISBN 978 1 78023 519 6

Contents

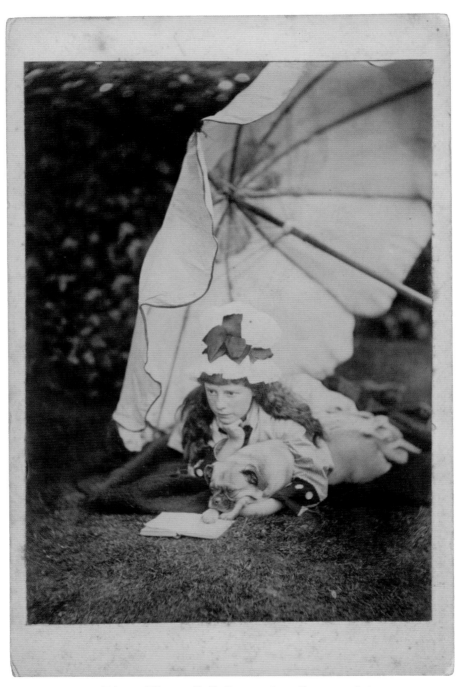

1 Edmund Draper, *Dolly Draper*, 1875, albumen print.

Introduction

ON 24 JANUARY 1877 the Reverend Charles Lutwidge Dodgson (1832–1898), better known by his pen name Lewis Carroll, wrote to Ellen 'Dolly' Draper, daughter of Ellen and Edward Thompson Draper, thanking her for a photograph of herself she had sent to him.[1] As was his custom, Carroll marked the back of the print with the date of acquisition and the date the image was taken: 'Dolly Draper rec'd Jan 24/77 done in middle of /75'. Not a photograph by him, but a photograph kept by Carroll, the costume piece had qualities in common with his own work: it 'is just the sort of photograph I like doing: I take my little friends in all sorts of wild dresses and positions, and I have lately taken several little girls as "Penelope Boothby" in a mob-cap like the one you have on' (VII, 19). I have located this photograph of Dolly Draper.[2] It captures the twelve-year-old child lounging outdoors under a garden parasol (illus. 1). Even without the benefit of Carroll's inscription on the reverse (illus. 2), the sitter's identity is clear from the props to which his letter refers. For the cap is very like the one worn by Xie Kitchin in his portraits of her from the same decade and a large sleeping dog, mentioned in Carroll's letter, is unmistakably present in the composition. Yet, with its relaxed garden setting, the mood of the photograph is different from his.

On 5 February of the same year Carroll sent a photographic portrait of himself to Dolly Draper, who remained for him at this point one of three 'unseen little friends'. The *carte de visite*, an assisted self-portrait possibly taken in 1872, was printed at Henry Peach Robinson's studio (illus. 3). It shows Carroll seated in semi-profile wearing a white bow tie. Holding a book on his lap, he looks low off to the right past the page he is in the process of turning.[3] On 19 April 1877, however, two months after dispatching this likeness to her, Carroll corresponded further regarding images of Dolly Draper. This time, however, he wrote to her father thanking him for his 'really overflowing generosity' in sending 'such a number of [his] photographs'.[4] While there are no precise details of those images sent by Edward Draper, Carroll's subsequent note to him, 'I shall specially treasure those of Dolly' (VII, 30), indicates that among them were several of the child. In all probability they resembled the extant photograph and,

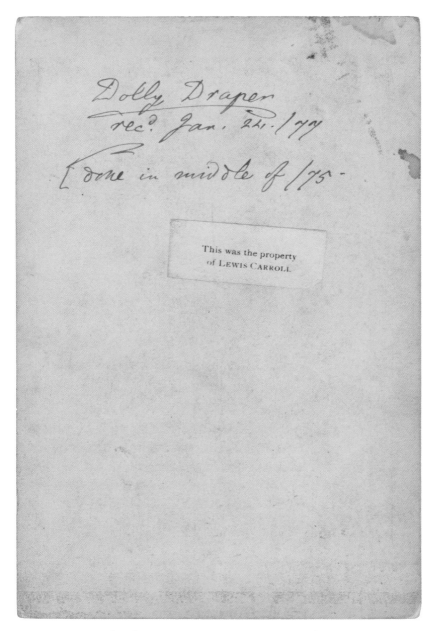

Dolly Draper
rec.ᵈ Jan. 21. /77

[done in middle of /75 –

This was the property
of LEWIS CARROLL

2 Reverse of *Dolly Draper*, 1875, with Lewis Carroll's inscription.

escaping the trappings of professional studios, their informality appealed to Carroll.

As fellow amateur photographers Carroll and Draper were not unusual in exchanging prints by mail and during his lifetime Carroll acquired a number of photographs in this manner. Indeed, changing hands through the post, photographs were frequently on the move. Letters provided wonderfully convenient vehicles for transporting photographic portraits to places remote from the people and locations they depicted. For Carroll, as the Draper correspondence demonstrates, photographs sometimes accompanied letters. On occasion they provided the sole reason for sending them. In this context, as well as guaranteeing order, Carroll's conscientiously maintained cross-referenced photographic and letter registers reflect a mutual involvement of their visual and linguistic entries.[5] Although both of these encyclopaedic documents are now lost, the recorded existence of thousands of photographs and letters testifies to an important, though largely unremarked, closeness for Carroll between the two forms of expression, photography and letter writing. Letters facilitated connections between photographs and places. They did so not simply by detailing sittings for Carroll's camera or by recording the circumstances of his purchase on his travels of *cartes de visite*. Rather, they provided a discursive space in which to explore conceptual connections, often intricate ones, between the medium of photography and particular locations.

This book is concerned precisely with such connections. It recognizes as central to them, as evident in the case of Dolly Draper, photographs of female children. The reference in my title to 'photography on the move' incorporates the geographical movement of Carroll as a nineteenth-century amateur photographer along with the migration of photographs themselves to places far from their points of origin. I range, therefore, from instances when Carroll travelled with his camera to those photographs he bought on his travels and had made in professional studios. His monumental trip to Russia without a camera in 1867, the subject of chapter Four, affected his subsequent 'costume' photographs in visibly distinctive ways, while his regular visits to Ore House, near Hastings, for speech therapy, explored in chapter Five, raised subtle connections between the nature of a photographic sitting and his experience of speech as imperfect. Theatrical events in London in the 1860s and '70s, on the other hand, the focus of chapter Three, inspired photographic preoccupations anticipating those

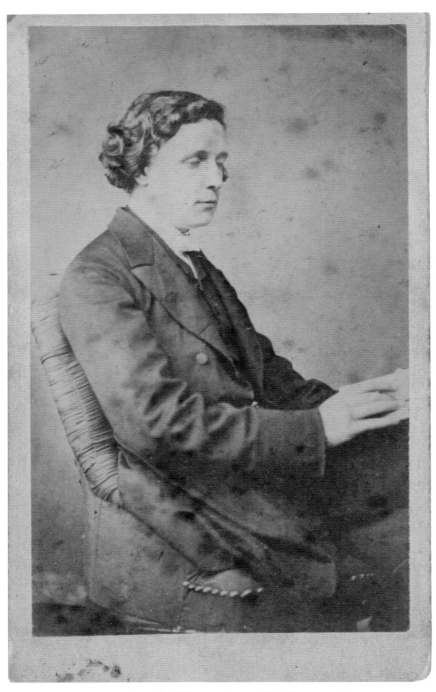

3 Lewis Carroll, *Self-portrait*, 1872(?), albumen print.

Carroll found in the seaside resort of Eastbourne in the 1880s, the focus of chapter Six. While, on the surface, he led a relatively sheltered life – most of it bound by the termly rhythms of Christ Church – places other than the college and the university town of Oxford loomed large in Carroll's experience both actually and imaginatively. Accessed by the train, as chapter Two demonstrates, they fed his fascination for photography just as his experience of particular locations was itself shaped by photographic interests.

Yet the phrase 'photography on the move' alludes also to Carroll's interest in what he thought of as 'moving pictures'. These took many forms. Quite apart from theatrical performances in conventional auditoria, Carroll enjoyed a host of popular spectacles such as swimming entertainments, skating and acrobatics taking place in novel venues. I am interested in what he regarded as the capacity of the 'still' photograph to preserve movement, as it were, in such contexts. Towards the end of his life, in 1886, such an impulse to capture the virtuosity of a range of performers found fruition in his play *Alice in Wonderland: A Musical Dream Play*.[6] It also gestured towards emerging cinema.

Carroll bought his first camera on 18 March 1856 from Ottewill and Company in London, nine years before the publication of what would become his most well-known book, *Alice's Adventures in Wonderland*. Costing £15, the purchase represented a serious investment for a prospective amateur photographer and when the portable folding rosewood box arrived on 1 May he began to experiment with 'spoiled collodion' that his friend Reginald Southey had given to him (II, 67).[7] With Southey's help, Carroll was soon adept at the new technology and for the next 24 years – using the wet collodion process that required considerable skill to secure good results – he took, processed, mounted and catalogued photographs at every available opportunity.

Not all amateurs were able to master with the assurance Carroll did the photographic method made available by Frederick Scott Archer in 1851.[8] Firstly, a negative, a sheet of glass the same size as the eventual print, had to be coated with collodion made from gun cotton – cotton dissolved in nitric and sulphuric acid – mixed either with ether, or alcohol and potassium iodide. After a few seconds, the photographer dipped the glass plate in a bath of nitrate that reacted with the potassium iodide to form light-sensitive silver iodide. The plate was then exposed in the camera. At all times during the intricate process the plate had to remain damp, hence

the name 'wet-plate process'. Once exposed the plate was developed immediately in a solution of pyrogallic and acetic acids, fixed and washed. Opportunities for error were considerable throughout the process; debris such as dust or a hair would be captured as an eternal fault on the eventual print. At first, managing with makeshift arrangements that often involved setting up his equipment in the homes of friends, from 1863 Carroll rented a space in Badcock's Yard in St Aldates. Finally, in 1872, he had a glass studio constructed above his rooms at Christ Church. There, Carroll continued to take photographs regularly; at the time of his death in 1898 his records indicate around 3,000 negatives. From the first assembling albums of those photographs he took, as Edward Wakeling indicates, his personal effects included 'thirty-four photographic albums, not all of these contained exclusively his own photographs'; of these 'at least twelve' have survived.[9]

The physical act of taking a photograph, from the initial sitting to the final print together with those technical skills it required, fascinated the author of the *Alice* books and preoccupied him for a significant period of his life.[10] He began photography at a time when the medium was still relatively new and held considerable intrigue. During its early decades photography possessed a peculiar cultural status, one signalled by its combined mechanical, physical and chemical origins. Unlike those manual methods of reproduction that preceded it, such as engraving, photography eliminated the trace of a hand; the causal, or indexical, connection to a referent determined the unique materiality of the photographic print. By a seemingly perfect correspondence with the object, together with those negative/positive shadow/light dichotomies that mark a temporal dimension to its presence as burnt into the plate, a photograph is always belatedly the thing it represents.

In 1880 Carroll recorded taking what appears to have been his last photograph and scholars have speculated upon this apparently sudden termination of one of his favourite activities. Some argue that he lost interest in the medium. Others cite as a primary cause the replacement of the wet plate photographic process by the dry plate. Still others eschew technical reasons in favour of personal ones, suggesting that Carroll's concern over increasing gossip about his relationships with girls and young women determined his decision.[11] Yet, as this book will demonstrate, effectively Carroll did not 'give up' photography in 1880. Since throughout his life he had sourced, and frequently bought, images by other photographers, post

1880 he continued to do so. In addition, he contrived opportunities to have photographs taken for him. He was involved in the hire of a camera and orchestrated photographic sittings at professional studios. As he continued to invest in them as material objects, and in the medium as a unique conceptual vehicle, Carroll accommodated in different ways what remained an enduring impulse to acquire photographs. Anticipating what Roland Barthes later referred to as 'clocks for seeing', cameras, and the business of photography, could not simply be put aside in the latter stages of his life.[12]

Carroll was therefore as much an owner and consumer of photographs as a maker of them. Yet his reputation as an auteur, an accomplished practitioner, has to some degree obscured his identity as an avid purchaser and collector of *cartes de visite* and other photographic forms. Carroll owned many studio and amateur portraits of children. Some of these originated from sittings he superintended. Others he sourced from studios and shops. Some he solicited from friends and acquaintances, or, as in the case of Dolly Draper, from children themselves. Carroll notes, for example, in his diary for 14 June 1869, a visit to meet the mother of a child, Mary Beatrix Tolhurst, whose photograph he had admired at the house of an acquaintance (VI, 89). On 3 August of that year he invited Charles and Elizabeth Tolhurst of Bracknell to Oxford so that he might photograph Beatrix. Though Carroll's photographs from that session have not come to light, I have located a *carte de visite* of the child he received subsequently in 1871. Made in the studio of Byrne & Co., Richmond, it shows the eight-year-old Beatrix Tolhurst posing with a hoop beside a highly carved table (illus. 4).[13] Branches appear in the foreground to accentuate the simulated woodland scene evident in the backdrop. In his signature violet ink, Carroll has neatly spaced on the front of the card her name and 'Xmas 1871'. Few such studio portraits in Carroll's possession appear to have survived, however, but those that have alter a well-rehearsed story.

In the light of such circumstances, exhibitions of Carroll's photographs always appear somewhat misplaced. Not simply in the sense that, transposed from the intimate leaves of albums to large gallery spaces, many nineteenth-century photographs do, but also because understanding of what photographs meant for Carroll changes in the context of photographs taken by others he owned, sought to own and, in some cases, treasured. Geoffrey Batchen, considering the modern snapshot, has rightly pointed out how traditional models of authorship from art history fail where that

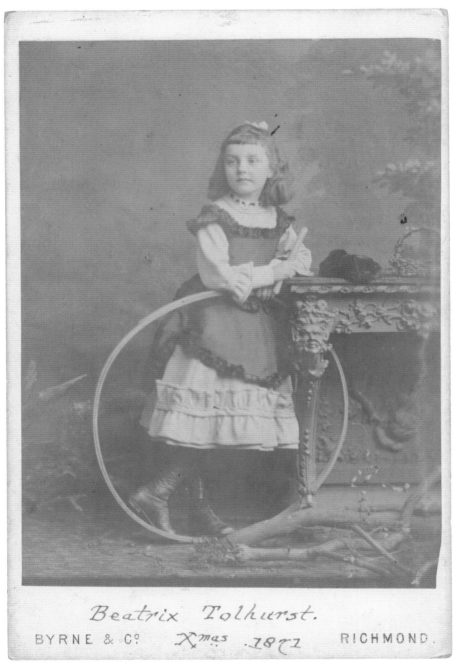

Beatrix Tolhurst.

BYRNE & C° Xmas 1871 RICHMOND.

4 Byrne & Co., Richmond, *Beatrix Tolhurst*, received by Carroll, 1871, *carte de visite*.

popular and very personal photographic form is concerned.[14] While there are obvious differences between nineteenth-century *cartes* and modern snaps, the former anticipate in vital ways the conundrum posed by other people's snapshots, 'boring', as they often are, to anyone without a personal investment in them. Since Victorian studio conventions encouraged repetition of particular visual codes through props and backdrops – the familiar Doric column or sylvan vista – many photographic portraits of the period appear impersonal, meaningless even, to those encountering them without a connection to their subjects. It is for similar reasons that photographs Carroll acquired have generated little interest aside from as documents supplying faces to the names of actors in his life. Yet, akin to snapshots, such seemingly innocuous studio and amateur portraits are significant for the circumstances of their origins and the sentiments they aroused in their owner. Those sentiments themselves accrue through the personal attachment of such images to specific times and places.

This book seeks to remember some of these forgotten photographs and to consider their significance to Carroll alongside photographs he took himself. For as material objects to which he was attached, such studio and amateur photographs – read in the context of his diaries and letters in which Carroll frequently alludes to their acquisition – reveal a great deal about the aesthetic, technological and conceptual capabilities of the medium that absorbed him. The attachment of photographs to particular places also demonstrates the limitations involved in separating aesthetic from psychic and social concerns in Carroll's work. I thereby explore photographs Carroll took, variously acquired, and hoped to acquire. I am interested in those ways in which he conceived them; inscribed them; displayed them; dispatched them by post; sequenced them in albums; and subsequently presented those albums to children and parents to encourage others to be pictured. Those photograph albums in turn provided vital triggers for conversation and the spinning of stories.[15] So too did a number of studio portraits he commissioned. To parcel off photographs he created from those Carroll collected is to curtail understanding of his investment in the medium as closely involved with habitual aspects of his life. Much remains to be told about Carroll's consumption of photographs. The acts of sourcing, trading and collecting them, in addition to taking and processing photographs, were vital components of a larger 'photographic' impulse that attached to place and moved with Carroll when he travelled.

1

'The [Glass] House': Christ Church, Oxford

BEFORE VENTURING FURTHER AFIELD with Carroll in his pursuit of photographs, I want to begin at Christ Church, Oxford, commonly known as 'the House', and effectively his home for 47 years. It was here on 1 July 1876 that Alexandra Kitchin (1864–1925), one of the children to whom Carroll alludes in his letter to Dolly Draper, crossed Tom Quad chaperoned by her mother, on her way to have her photograph taken. Not at a professional studio, however, but at the photographic studio built above Carroll's college rooms. Arriving there, Xie, as she was affectionately known, donned a mob-cap and fancy costume to pose in the guise of Joshua Reynolds's *Penelope Boothby*, painted in 1788 (illus. 5). The daughter of the historian and Student of Christ Church George William Kitchin, Xie was one a string of little girls who, over the course of a three-month period, had filed into that most traditional of Oxford colleges to be photographed. Prior to the sitting, in all likelihood she had enjoyed a picnic of Bath buns in Carroll's sitting room and the chance to play with a mechanical bear and talking doll emptied from the cupboard there. But the highlight of the visit was to pose for the camera and afterwards steal into the mysterious darkroom to be allowed to watch a ghostly form appear upon the glass plate of the negative.

Four years earlier, in February 1872, Carroll had moved into his purpose-built studio.[1] Close at hand he enjoyed the convenience of a dedicated darkroom and a changing room for models. From March of that year he began taking photographs there and was able to operate like a proper photographer; a situation he had long wished for. In the new facility, Carroll had space to house his negatives rather than store them with commercial printers, while the roof provided a place to set out printing frames for exposure to the sun. Writing on 11 May of that year to Mary MacDonald, the daughter of his contemporary and friend the novelist and clergyman George MacDonald, Carroll notes that he is 'taking pictures almost every day' and were she to 'bring [to Oxford her] best theatrical

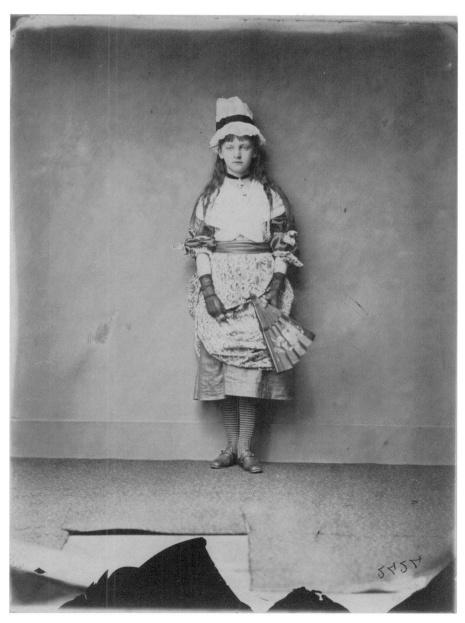

5 Lewis Carroll (C. L. Dodgson), '*Penelope Boothby*' (standing), 1876,
albumen print.

6 Lewis Carroll (C. L. Dodgson), *Alice Liddell*, 25 June 1870, albumen *carte de visite*.

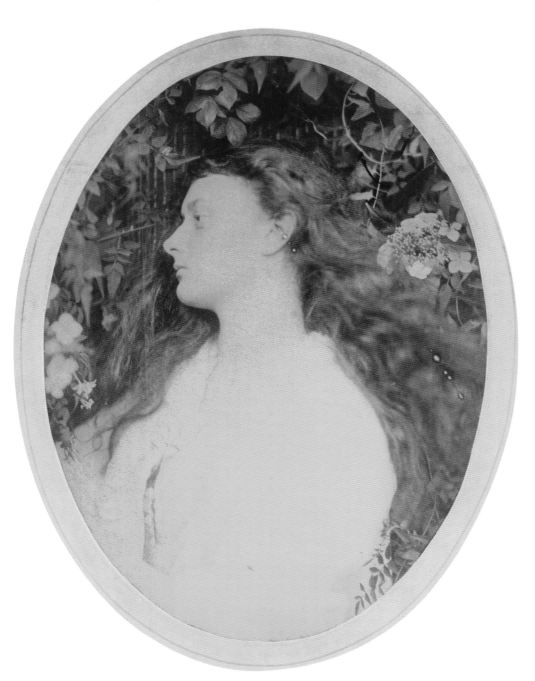

7 Julia Margaret Cameron,
Alethea, 1872, albumen print.

"get up'" he would make 'a splendid picture' of her.[2] He carried on taking photographs at a rapid rate; the glass structure reduced exposure times allowing photography more easily in dull weather. Between May and July of 1873, for example, Xie Kitchin, Alice, Ida and Carry Mason, Julia and Ethel Arnold, Herbert Kitchin, Lily Bruce, Miss Ward, Miss Jones, Margaret and Frederica Morell, Isabel Fane, Maud, Isabel and Helen Standen and Beatrice and Ethel Hatch all came to be photographed: six of them on more than one occasion.[3]

It must have been a strange sight in the all-male context of Christ Church, and of Oxford colleges more generally, to witness figures of little girls entering and leaving. Prior to this period, during the late 1850s and early 1860s, Carroll had enjoyed a ready supply of child subjects at the nearby Deanery. Henry George Liddell, who had succeeded Thomas Gaisford as Dean of Christ Church in June 1855, had had six children growing up there, four of whom Carroll had photographed regularly in the garden.[4] By 1876 Alice Pleasance Liddell, the inspiration for *Alice's Adventures in Wonderland* (1865), was a woman of 24. She had last sat for Carroll to take her picture on 25 June 1870 at the age of eighteen (illus. 6). On 24 April 1873, on visiting the Dean, the author of the *Alice* books had been invited into the drawing room by Lorina Liddell senior to view new photographs of her daughters and Alice had proudly shown him three of herself by his contemporary amateur Julia Margaret Cameron. The Alice Carroll had captured in his own photographs of the 1850s and '60s had been transformed by Cameron's large-format images into the mature goddesses of 'Alethea' (illus. 7), 'Pomona' (illus. 8) and 'St Agnes'.[5]

By contrast, on her visit to be photographed in 1876, Xie Kitchin was still a minor and she belonged to a third generation of Carroll's 'child-friends'. Four successful prints survive from that session. Two of them create the persona of 'Penelope Boothby' from Reynolds's celebrated portrait of the three-year-old daughter of Sir Brooke Boothby. That portrait had become retrospectively imbued with significance following the child's death in 1791 and remained popular in the 1870s in the form of Samuel Cousins's mezzotint after the painting (illus. 9). Mourning the loss of his six-year-old daughter, Boothby had commissioned a marble funerary monument from the sculptor Thomas Banks and published a collection of his own commemorative verses.[6] In 1793, with the exhibit of 'the plaster model for the final sculpture', many were deeply moved by its portrayal

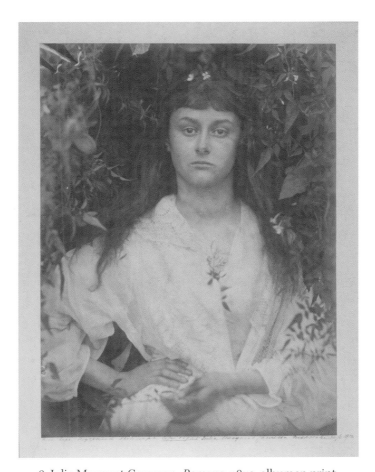

8 Julia Margaret Cameron, *Pomona*, 1872, albumen print.

of the apparent life of a sleeping child.[7] When Carroll recalled 'Penelope Boothby', therefore, he referred photographically to a child associated in cultural memory with public outpourings of grief.

In the standing version of Carroll's *Penelope Boothby* (see illus. 5), Xie Kitchin poses centrally against the wall, her left hand displaying a half-opened fan. Apart from the child's white mob-cap with its dark ribbon, and her dark fingerless gloves, there is little to suggest the original. Carroll attempts to recreate with a shawl her white crossed bodice and gives his subject a similar, though narrower, sash. Other details, by comparison, the striped stockings, decorative sleeves, black choker with heavy metal cross and printed overskirt, are his invention and much fussier than their

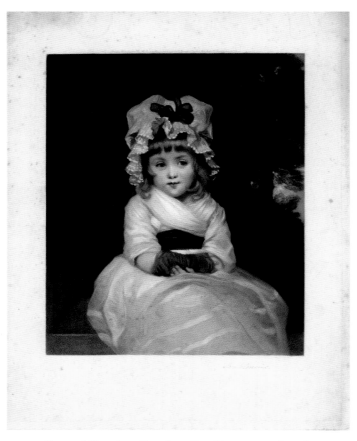

9 Samuel Cousins, *Penelope Boothby,* mezzotint after
Sir Joshua Reynolds, published 1874.

painted counterparts. Even the signature mob-cap of Reynolds's original,
its caul barely generous enough to accommodate her hair, appears perched
awkwardly on Xie Kitchin's head. With her eye-line directed slightly off to
the left, the child holds a sombre expression. In Carroll's seated version of
the photograph, with her chin resting on her hand, she adapts a distinctly
mature pose (illus. 10). In so doing the twelve-year-old turns the faraway
look of Reynolds's infant subject into a direct unflinching gaze into the
camera lens.

Carroll's choice of the persona of Penelope Boothby as photographic
subject emphasizes the enduring significance to him of dressing up chil-
dren to photograph, bringing to mind one of his earliest in the genre, and

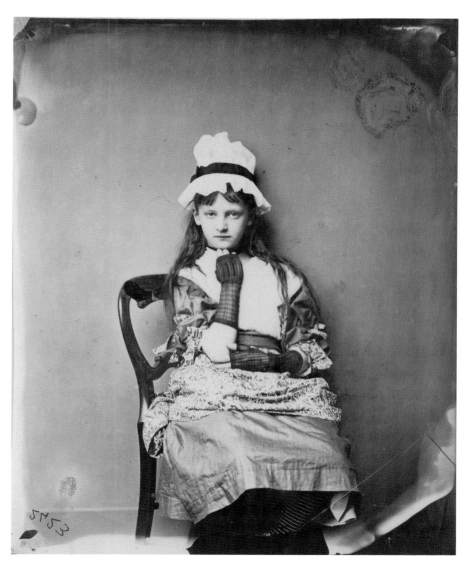

10 Lewis Carroll (C. L. Dodgson), *Penelope Boothby* (seated), 1876, albumen print.

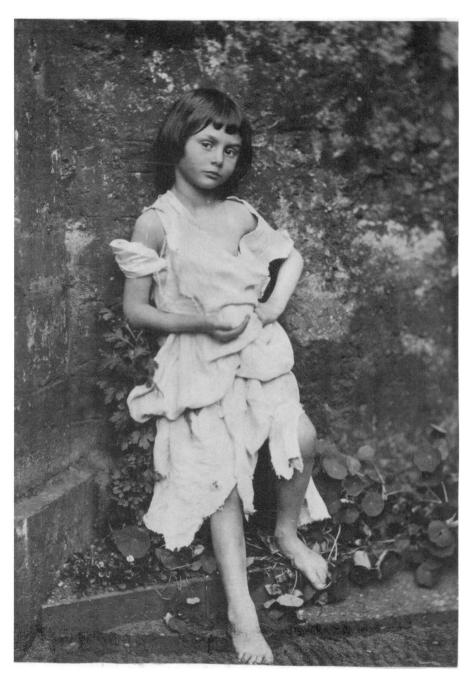

11 Lewis Carroll (C. L. Dodgson), *Alice Liddell as 'The Beggar Maid'*, 1858, albumen print.

his best-known child portrait, *Alice Liddell as 'The Beggar Maid'* (illus. 11). Possibly intended as a companion piece to the less familiar *Alice Liddell Dressed in her Best Outfit*, and conceivably taken on the same day in 1858,[8] this now controversial image of a child dressed in rags, posed begging for alms, refers to the story of the ancient African King Cophetua and his 'beggar maid', resurrected by poets in the nineteenth century (illus. 12). Alfred Tennyson's 'The Beggar Maid', written in 1833 and published in

12 Julia Margaret Cameron, *King Cophetua and the Beggar Maid*, 1875, albumen print.

Poems (1842), was most likely an inspiration for Carroll's photograph.[9] As the speaker of the poem relates the admiration of onlookers for the beggar's rare attributes, 'more fair than words can say', the reader, like the viewer of Carroll's photograph, is invited to see through her 'poor attire'. Her clothing is at the same time, however, key to her unparalleled attraction.

The register of Carroll's 'Beggar Maid' alters when read against its 'companion' photograph *Alice Liddell Dressed in her Best Outfit*, which shows a clean upper middle-class child. Pictured in ragged clothing Alice personates the street Arab in a popular conceit of the period but, changing her back into neat contemporary Victorian dress, Carroll explores the difference between the two states in a 'before and after' that overtly signals the more subtle metamorphic potential of photography. The persona of a beggar maid, however, was not a photographic one-off for Carroll. Xie Kitchin also posed in the role that would become synonymous with Carroll's celebrated likeness of 'Alice'. In so doing, she joined others who had 'sat' for his camera in the 'beggar' dress. As a photographer, choreographing successive children in the same roles, he took particular pleasure in capturing qualities of resemblance.[10]

But in his take on 'Penelope Boothby' Carroll raises the additional spectre of infant mortality that haunted nineteenth-century photographic portraits more generally as it had done earlier painted and sculpted ones. Referencing a painted portrait commemorating a dead child, Carroll's photograph calls to mind a particular state of arrested development. In evoking Reynolds's younger subject, Carroll alludes to a quality peculiar to the infant that the poet and essayist James Henry Leigh Hunt had earlier uniquely captured in his essay 'Deaths of Little Children'.[11] Written in 1820, at a time of high infant mortality, Hunt's piece theorizes the impact upon adults of the deaths of children. He regards such loss as a 'bitter' necessity 'thrown into the cup of humanity', not because he claims 'the loss of one child enables us to appreciate those remaining' but rather because 'if no deaths ever took place, we should regard every child as a man or woman secured'.[12] As a consequence, Hunt further notes, an unbroken connection with infancy would be lost, in which case:

> Girls and boys would be future men and women, not present children. They would have attained their full growth in our imaginations, and might as well have been men and women at once. On the other hand, those who

have lost an infant are never, as it were, without an infant child. They are the only persons who, in one sense, retain it always.[13]

Hunt does more than recognize that, by fixing a stage prior to maturity, premature death makes a child immortal. He communicates in powerful terms the enduring identity of a dead child. To lose a child is paradoxically to keep one close, he claims, since that loss prevents an adult self from supplanting the infant one. As the deaths of children prevent their being regarded as incipient adults – and the category of infancy becomes something other than a route to maturity – Hunt anticipates temporal implications essential to photography, not only in the broad sense of what Roland Barthes has called the 'catastrophe' of the photograph, its propensity to 'tell' death in the future, but by petrifying a child at a point in time such that an owner of a photographic image 'in one sense, retain[s that child] always' as uniquely attached to it.

Portraits were Carroll's preferred photographic genre. Although he took pictures of adults, including a number of eminent contemporaries, it was undoubtedly the case that he enjoyed photographing little girls more than other subjects. His preference for female minors might not have proved so problematical were it not for the fact that within the all-male Oxford college environment he was photographing other people's daughters. But it is pointless to try to argue, as some have done, that Carroll lacked discrimination and relished just as much photographing objects such as the skeleton of a 'tunny fish' for the new Oxford Museum – an unlikely assumption whichever way one looks at it. It is equally important to resist a crude psychobiography in which Carroll's interest in photographing little girls is read either as a displacement of his feelings as a 'frustrated bachelor' or as a straightforward form of perversion.[14] These polarized interpretations oversimplify both the place of photographs in his life and also what it meant historically to photograph children in the nineteenth century. Since during the period in which Carroll worked photography had not yet been seamlessly accommodated to existing categories of cultural and aesthetic response, it is important to be alert to provisional aspects of the new medium as they intersect with similarly provisional definitions of childhood.

It was in the nineteenth century that a modern Western concept of childhood acquired, through photographic representation, a particular

form of visual ubiquity. By the 1850s photographic portraits of children had already begun to constitute a popular genre and during the second half of the century, in particular, childhood became the object of systematic scientific investigation as the camera acquired the status of a major instrument of classification more generally. At the same time, fine art and amateur photography sustained a profound connection with the figures of children. While before the invention of photography images of children abound, it is those representational possibilities offered by photographs that provide new methods by which to generate children's likenesses. The implicit tendency of early photography to unsettle epistemological questions resembled the status of childhood as a variously demarcated and contested stage of human development.

There are a number of ways in which to account for the emergence in the nineteenth century of what would increasingly become a special connection between child and photograph. Most obviously, the relatively instantaneous process of taking a photograph provided a fitting method by which to preserve a transitional state. At the same time, as Hunt's pre-photographic essay anticipates, a photographic portrait uniquely facilitated identification through its links with mortality and loss: the death or absence of a loved one. It is in such a context that one may situate, for example, the popularity in the nineteenth century of post-mortem photographs of children. Yet, in more general terms, photographic portraits of children evoke, in an overdetermined form, that which all photographic portraits have the capacity to evoke, namely a desire to identify with a photographed subject simultaneously in terms of the restoration of a lost object (the raising of the dead) and in the form of a hallucination or premonition of the future. As I have argued in *The Politics of Focus*, photographs of children perhaps more than any others invite experience in a single image of the simultaneous existence of multiple points of time.[15] As past and future tenses coexist in the photographic image it becomes impossible to refuse identification with the figure of a child, prompting fresh consideration of that disarmingly simple yet irrefutable quality of the medium that enables a subject to occupy at the same time more than one temporal 'reality', to experience a sense of that which is yet to come as, in effect, already having been.

A photographic sitting of the period involved an encounter, albeit standardized or unorthodox, in which 'trust', together with a relative degree of unselfconsciousness, were crucial. The very action of uncapping,

of exposing the camera lens to take a photograph, and then re-covering it, emphasized the role of duration in the process. In real terms it was one that highlighted exposure in a practice distinct from the later and, from the time of the first Kodak, ubiquitous trigger mechanism of releasing a shutter that, as Barthes and Susan Sontag have pointed out, gave rise to a notion of 'shooting' a picture.[16] The quality of duration implicit in the slower process of exposing the 'eye' of the lens generated a distinctive 'look' in the resulting image. For Walter Benjamin, referring to the calotypes of David Octavius Hill and Robert Adamson, it conveyed a sense of subjects appearing to grow into their images, a condition of permanence evident in the indelible creases of their clothing.[17] What Benjamin refers to as 'the eloquent subsistence of the future' in the past moment captured in a photograph dwindles, he claims, following the commercialization of photography that accompanied the reduction of exposure times.[18] As with technological improvements photographers were able to take pictures more quickly, lost was a palpable sense of the physical trace of time passed, passing and yet to pass in the image.

Carroll was drawn to the magical distinctiveness of photographic representation and its unique physical relationship to time. He recognized that while a photograph, like any other visual image, might benefit from artistry, its physical and chemical existence always, in some senses, override it. As if acknowledging this fact, at the end of 'Alice's Adventures Underground' (the manuscript version of *Alice's Adventures in Wonderland*) Carroll pasted a photograph of the face of a young Alice Liddell (illus. 13). It was cropped from a larger portrait format he took of her in 1860 in which she is seated with ferns (illus. 14). Beneath it was discovered, long after his death, his original sketch of the child.[19] Readers have tended to construe the author's act of covering the original drawing with a photograph as a sign of dissatisfaction with his draughtsmanship. Yet, rather than a lack of confidence in his ability to draw, might not the photograph instead celebrate the singular reproductive capacity of photography? For in reinstating the physical relationship of a photograph to an original, the placement of the photograph over the drawing captures powerfully the marked difference of the photographic medium from such a graphic form of representation. It is telling in this context that, when later he published the facsimile edition of his manuscript 'Alice's Adventures Underground', Carroll covered the portrait photograph of Alice Liddell. Not wishing it to

of her own little sister. So the boat wound slowly along, beneath the bright summer-day, with its merry crew and its music of voices and laughter, till it passed round one of the many turnings of the stream, and she saw it no more.

Then she thought, (in a dream within the dream, as it were,) how this same little Alice would, in the after-time, be herself a grown woman: and how she would keep, through her riper years, the simple and loving heart of her childhood: and how she would gather around her other little children, and make *their* eyes bright and eager with many a wonderful tale, perhaps even with these very adventures of the little Alice of long-ago: and how she would feel with all their simple sorrows, and find a pleasure in all their simple joys, remembering her own child-life, and the happy summer days.

13 Lewis Carroll (C. L. Dodgson), photograph cut from *Alice Liddell*, 1860, pasted on the final page of the manuscript of *Alice's Adventures Underground*.

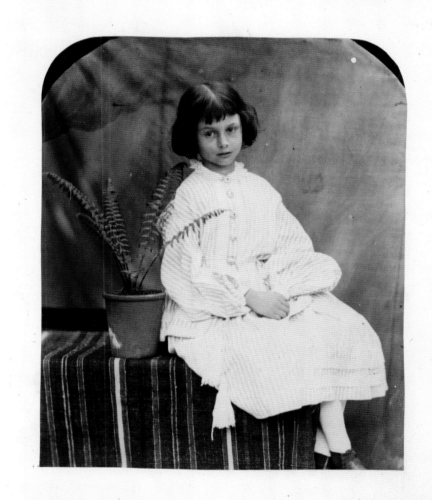

Alice

14 Lewis Carroll (C. L. Dodgson), *Alice Liddell*, 1860, albumen print.

be seen, he withheld from prospective readers the intimate status of the cropped portrait photograph of Alice Liddell.[20]

Accentuating his interest in the temporal distinctiveness of photography, and its peculiar attachment to the corporeality of the child subject, Carroll highlights complex and provisional ways in the photographic medium and an emergent concept of 'childhood' were each implicated in the other. He further prompts questioning of those processes by which in the period a child's body (for Carroll specifically that of a little girl) comes to signal the most appropriate object for a camera. As Benjamin and Barthes have demonstrated, an adult subject's identification of him or herself with a photograph of a child involves a kind of infantilization before the image. Or, to put it differently, a photographic portrait alludes to a future as a place of return, as a realm at some level already familiar. In the case of Benjamin's well-known description of a photograph of the young Franz Kafka, caught in the 'upholstered tropics of the photographic studio', a viewer specifically identifies with the humiliation read in the uncomfortable countenance of the child subject.[21] The picture taken for an adult album compounds not only the photographed child's lack of agency but that peculiar brand of powerlessness implicit in having one's likeness 'taken'. In related terms, for Barthes, mourning his mother in the writing of *Camera Lucida*, the image that most fittingly restores her to him is a photograph of her as a child. That photograph originates precisely from a time when his mother was unknown to him.[22] Such poignant examples of identification, otherwise evident in Barthes' figure of the 'amorous subject' invariably feminized by the act of waiting for the beloved, resemble those to which, via photographs of girls, Carroll was drawn.[23]

Critics have addressed the middle-class Victorian male fascination with the little girl as a desire to reconnect with a long-lost feminine phase. Following on from more general studies such as U. C. Knoepflmacher's *Ventures into Childland*, which deals largely with literary representations of femininity in the genre of the fairy tale, and James Kincaid's *Child Loving*, which tends not to demarcate in terms of gender adult male affiliations with children, Catherine Robson's *Men in Wonderland* specifically takes up the nineteenth-century gentleman's investment in a condition of girlhood.[24] Robson traces Victorian male investment in a fantasy of girlhood as a crucial psychic stage in developing masculinity that signals a pervasive longing among middle-class men for a lost feminine self. It is a selfhood associated

for a male with childhood as a feminine realm he had previously inhabited until forced to leave it behind for the masculine world of school. Once lost, the nineteenth-century gentleman might access that earlier self in fantasy through the figure of the girl. Robson's interpretation of the importance of girlhood in the period is useful in cutting through simplistic labels of deviance used to explain tendencies to privilege the child over the adult. In this context of identification with the figure of the girl, however, it is important to consider how, owing to its indexicality and capacity for temporal disjunction, photography differs from other forms of visual representation.

During the period in which Carroll was working parameters of girlhood and womanhood were variously defined. Legal debates around the age of consent were very much part of the discourse in which he had to situate his desire to photograph minors. On two occasions in 1885 he wrote to the Prime Minister, Lord Salisbury, expressing concerns over the impact of Thomas Stead's notorious revelations of child trafficking in the *Pall Mall Gazette*.[25] Carroll expressed a preference for photographs of girls *below* the age of consent. His own photographs frequently preserved them as minors. At the same time, however, were it possible to override acknowledging photographic subjects as consenting adults, acquiring instead the consent of parents and effectively still treating those subjects as dependents, Carroll would secure 'sitters' *above* the age of consent. Sensitive to gossip and fully aware that his photographic sittings might provoke questions, he was careful to explain in letters to the parents of his 'sitters' the legitimacy of his wish to photograph minors. He claimed never to have undertaken a photographic session without the consent of the child in question.[26] Yet the fact that Carroll entertained a degree of flexibility around concepts of majority and minority suggests one attraction of photographs was their capacity to fast forward minority and transform majority back to minority, or disguise a distinction between them.

Throughout his photographic career, in letters and his private journals, Carroll reflects upon the increasing idiosyncrasy and extremity of his practice. He recognizes, too, and voices quite self-consciously, the insistence of his pattern of procurement of photographic 'victims', as he self-ironizingly called them. In addition, however, Carroll registers with comic flourish his eagerness to gain photographs of the children of friends and acquaintances. In a letter of 23 January 1872 to Anne Isabella Thackeray, eldest daughter of the novelist William Makepeace Thackeray, he writes:

> You would be conferring a great additional favour if you could for love
> or money get me photographs of those charming little friends of yours,
> Gaynor and Amy – *especially* (if such a thing exists) one of Amy at 3½ as
> a sailor. You will think me very greedy, but, as the Americans say, 'I'm a
> whale at' photographs.[27]

Likewise, as late as September 1888, Carroll records taking the actress
Isa Bowman, on an extended visit to him in Eastbourne, to the photog-
rapher William Hardy Kent's studio where he 'got three photos done, two
as Willie [the notorious character from *East Lynne*] and one in sailor frock'
(VIII, 423). He has Isa Bowman photographed not as herself but cross-
dressed in theatrical guises.

 Yet, while the photographic sitting, the resulting negatives and prints
and compiling of albums all fascinated Carroll, he was also drawn to more
abstract implications of the medium. In wishing to photograph and acquire
photographs he explored the significance of photography as a technol-
ogy of capture. Drawn to its conceptual intricacies, Carroll enjoyed the
metamorphic potential within the unitary image. When photographing
children he was impelled by that peculiar nature of prophecy that photo-
graphs articulate. Occupying shifting identifications with those subjects
photographed, he welcomed the activation by the medium of the anterior
future tense. In so doing, he was not simply interested in reclaiming via
the image a fleeting past but also in anticipating, and thereby inhabiting in
advance, an uncertain future.

◗◗ Dreaming Photographs ◖◖

Writing in his diary on 15 May 1879, in a relatively rare discursive passage,
Carroll records 'as a curiosity' a dream he had the previous night contain-
ing 'the same person [the actress Marion 'Polly' Terry, sister of Ellen Terry]
at two different periods of life':

> And there was Polly, the child, seated in the room, and looking about 9
> or 10 years old: and I was distinctly conscious of the fact, yet without any
> feeling of surprise at its incongruity, that I was going to take the *child*
> Polly with me to the theatre, to see the *grown-up* Polly act! Both figures,

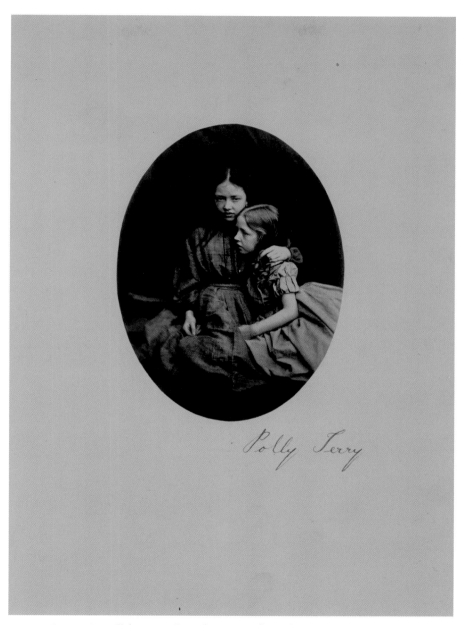

Polly Terry

15 Lewis Carroll (C. L. Dodgson), *Marion ('Polly') and Florence Terry*, 1865, *Photographs*, vol. III, albumen print.

Polly as a child and Polly as a woman, are I suppose equally clear in my ordinary waking memory: and it seems that in sleep I had contrived to give to the two pictures separate individualities (VII, 175–6).

At one level, this splitting into two of Polly Terry gives graphic form to the degree of interchangeability among Carroll's child-friends. Yet, if there is a sense in which one little girl may invariably substitute for another as photographic model and, in Polly Terry's case, one sister for another, since Carroll photographed her siblings, implicit in this example is a different order of substitution. In the dream the doppelganger Polly embodies that temporal dimension, the simultaneous existence of multiple stages of development that photographs generate more generally. The child/woman is divided into two different embodiments (present and future Polly and past and present Polly) united miraculously by the temporal action of photography. Rather tellingly, Carroll refers to the two figures of Polly as 'pictures' and, in so doing, his 'curious' dream tests out the workings of the photographic image. In staging the simultaneous existence of the child and adult Polly, the dream captures that temporal fluctuation that a photographic portrait has the capacity to hold in a single image. To reverse the positions of the child and the adult Polly, such that the adult watched herself as a child, would produce a different effect, one of retrospection. But as it stands, the course of Carroll's dream, in which the child is to be taken to see her adult self act, resembles a premonition, the clairvoyance of photographic agency.

At the same time, in facilitating Polly's seeing herself in the future, the dream attributes wish fulfilment to the child. Staging in advance her talent as an adult actress, Carroll does not want to jettison the grown-up Polly for the child but rather to make her child self live again simultaneously with her mature one. Key in this respect is the capacity of the dreaming mind to generate more than one child, more than one 'picture', but 'without any feeling of surprise at its incongruity'.

This memorable dream inflects a reading of Carroll's photograph *Marion ('Polly') and Florence Terry* (illus. 15) taken at their home in Stanhope Street, London, on 14 July 1865. The sisters, aged eleven and nine, are pictured with the head of the younger girl pressed comfortingly against the cheek of the elder. Their two bodies merge, as does their clothing, into one billowing dress while the combination of one girl's full-face and the other's profile, along with the striking resemblance between the

two sisters, suggests different physical facets of a single child. In arranging his sitters in this way, Carroll appears most interested in effectively picturing, as one face, two sides of the same coin, full-face and profile, as it were. Moreover, the monochrome of photography, in highlighting the tonal variation and texture of the fabrics of the children's dresses, the prominent white channels of the girls' centre-partings, and bleached thumbnails, consummately expresses the touch of the sororal embrace. These qualities, along with the assured hand with which Polly Terry has signed the image, impress Carroll's attachment to the medium for its ability to fix sibling resemblance.

In taking the photograph of Marion and Florence Terry Carroll indulged what he regularly acknowledged as a time-consuming habit. But photographs of girls also embodied for him a 'compulsion' in the sense of a persistent urge both to take and to acquire them. Thus, when on 25 March 1863 Carroll lists in his diary under 'photographed or to be photographed' the names of 107 girls grouped together according to their first names, the very heading blurs a distinction between those children already preserved photographically and those he yet desires to capture (IV, 178–81). These include four Alices, seven Ediths, fourteen Marys and a single Lily (MacDonald). In eighteen cases the children's birthdays are also noted. This process of listing past and future child subjects establishes a type of equivalence for Carroll between the thought of photographing and photographing itself. Indeed, a wish to photograph is in some ways congruent with the act of photographing such that to think of photographing a child is already in a sense to photograph her. But, as this example further intimates, the child's name is of vital importance to Carroll's wish to photograph and retrospectively to the memory of taking a likeness.

In Carroll's story 'A Photographer's Day Out', published in the *South Shields Amateur Magazine* (1860), the name 'Amelia' connotes an overwhelming desire on the part of the first-person narrator to photograph 'a young lady' in possession of the name.[28] Indeed, as elsewhere in Carroll's writing, investment in a female name precedes acquaintance with its owner: 'why is it, I wonder, that I dote on the name Amelia more than any other word in the English language?'[29] Structured as diary entries, the story comically explores the perils of family portraiture for a photographer who longs only to capture 'a young lady'. Carroll's text mocks each family member's pretensions as they adopt ridiculous poses for the camera. The

'Paterfamilias' with his expression 'of a man with a bone in his throat' goes first, followed by his wife who, with Shakespearian aspirations, puts on 'a ruffle' and 'a Highland scarf' and poses with the unlikely prop of 'a hunting whip'.[30] Following subsequent photographs of the 'inevitable' baby and children, the intended *pièce de résistance*, a family group, fails but it clears the way for the narrator to accomplish 'the aim' of his life, namely to 'photograph an Amelia!'

The distinctive function of the name 'Amelia' in this early text establishes a role for names more generally in Carroll's work. Just as the speaker in 'A Photographer's Day Out' relishes the very pronunciation of a name as attached to a hypothetically 'ideal' photographic subject, Carroll makes much of the names of those children he photographs. Helmut Gernsheim was the first to point out the relative oddity of the diary entry for 25 March 1863 in which Carroll grouped photographic subjects according to their shared first names.[31] But what has subsequently become apparent is that this process of listing and repeating names evokes the power of photography to capture their owners, to generate multiple images of a single 'Constance' or 'Grace'. Just as for the narrator in 'A Photographer's Day Out' to speak the name 'Amelia' is to align it with photographic permanence, for Carroll to register the names of children is to grant to them the indelibility of physical imprints.

Carroll was from the first keen to incorporate into his albums the signatures of photographic subjects. Indeed, he sometimes included a signature on an album page in anticipation of securing a likeness to go with it. Everywhere apparent in his photograph albums are intricate varieties of letter-formation and haphazard spacing characteristic of a child's attempts at neat copperplate script. On some occasions the signatory has omitted a letter or, as in the case of the photograph *Irene MacDonald*, 'Autographed' (1863), omitted one letter and transposed another.[32] In such portraits, the combined effect of photograph and signature – the alignment of the inscription of a hand with photographic trace – impresses both the closeness and distinctiveness of each. The juxtaposition of the technologically and the manually generated forms begs the question of what kind of mark, in relation to that of writing, photography constitutes.

As Carroll embraced the potent appeal of a medium at once thoroughly scientific and wonderfully mysterious, he further theorized its merits in sophisticated and witty prose. In September 1855, a year before he began photographing, Carroll wrote 'Photography Extraordinary', applying principles of photographic physics and chemistry to the agency of the human mind. He inserted the story as a cutting in *Mischmasch*, his family magazine that comprised texts he had written for the *Whitby Gazette* and the *Oxonian Advertiser.*[33] Relating a 'mesmeric rapport' between the mind of a photographic subject, or 'patient' as he calls him, and the glass plate of a negative, Carroll's story plays upon the existence of latent and manifest images as applied to the mental realm. The narrator introduces a secret photographic 'experiment' to which he has privileged access. Its benefits as applied to the mind show the capacity of the medium to 'develop' to the highest degree of intensity even the 'feeblest' of intellects. Moreover, the revolutionary impact upon the creative faculty of this invention is, the narrator claims, to significantly develop any literary style and thereby 'reduce the art of Novel-writing to the merest mechanical labour'.[34] To demonstrate, he submits various schools of literature to the test. First goes 'the milk-and-water School of Novels', followed by the infinitely more 'saleable' 'Matter-of-Fact School'. Finally, 'the Sporadic or German School' takes its turn, to be greeted by 'indescribable sensations of surprise and delight'.[35] For in this case, poetic language reacts so effusively to 'photographic' chemicals that, faced with Byron's 'fiery epithets', the system overloads to leave the photographic paper 'scorched and blistered'.[36]

'Photography Extraordinary' offers a prospective account of a young Carroll just beginning his academic career at Christ Church. He had only recently encountered photography and hankered after a camera of his own. Yet the fictional scenario ingeniously situates 'photographic' agency in a context prior to the invention of the medium and, in so doing, the piece also predicts just how indispensable photography will become to Carroll's creative life: not only in the form of his output of photographs but, as photography turns it into an automatic one, the act of writing. It is unusual to find as early as 1855 the links Carroll establishes between photographic agency and writing. Nonetheless, while the model of latent and manifest content, both in the forms of images and writing, would later come to characterize

theories of the unconscious mind as exemplified most famously by the work of Sigmund Freud (especially in the model of the mystic writing pad), a prototype had surfaced six years earlier than Carroll's story in the figure of the palimpsest in Thomas De Quincey's *Suspiria de profundis*.[37] De Quincey's fascination for the dreaming capacity as 'the one great tube through which man communicates with the shadowy' chimes with aspects of Carroll's tale.[38] Restoring that which was unknown, or thought to be lost, the camera functions rather like the mechanism of the unconscious in dreams. De Quincey famously likens memories to 'lost' inscriptions restored by modern chemicals as archaeological layers of a palimpsest. He thereby presents memory in the form of a linguistic model: a code that may be cracked.[39] For Carroll, scientific discovery similarly underpins his fictional account of photography as revelatory.

Close to the conclusion of 'Photography Extraordinary', the narrator claims: 'the mind reels as it contemplates the stupendous addition thus made to the powers of science'.[40] 'Photography Extraordinary' is an extraordinary text, not only because it forges a relatively early connection between photography and the unconscious mind, but because it rehearses remarkable aspects of the medium that will come to populate both Carroll's fictional writings and his personal ones, especially his letters that chart, along with his diary entries, the extent and details of his passion for the relatively new technology of reproduction. Not only do they record photographic sittings and elaborate schemes for securing an ongoing supply of child subjects for his lens but, as subsequent chapters will demonstrate, they reveal his complex psychological stake in representing the child photographically. Frequently adopting personae in his letters to children – the wronged lover berating his mistress, the fickle suitor disregarding a forgotten tryst, or the avuncular figure offering measured advice – Carroll's personal investment in the medium is bound up with the larger impact of photography upon visual perception and cognition.

While Carroll's 'Photography Extraordinary' rehearses a version of Benjamin's 'optical unconscious' in which the action of photography releases hidden phenomena, 'A Photographer's Day Out' differently reveals how, with an exposure time of '1 minute and 40 seconds', things get in the way that were not 'seen' at the point of taking.[41] They get caught, that is, in a very different way from in painting, engraving or, indeed, writing, unless it claims to be automatic. At the same time, when they are not static throughout

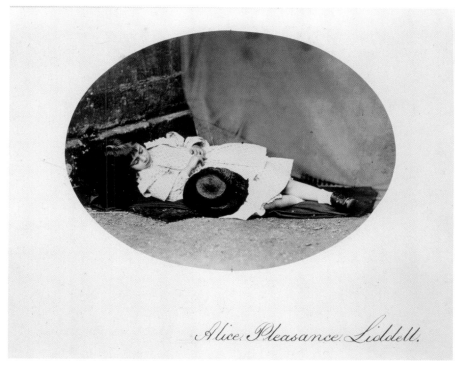

Alice Pleasance Liddell.

16 Lewis Carroll (C. L. Dodgson), *Alice Liddell* [sleeping], 1860, albumen print.

an exposure, objects appear transformed in a photographic image, some-
times beyond recognition. In 'A Photographer's Day Out', movement during
a photograph turns picturesque compositional elements of a farmer and a
cow into grotesque ones. The cow gains additional heads, while the farmer
is equally afflicted: 'I should be sorry to state how many arms and legs
he appeared with – nevermind! call him a spider, a centipede, anything.'[42]
Transforming the appearance of objects, or capturing random ones with
the same degree of faith as those consciously staged, a photograph thereby
implicitly poses the question of how to visually determine the difference
between those intentionally and unintentionally arrested objects.

Carroll's photograph *Alice Liddell* [sleeping] (illus. 16) of 1860 demon-
strates this point in more subtle terms than 'A Photographer's Day Out'.
It often remained necessary in the period to take the subject outside to
ensure sufficient light for a tolerable exposure time and Carroll has posed
the child as if asleep in an outdoor space he has done his best to mask.
In the portrait, taken in the Deanery garden, Christ Church, a canvas

backdrop fails to accommodate the whole frame and the viewer is left to speculate upon what may lie at the edges and, by extension, beyond the border of the image. A photograph of a child pretending to be asleep might look awkward in many outside contexts. Here that awkwardness is exaggerated by apparently insignificant details, such as the chips of gravel in the foreground that, in their relatively high degree of focus, impress the height of the photographer's point of view.

Such visual discrepancy, generated by the fact that the medium treats with equal precision a precious object and a stray detail, does not disappear from Carroll's photographs once he need no longer go outdoors, enjoying instead the favourable conditions of his purpose-built studio. During the 1870s a residue of that awkwardness persists in his repeated juxtaposition of dressed-up children and barren interior spaces. But the indiscriminate agency of the medium remains in other ways. When in 1873 Carroll centred against a wall in his studio Xie Kitchin dressed in Greek costume, three fugitive bars of sunlight imprinted themselves to the left of the child (illus. 17). These remain as indelibly present in the print as the child herself. With the overt presence of light this later, more sophisticated, studio shot retains a quality of the earlier one. It is a reminder that part of the emotional pull of photographs for Carroll remained lodged in that agency beyond the control of the photographer. In thrall to light, *photos*, photography was a dependent technology. Appearing to elude the eye of the photographer, this quality of something unseen but present at the time of taking the photograph evokes a peculiar quality of prophecy. Such a quality conveys that sense of incipience that Emmanuel Levinas has referred to as a type of 'presentiment of fate in the image'.[43]

In 1876, dressing up Xie Kitchin as 'Penelope Boothby' to photograph in his Christ Church studio, Carroll had moved a long way from his 1857 parody of Henry Wadsworth Longfellow's *The Song of Hiawatha*, 'Hiawatha's Photographing', published in the *Train* in December of that year.[44] The poem dramatizes the enigma of the photographic process together with the singular persona of the photographer. In his witty imitation of what he called the 'verbal jingle' of Longfellow's metre, Carroll explores the tricky business of collodion photography:

> First, a piece of glass he coated
> With Collodion, and plunged it

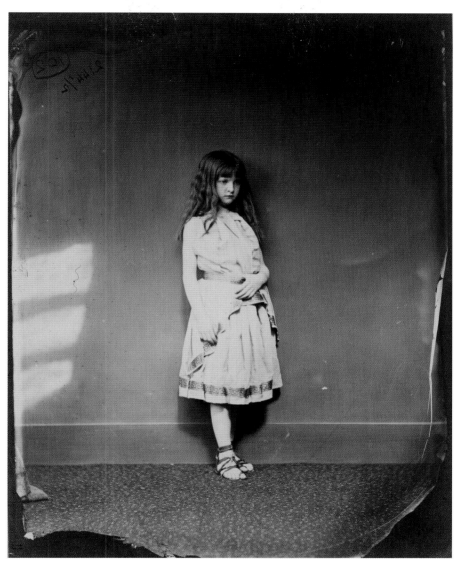

17 Lewis Carroll (C. L. Dodgson), *Alexandra ('Xie') Kitchin in Greek Dress*,
12 June 1873, albumen print.

In a bath of Lunar Caustic
Carefully dissolved in water:
There he left it certain minutes.

The precise and laborious method required to make a photograph stretches
the metre, though not quite to breaking point:

Finally, he fixed each picture
With a saturate solution
Of a certain salt of Soda –
Chemists call it Hyposulphite.
(Very difficult the name is
For a metre like the present
But periphrasis has done it.)

Regardless of his considerable efforts, however, Hiawatha's sitters regard
the success of a final family 'grouped' photograph as scant compensation
for what they judge the 'failure' of their individual likenesses.

In Hiawatha, just one year after acquiring his first camera, Carroll had
created a memorable persona for the photographer. Unwilling to put up
with abuse for failing to flatter his sitters, and lacking 'that calm delib-
eration, / That intense deliberation / Which photographers aspire to',
Hiawatha looks to the railway to make a quick escape:

Hurriedly he took his ticket,
Hurriedly the train received him:
Thus departed Hiawatha.

Saved by the train! However, as Carroll's fictional photographer beats a
retreat to the station he also anticipates what would become the itinerant
figure of his author. Even with a much-desired studio of his own, Carroll
continued, as he had always done, to get out and about for photographs.
As subsequent chapters will demonstrate, Carroll's wish to picture Xie, and
other little girls, in a range of costumes found its origins, and complement,
in a wealth of contexts beyond Christ Church. For his regular excursions
to the London theatre and other entertainments, his annual visits to the
seaside and for his one trip abroad, to Russia, Carroll took the train.

2

Carroll on the Train

MINOS: If the gentleman wanted to catch his train – by the way, *had* they
trains in Egypt in ancient days?
NIEMAND: Certainly. Read your 'Antony and Cleopatra', Act 1, Scene 1:
'*Exeunt Antony and Cleopatra with their train*'.[1]

SHAKESPEARE WITH TRAINS WOULD have been a fine thing as far as
Lewis Carroll was concerned. Unlike many of his contemporaries,
he did not begrudge the spread of railways. Instead, he enjoyed the
freedom they gave him. By the time Carroll wrote the above punning
interchange in *Euclid and his Modern Rivals* (1879) the train had become
as essential to him as theirs to Antony and Cleopatra. Yet, as his prime
mode of transport, the railway also retained significant novelty. Carroll
regularly took the train to and from the theatre in London; he also took
it to the seaside, to visit friends and relatives across the country and for
his 'ambitious' trip in 1867 to Russia. Moreover, he was unusual among
certain of his eminent contemporaries in actively embracing the rail-
way; Alfred Tennyson and John Ruskin – to name but two – were highly
critical of it. While, after initial enthusiasm, in 1886 Tennyson mounted a
vituperative attack in his poem 'Locksley Hall Sixty Years After', Ruskin's
antipathy was regular and frequent. In *Fors Clavigera*, his letters to work-
ing men, for example, Ruskin bemoaned the blight on the landscape of
the Peak District of a half an hour's reduction in rail time between Buxton
and Bakewell.[2] Elsewhere, he tells of his horror, having arrived in Venice
in the 1840s, to find that the railway has got there before him. Carroll, by
comparison, brought the train into his fictional and non-fictional publica-
tions and in his letters and diaries frequently reflected upon its potential
as a context for comic encounters.

Almost as if confirming Carroll's love of both of them, the invention
and rapid spread of steam trains coincided with the invention and rapid

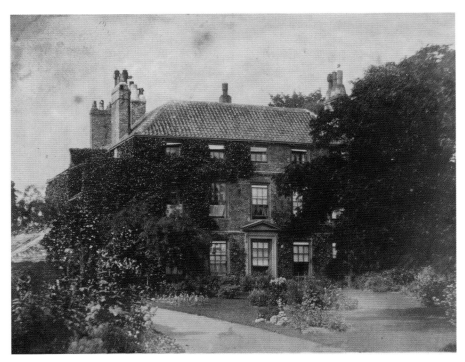

18 Lewis Carroll (C. L. Dodgson), *Croft Rectory*, 1856, albumen print.

popularization of photographs. Indeed, both inventions proliferated expo-
nentially over a relatively small period of time. The Rectory at Croft-on-Tees,
the Dodgson family home from 1843 to 1868 (illus. 18), was just a few miles
from the Stockton and Darlington line where in 1825 George Stephenson
had established the world's first public railway (illus. 19). Twenty-seven
years later, in 1852, there were 6,600 miles of railway track in Britain and
all the main lines into London had been completed by the 1860s.[3] During
the same period advances in photography were proving similarly trans-
formative as *cartes de visite* gained popularity. Moreover, the new medium
of photography was itself responsible for detailed visual documentation
of the development of the railways. As distinct technologies of modernity
that had considerable impact upon the fabric of nineteenth-century life,
the camera and the train came together for Carroll in compelling ways. In
a most obvious sense the railway facilitated Carroll's new hobby of photog-
raphy. From 1856 onwards it allowed him to travel with his camera and
move his equipment between photographic opportunities.

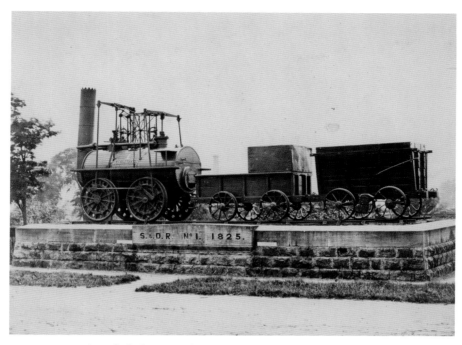

19 Unidentified photographer, *Stockton to Darlington Locomotive no. 1*,
monument, owned by Lewis Carroll (C. L. Dodgson).

When Carroll arrived at Christ Church in May 1850 the line from
Paddington had recently reached the outskirts of Oxford, transforming
accessibility to the capital; fourteen years later he records travelling on the
new Metropolitan Underground Railway that opened in January 1863 (illus.
20).[4] In 1857 an average journey time of two and a half hours from Oxford to
Paddington meant that he could travel to London quite frequently during
the academic term. Many of Carroll's 'child friend[ships]' originated on train
journeys, on station platforms or following delays to trains. It would not be
an exaggeration to state that the railway granted him independence and
unique opportunities to meet potential photographic subjects. A chance
meeting with a child in transit frequently resulted in Carroll's promise to
her of an *Alice* book. In turn, such correspondence sometimes generated
photographic sittings that, through word of mouth, led to more of the
same. Additionally, railway paraphernalia, such as tickets, timetables and
left-luggage – together with the relatively novel concept of 'railway time'
– were all of keen interest to the Oxford don. However, underpinning such

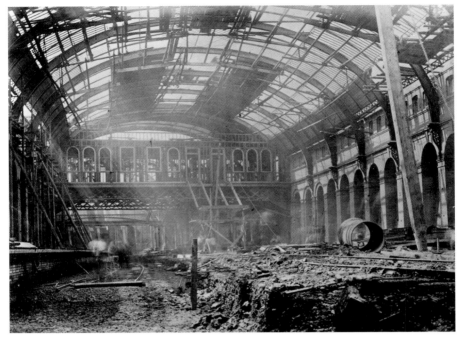

20 Unidentified photographer, *Metropolitan Railway, rail level view of King's Cross Station under construction*, January 1862.

supplementary trappings, Carroll recognized the rail journey as singularly transformative. Circumscribed by the carriage, as proxy for a domestic interior, and dependent upon connections measured by the new commodity of 'railway time', a rail passenger inhabited a new type of space that might, dependent upon the comfort of accommodation and the nature of fellow occupants, afford social interaction or intense reflection.

The railway journey in Carroll's quotidian experience was a rich source of photographic child subjects and a catalyst for verbal improvisation. More specifically for Carroll, in sanctioning temporary suspension of duties and obligations, the rail journey approached the performative freedom of a photographic sitting. He experienced the physical space of the train as emotionally and cognitively liberating. While fascinated by the distinctive experience of locomotion, Carroll did not record his response in those terms that Wolfgang Schivelbusch has summed up as 'the annihilation of time and space'.[5] Instead, he found a key appeal of the railway in those impulsive, and frequently inspired, meetings that took place when one

was suspended between stops. Since rail journeys involved transportation of property as well as people, they provided ample opportunities to leave property behind or, indeed, to lose it. On leaving his destinations, the itinerant, happily rail-bound Carroll invariably left things behind. Sometimes it was a glove; at others, an umbrella. On one occasion he left a photograph album. Especially in the realm of his letters, Carroll playfully enjoyed anticipating leaving such things behind and imagining the circumstances of subsequently retrieving them. Since, in Freudian terms, the leaving behind of an object is symptomatic of a wish to return, we should also examine what it might mean for Carroll to anticipate in some senses his own unconscious, rail-inspired, motivations for doing so.

THE RAIL TICKET

In a letter of 15 May 1869 following a rail journey with the thirteen-year-old Isabel Seymour, the eldest daughter of Henry Fortescue Seymour, Fellow of All Souls, Oxford, Carroll writes:

> My dear Isabel,
> Words cannot tell how horrified, terrified, petrified . . . I was when I found that I had carried off your ticket to Guildford.
> I hardly dare ask what really happened at Paddington, whether the gentleman and lady, who were in the carriage, helped you out of the difficulty, or whether your maid had enough money, or whether you had to go to prison. If so, never mind: I'll do my best to get you out, and at any rate you shan't be executed.[6]

The catastrophe of the purloined ticket, as he here relates it, provides Carroll with a pretext for a second ingenious missive to the child. In this letter of 29 May 1869, claiming to offer the '*real*' reason 'for having carried off [Isabel Seymour's] railway-ticket', Carroll maintains he did so in order to give her '*a really exciting adventure*'. Enumerating two alternative plans – the first involving a loaded pistol, the second a rattlesnake disguised as a Banbury-cake – he explains how his eventual decision to plump for a third apparently more conservative 'adventure' turns out in its own way to be equally inventive. For he decides:

To keep the ticket, so that you might be alarmed when you got to London. Of course I arranged thoroughly with the Guard that the thing was not to be overdone. He was to look a little stern at first, and then gradually to let his expressive features kindle into a smile of benevolence.

P.S. I must tell you candidly that the whole of this letter is a hoax, and that my *real* reason was – to be able to make you a nice little portable present. Friends suggested a corkscrew, a work-box, or a harmonium: but, as I cleverly remarked, 'These are all very well in their way, but you can only use them *sometimes* – whereas a railway ticket is *always* handy!' Have I chosen well?[7]

The dramatic scenario as played out in Carroll's correspondence with the child points up the possibilities for railway intrigue and his pleasure in spinning stories from it. Singing the praises of a perpetually functional railway ticket, Carroll sends one back to Isabel Seymour – 'a portable present' as he designates it – in lieu of her 'lost' ticket. When compared as it is with a motley assortment of 'corkscrew', 'work-box' and 'harmonium', a rail ticket boasts the benefit of unrivalled portability. Indeed, in Carroll's scheme, a ticket is currency in a way that a harmonium is not and, although corkscrew and box are irrefutably useful objects, they do not provide passports to places. On the other hand, however, whereas a corkscrew and work-box offer repeated use, a railway ticket, affording simply an outward and return journey, holds a value that is soon used up.

Yet physically innocuous and readily available as they are, rail tickets offer little visual clue to what Carroll regards as their perpetual 'hand[iness]'. At the same time, as his letters on the subject to his child recipient reveal, it is in their precise forms of small, identical and easy to misplace objects that rail tickets generate melodramatic situations. In 'Looking-Glass Insects', chapter Three of *Through the Looking-Glass, and What Alice Found There* (1872), the ticket itself, as material object, provides a memorable source of comedy. Having made a 'grand survey of the country' and determined 'to get into the Third Square' of the chessboard, the next thing Alice encounters is the voice of a railway Guard demanding 'Tickets, please!'[8] Finding herself seated in a railway carriage she discovers 'in a moment everybody was holding out a ticket: they were about the same size as the people, and quite seemed to fill the carriage'.[9] Yet, unlike Isabel Seymour before her,

Alice is missing a ticket, not because someone has inadvertently carried it off, but because, bound by the rules of a chessboard, she had not anticipated travelling by rail. Furthermore, even had she planned to catch a train, she explains 'in a frightened tone', 'there wasn't a ticket office where I came from'.[10] While in Carroll's letter to Isabel Seymour the small size of railway tickets belies their importance, in *Through the Looking-Glass* their inflated proportions, which appear 'to fill the carriage', make their very absence highly conspicuous. With their relative physical insignificance transformed into unwieldy dimensions, tickets are impossible to hide. So too, thereby, is their absence.

The strangeness of Alice's travelling companions in the railway carriage of *Through the Looking-Glass* matches the oddity of their tickets. In addition to a gentleman dressed in white paper, a Horse, a Goat and a Beetle, Alice encounters the tiny Gnat whose direct and barely audible 'sighs' appear in appropriately scaled font on the page. The reported punishment for travelling without a ticket, to 'go back as luggage!',[11] is a joke, or indeed a threat, that Carroll had first used in 1855 in *La Guida di Bragia: A Ballad Opera for the Marionette Theatre* in which, as I'll show, luggage plays a key role.[12] What is more, the appeal of the concept of human luggage had stayed fresh for Carroll in the interim between that early text and *Through the Looking-Glass* owing to its power to conjure absurd images such as those of travellers sporting labels designed for fragile parcels. As Hugh Haughton points out, 'Lass, with care' is 'Glass' with the 'G' removed,[13] and the threat of being 'sent' as luggage evokes a lack of control many rail travellers apparently felt at the time; a sense that in putting themselves in the hands of rail operators they moved from place to place in the manner of commodities. Indeed, without much trace of humour, Ruskin suggested that such modern travellers, untouched by the space they traversed, resembled human parcels.[14] In *Through the Looking-Glass*, by comparison, the advice to the ticketless Alice from 'the gentleman dressed in white paper' – 'Never mind what they all say, my dear, but take a return-ticket every time the train stops'[15] – appears to her just as irrational as the prospect of becoming a parcel. Furthermore, perturbed by this idea of a perpetual 'return' journey, and expressing a wish to be back in the wood – 'I don't belong to this railway journey at all' – Alice's use of the word 'belong' assigns to travelling by train the status of a mode of being.

The well-known comic scenario of 'Looking-Glass Insects' appears in embryo as early as 1852 in Carroll's interest in photography encouraged by his Uncle Skeffington Dodgson's passion, not only for the medium, but for all manner of gadgets. On his summer vacation from Oxford in 1852 Carroll describes in detail, in a letter to his sister Elizabeth, a visit to his uncle that introduces railway travel as a kind of imperative generated, as it is, by the optical range of the microscope:

> He has as usual got a great number of new oddities, including a lathe, telescope stand, crest stamp (see top of this notesheet), a beautiful little pocket instrument for measuring distances on a map, refrigerator, etc., etc. We had an observation of the moon and Jupiter last night, and afterwards live animalcula in his large microscope: this is a most interesting sight, as the creatures are most conveniently transparent, and you see all kinds of organs jumping about like a complicated piece of machinery, and even circulation of the blood. Everything goes on at railway speed, so I suppose they must be some of those insects who only live a day or two, and try to make the most of it.[16]

This striking passage brings together optical mediation – from telescope to microscope – with 'railway speed' to anticipate an incongruous Carrollian scene. In a miraculous compilation of what Carroll calls 'oddities', extremes of vision emerge alongside new technologies such as a refrigerator. Yet there is a glorious logic to the hotchpotch registering at the level of sight. Carroll here enjoys the microscope for the animation it reveals. For, owing to their 'convenient transparen[cy]', the furious movement within 'animalcula' hidden to the naked eye is evident to its mediated counterpart. Most intriguingly, the brief life of insects, and their desire to 'make the most of it' as a pretext for their 'railway speed', anticipates the behaviour of those insects in *Through the Looking-Glass*, especially that of the Gnat that finally 'seemed to have sighed itself away'.[17]

Tenniel's celebrated illustration for the railway carriage episode in *Through the Looking-Glass* depicts the Guard who, having appeared to check tickets, trains upon the figure of Alice a menacingly large opera glass (illus. 21). Simultaneously, the text alludes to relative shifts in focal

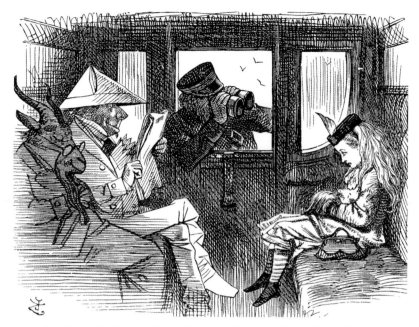

21 John Tenniel, Alice on the train, from *Through the Looking-Glass* (1872).

length in the form of three distinctive instruments as the Guard peers at Alice: 'first through a telescope, then through a microscope, and then an opera glass'. In focusing such shifts from the monocular to the binocular, and with more than a passing nod to scopophilia, Carroll's and Tenniel's railway carriages establish a dynamic in which the child figure is subject to the lens. Picturing a scene in which intense scrutiny by magnification seems ludicrously misplaced, Tenniel draws attention to the intrusiveness of mediation per se. Moreover, while a camera might easily replace the opera glass in the illustration, the opera glass in question introduces to the peculiar self-contained space of the railway carriage an additional theatrical dimension.

Caricature of rail passengers receives a different spin in Carroll's letter of April 1868 to the eleven-year-old Agnes ('Dolly') Argles:

Perhaps you remarked that old lady who was sitting next to me in the carriage? I mean the one with hooked eyes and a dark blue nose. Well the moment the train went off, she said to me (by the by, it was her language that first made me think she wasn't *quite* a lady) she said to me, 'Was

them three young ladies on the plank-form, what held their hankerchers to their eyes, a shedding crystial tears, or was they shamming?'[18]

As the context of his railway observation reveals, Carroll's unusual travelling companion's malapropisms provide a way of comically staging an emotional goodbye from 'Dolly' and her sisters that brings to mind the more general and fundamental function of the railway station in emotional encounters. It is also telling that the visual oddity of Carroll's fellow traveller – 'hooked eyes and a dark-blue nose' – prefaces her verbal idiosyncrasy.

A letter to Carroll's 'child friend' Edith Jebb, aged ten, dated 18 January 1870, begins in similar fashion:

Did you happen to notice that curious-looking gentleman who was in the railway-carriage with me, when I left Doncaster? I mean the one with a nose this shape – (I don't know any name for that sort of nose) and eyes like this. He was peeping with one eye out of the window, just when I was leaning out to whisper 'good-bye' into your ear (only I forgot where your ear was exactly, and somehow fancied it was just above your chin), and when the train moved off he said, 'She seems to be vs.y?'[19]

On this occasion, again confirming the railway carriage as a prime context for odd visual specimens and richly comic stories, Carroll adds graphic flourishes of the cartoonist's sketch to indicate the peculiar qualities of bird-like noses and shifty eyes (illus. 22). Furthermore, Carroll's wordplay in the letter to Edith Jebb both conceals an attempted kiss ('the place above the chin' being the mouth, and itinerant and stolen kisses being

[Leicester]
January 18, 1870

My dear Edith,

Did you happen to notice that curious-looking gentleman who was in the railway-carriage with me, when I left Doncaster? I mean the one with a nose this shape – (I don't know any name for that sort of nose) and eyes like this He was peeping with one eye out of the window,

22 Lewis Carroll, letter to Edith Jebb, 18 January 1870.

common motifs in Carroll's letters to children) and also registers his inter-
est in verbal contractions. For somewhat on a par with 'the old lady' in
the previously cited letter, 'the curious-looking gentleman' finds it difficult
to converse, finally proclaiming Carroll's head to be 'MT'.[20] To condense
into less offensive capital letters the word 'empty' clearly puzzled the
child recipient, as was revealed by Carroll's subsequent reply to a letter
from her.[21] Additionally, though, the inclusion of graphic caricatures in
the above letter to Edith Jebb suggests words are not wholly adequate to
the purpose of recording the diverse characters encountered on the train.
To compensate, therefore, small sketches erupt in the text anticipating
Carroll's inventive rebus letter in which pictures are not separate from
words but morph into them as pictorial homonyms.

The impact of the double sketch of the nose of Carroll's peculiar travel-
ling companion resembles other graphic forms such as looking-glass letters
and elaborate monograms that he enjoyed creating for children. But, impor-
tantly, both of the above examples from his letters demonstrate a fertile link
for Carroll between railway travel and improvised word-play that in turn
lends itself to visual record. In larger terms, the train carriage fosters a crea-
tive interchange between visual and verbal, suggesting that words alone are
not adequate to capture the satirical range of such railway encounters. Not
surprisingly, in this context, the railway carriage was a 'favourite satirical
type' for *Punch* 'cuts' by Leach and other less well-known *Punch* artists.[22]
Tenniel's wood engraving conveys the peculiarly absurd and surreal nature
of the scene from *Looking-Glass* but the perspective from which he pictures
the carriage, with the Guard looking in, confronting the viewer from the
outside, especially impresses the captive nature of its passengers. Since
there were no corridor trains in the 1860s, once installed in a carriage a
passenger would have had to wait until the next stop to rid him or herself of
irksome travelling companions of the type Alice faces.

While Tenniel highlights Carroll's interest in the diverse range of
passengers using the relatively new form of public transport, such diversity
was mitigated, to some extent, by the division into classes – first to third –
of railway carriages. Indeed, social class became very much at issue during
a railway journey and much has been made of the place of rail travel in
cementing class distinctions in Victorian Britain.

Before railway travel, stagecoach passengers only had a choice of
riding inside or outside the coach. But the division of railway travel into

three classes did not happen initially; at first there existed no third-class provision and, for the poor, all rail journeys were prohibitively expensive.[23] When it did come, classification, in some cases, also extended to facilities such as booking-halls and waiting rooms. There are various instances in his correspondence where Carroll expresses concern for children and young women travelling in third-class accommodation. Donald Thomas cites the example of Margaret Bradley, around sixteen at the time, the daughter of Carroll's friend George Bradley, Headmaster of Marlborough and then the Master of University College, Oxford, who in 1871 travelled alone by third-class rail. Spotting her at Reading unaccompanied, Carroll 'left his first-class carriage to join her for the rest of the journey'.[24] However, Margaret Bradley's version of this event, that once she revealed her ineptitude for puzzles Carroll took no further interest in her, shows the extent to which the pleasure of a random railway encounter did not necessarily work both ways.[25]

Contemporary painters soon took up the subject of class difference as determined by rail travel. Abraham Solomon's paintings *First Class – the Meeting: 'And at first meeting loved'* (1854) and *Second Class – the Parting: 'Thus part we rich in sorrow parting poor'* (1854),[26] conceived as a pair, depict class difference from the perspective of the interiors of classified carriages. Solomon shows that, even with a chaperone, in a first-class carriage a female passenger was not exempt from male notice. *First Class* (illus. 23) portrays a scene of flirtation. A young woman is subject to male attention while her father dozes in the corner. Criticism of the painting that centred on an emerging *tendresse* between the young couple led the artist to paint a second version playing down the power of the chance railway encounter (illus. 24). In the second painting the young man converses with the father rather than the daughter.[27] In spite of producing a toned-down version, however, Solomon kept the original painting. Perhaps he did so because of an interest in the possibility of such a chance encounter as occasioned by the train.

There was, by comparison, no criticism of the differently emotionally loaded companion painting. In that work, *Second Class* (illus. 25), a mother accompanying her son by train, most probably to a port for emigration, provides a scene of pathos heightened by the spartan railway carriage in which bundles of luggage rest on the bench that serves as a seat. Their journey, conceivably their last together, takes place in the company of three other passengers. One of them, perhaps the boy's sister, apprehends

the emotional weight of the scene. The significance of parting appears writ large in posters advertising Australian destinations displayed in the carriage. In both paintings, Solomon pictures the interior spaces of trains from positions that call attention to intimate interaction between passengers. Instead of providing a view directly out of it, each painting focuses the singular nature of an enclosed compartment. In this sense, Solomon's *Second Class* anticipates Honoré Daumier's *The Third Class Carriage* of 1864, which emphasizes the physical closeness of its poor passengers over and above a view beyond it.

Tenniel, by distinction, takes his perspective of looking from the inside out of a railway carriage from another contemporary painting, *Travelling Companions* (illus. 26) by Augustus Leopold Egg of 1862,[28] best known for its approximately symmetrical rendering of two identically dressed women who face each other across a carriage. Their relaxed poses and the luxury of their dress set against a beautiful coastal view identify the women as members of the leisured class. But what especially links Egg's painting with Tenniel's illustration is its stress upon the distinctive carriage space produced by drawing the eye to a view out of it. Iridescent pools of natural light falling upon the women's gowns and the sides of their faces reinforce the brightness of their source in the exterior view. These areas of natural illumination, heightened by the satin fabric upon which they fall, remind a viewer that he or she looks into the carriage from the position of a second carriage window located opposite the one pictured. As a result, for both Egg and Tenniel it is the aperture of a window, a self-conscious device of mediation, that draws attention to the viewing produced from the confines of a railway carriage.

In addition to the unique physical space of the railway carriage, however, its eccentric inhabitants in *Through the Looking-Glass* further signal in the openly playful context of Carroll's fiction for children fundamental aspects of rail transport that fascinated him. He was drawn to the potential for extraordinary events to occur while a rail traveller was in transit, yet to experience an exceptional encounter on a journey it was not necessary for social mores to be set aside. Rather, they might be adapted in inventive ways such that a seasoned railway traveller such as Carroll felt empowered to strike up conversations with strangers on trains, to invite children to play the games from his bag, in ways he might not have done elsewhere. The railway carriage was a space in which on 24 December

23 Abraham Solomon, *First Class – the Meeting: 'And at first meeting loved'*, 1854, oil on canvas.

24 After Abraham Solomon, *First Class – the Meeting: 'And at first meeting loved'*, second version, 1854, lithograph.

25 After Abraham Solomon, *Second Class – the Parting:*
'Thus part we rich in sorrow parting poor', 1854, lithograph.

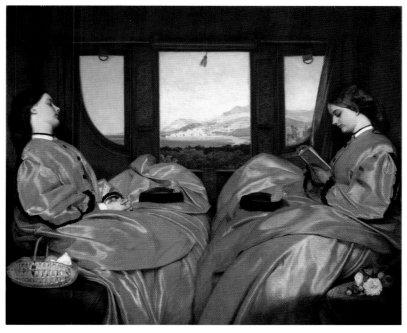

26 Augustus Leopold Egg, *Travelling Companions*, 1862, oil on canvas.

1866 Carroll delighted in producing his '*in statu quo* chess-board' to amuse himself and 'one of [his] travelling companions'.[29] On another occasion he put to good use his folding scissors. Precisely because it was a public space that quickly, if only temporarily, became *private* to its exclusive inhabitants, the railway carriage sanctioned improvisation. Yet in addition to fostering such possibilities, since each journey was temporally circumscribed, it had qualities in common with the self-contained form of a photographic session as Carroll conceived and engineered it.

Precise synchronization of clocks governed a railway journey and a successful photographic take. While theorists including Benjamin, Barthes and Heinrich Schwarz have discussed the theoretical implications of duration for the photographic sitting,[30] as previously noted, Carroll, like any photographer of the mid-nineteenth century, was preoccupied with the practicalities of exposure times and the intricate adjustments necessary to ensure tolerable results. Also, however, since a railway journey and a photographic sitting held a subject captive for a predetermined period, both contained imaginative freedom for extemporization. In a related sense, a resulting photographic image bore a conceptual connection to the circumscribed space of a railway carriage. Considering the 'confined space' of the photograph, Mary Price has likened the 'explosive energies' it compresses to 'the unconscious energies Freud describes as emerging in a joke or a dream'. For Price, such capacities arrested by the 'closure' of a photographic frame incite a viewer 'to puzzle out its literal and conceptual contents': 'The release achieved by comprehension of a joke, dream or metaphor is satisfying: in the Freudian joke because repressed ideas, which have gathered strength from their repression, are discharged with laughter.' Likewise, 'the very closure of a photographic frame compresses energies'.[31] Thus while Price identifies a continuum between the very different lengths of time spent posing by artists' and photographers' models, in order to dislodge a sense that it is in the 'time involved' in taking it that the magic of a photograph resides, she acknowledges Benjamin's reflection on time as focusing in important ways 'the anomaly of temporal dislocation'.[32] For Carroll, rather like the 'closure of the photographic frame', the railway carriage provided a novel space in which energies were concentrated to generate a wellspring of potential.

Extraordinary encounters were not unheard of on the railway. But a sense of uncommon possibility as belonging to train travel was by no means unique to Carroll's writing, Tenniel's illustration, or Solomon's and Egg's paintings. In fact, many nineteenth-century fictional texts made the train instrumental to their plots; Dickens's 'The Signalman' is perhaps the best-known example of a ghostly type of this genre. A less familiar text, 'The Portrait Painter's Story', the first of 'Four Stories' published in *All the Year Round* in 1861 evokes a quality of the carriage particular to Carroll's investment in it.[33] As Louise Henson has pointed out, 'the "well-authenticated" but unexplained ghostly encounter had an important place in [Dickens's] journal',[34] and proved especially intriguing because, following its publication, the artist Thomas Frank Heaphy (1813–1873) accused *All the Year Round* of plagiarizing an uncanny autobiographical account of his own. Dickens promptly countered this accusation, claiming he had simply included the piece as a sensational story already circulating in the public domain. Subsequently reading a version of the same tale sent to him by Heaphy, however, Dickens immediately acknowledged its superiority over the earlier account and published it in the journal on 5 October 1861. Nine years after his death Heaphy's widow brought out the story separately as *A Wonderful Ghost Story; Being Mr H's Own Narrative; a Recital of Facts with Unpublished Letters from Charles Dickens Respecting it*.[35] Carroll never doubted Heaphy's claim to authorship of the tale and was fascinated by the supernatural aspects of an apparently commonplace meeting on the railway.

When 'a well-known English artist' catches the train out of London to undertake a portrait commission at a stately home he finds himself alone in a carriage, only to be joined at the first station by 'a young lady' who takes her time to arrange herself comfortably.[36] Generated by the peculiar circumstances of locomotion, an intimate conversation ensues. The 'young lady' promptly puzzles the artist with her enigmatic question as to whether, after one or two meetings, he would be able to remember a face well enough to paint its true likeness. Before he has had time to ponder her identity, however, the woman alights abruptly at the next stop. She later materializes, unseen by anyone other than the narrator, in the stately home where he is to execute the portrait commission: 'as surely as the young lady had been his companion in the railway carriage, so surely, she

had sat beside him at the dinner table.'[37] While the text initially suggests that deception would be difficult in the broad daylight of a railway carriage, what ensues complicates that assumption, for the woman turns out to be a revenant soliciting the services of the artist for a posthumous portrait of herself to comfort her grieving father.

Heaphy highlights the fleeting nature of meetings on the train. But in focusing upon a remarkable encounter he reminds a reader that, as perfect settings for greetings and farewells, trains initiated memorable occasions in people's lives and held the potential to inaugurate extraordinary events.[38] Certainly for Carroll, as for Dickens, the possibility for unexpected encounters was one of the attractions of rail travel. What is more, Carroll's interest in the supernatural events of Heaphy's story gained intensity when he discovered a visual counterpart. In a letter of 26 April 1867 to his sister Mary, Carroll documents a visit to Heaphy's studio, explaining:

> we had a very interesting talk about the ghost, which is certainly one of the most curious and inexplicable stories I ever heard. He showed me her picture (life-size), and she must have been very lovely, if it is like her (or 'like it', whichever is the correct pronoun).[39]

Thus Heaphy, as artist as well as author, unveils for his visitor a painting of the ghost featuring in his supernatural story based, he claims, on a real-life experience. In viewing the image not only does Carroll refer to the model for the painting in the past tense, reading her in the persona of the ghost, but he equivocates over the pronoun. He is unsure whether or not a ghost might be gendered.[40]

The incident of Heaphy's ghost is a curious one in Carroll's correspondence. When set in the context of Solomon's painting of the meeting of a young man and woman in *First Class*, however, especially apparent is the related manner in which story and painting explore a frank, unguarded exchange as sanctioned by rail travel. In turning his young woman into a ghost, however, Heaphy implicitly avoids the criticism of sexual impropriety levelled against Solomon. Nevertheless, Heaphy's text encourages its readers to experience on the train the potential for unorthodox encounters per se.

Taken together, these incidences – from Carroll's letters, 'Looking-Glass Insects' and Heaphy's ghost story – begin to articulate qualities of railway travel, apart from its relative novelty, that attracted Carroll. Such appeal

further corresponded in a number of ways both with the act of photograph-
ing and the agency of photography. Just as the railway carriage afforded
a protected space from which to experience a rapidly moving and chang-
ing environment, photographs allowed viewers to vicariously experience
distant and unknown places from the safety of home. Yet sustaining an
exciting tension between safety and adventure, collapsing space and time,
the train also provided a new kind of fantasy space. It encouraged a traveller
to imagine. To look out of a moving train was not only to be able to peer into
otherwise inaccessible places but to gain visual entry to new worlds from a
'safe' place beyond them. Likewise, in addition to opening up geographical
spaces, photographs provided access to inner worlds.

Yet for many nineteenth-century commentators railway travel
was more likely to signal loss rather than gain, and loss of many kinds.
Thomas De Quincey, for example, reflecting upon the evocative power
of the mail-coach displaced by the train, emphasizes the former's 'share
in developing the anarchies of [his] subsequent dreams'.[41] He recognizes
the regular motion of the train as distinct from the motion of the stage
coach. Nineteenth-century rail travellers remarked upon the distinctive
experience of railway 'speed' as being more predictable than 'horse' power
and some found the 'velocity' of the train newly thrilling. While 'as early as
1843, the average speed on all railway lines was 21½ miles per hour', some
trains reached speeds of 60 miles per hour, 'six times the rate of travel in
a fast stage coach'.[42] But, as far as De Quincey was concerned, the thrill of
sitting on the outside of a mail-coach, rather than the cramped and more
expensive inside accommodation, far exceeded that experienced in a rail-
way carriage. His preference had to do with the experience of 'the air, the
freedom of prospect, the proximity of the horse, the elevation of seat'.[43] The
modern railway, he claimed, robbed a traveller of the experience of speed
and distance, substituting '*alien* evidence' – someone saying 'we have gone
fifty miles in the hour' – for a physiological sense of velocity.[44] While, for
many of his contemporaries the pace of the railway was all too detectable
in jolts and bone-shaking motion, De Quincey was nostalgic precisely for
an experience of speed as felt upon the body.

"REFRESHMENT ROOMS.", "AND IMMEDIATELY SIEZE A PORK PIE.", "THE MOMENT THE TRAIN ARRIVES AT WOLVERTON, RUSH TO THE REFRESHMENT ROOM LIKE THE WHIRLWIND;", "IF YOU ARE FOOLISH, HAVE A GLASS OF HOT BRANDY AND WATER, WHICH WILL BEGIN TO COOL JUST AS THE BELL RING FOR DEPARTURE.", "BUT IF YOU ARE WISE, YOU WILL HAVE A PINT BOTTLE OF CREAMY STOUT, WHICH YOU WILL HAVE TIME TO DRINK WITH DIGNIFIED GUSTO.", "REFRESHMENT", "WARM YOURSELF ... STOVE BEFORE Y...", "PAY ... IF Y...", "IF YOU ...", "WHY...", "SO MUCH THE WORSE FOR THE REFRESHMENT ROOM."

⤫ The Station ⤫

But it was not only the experience of the peculiar motion of the train that was lacking. For many, De Quincey included, the modern railway station lacked a heart. Referring to 'the hurried and fluctuating groups' at a station, he laments the loss of the significant 'centre' of 'interest' vital to the coach.[45] Indeed, he regarded the disparate crowds at a railway station as mirrored by the separate carriages in the train.[46] William Powell Frith's popular and monumental painting *The Railway Station* (1862) encapsulates precisely the frenetic sense of disunity that De Quincey finds troubling.[47] In this regard, although he does not mention them, one imagines De Quincey would have

27 'The Old Stoker' (George Augustus Sala), 'Refreshment Rooms',
from the series *Practical Exposition of Mr J.M.W. Turner's Picture
'Rain, Steam, Speed': Trifles for Travellers, c.* 1850.

been similarly unimpressed by the station's various offices; left luggage, booking office and lost property would have contributed in equal proportions to a dissipating effect. Of these, the provision for refreshment, and guides about how best to secure it, may have incited his particular irritation.

Before the 1880s, when the dining car came into operation, long journeys included designated refreshment stops timed at ten minutes. As a consequence, eating and drinking, especially hot fluids, became new arts as evident in parodies such as this one by George Augustus Sala (illus. 27). *The Railway Traveller's Handy Book of Hints, Suggestions and*

Advice (1862) gives vital information on how to make best use of a timed refreshment stop:

> When the train is on the point of stopping, mark well the place where the words 'Refreshment-Room' are written up, so that directly the train stops, you may make at once for this place without wasting your time in looking for it. Walk straight up to that part of the counter where one of the attendants is stationed, and having, in parliamentary phraseology, 'caught her eye', declare your wants. But in doing this, be quick and concise. If you desire a basin of soup, never mind the words 'a basin of', but simply utter the monosyllable 'soup'; so with a cup of tea, content yourself with calling out the latter word; a bottle of ale, 'ale' etc. -Call out distinctly and in a loud voice, have the precise sum ready, if you know what it will be, or at any rate tender a small coin.[48]

Particular to a tee, with its tips on linguistic short cuts for saving time, the above *Handy Book* might have been written by Carroll, who was particular in preparing for comfort on his train journeys. As the actress Isa Bowman recalls during her time spent with him in Eastbourne in the 1880s and '90s, Carroll would arrange 'in different partitions of the two purses that he carried', the correct 'sums for cabs, porters, newspapers, refreshments and other expenses of a journey'.[49] Alongside the refreshment room, to assuage hunger, however, travellers benefited from the railway bookstall to alleviate boredom or, indeed, eye contact with fellow passengers. Victorians bought newspapers and changed library books at the station and 'just as the railways promoted the use of standard time ("railway time") and the distribution of fresh milk ("railway milk") they also fostered the habit of reading'.[50] But, while railways helped the sale of newspapers, they produced a new market for books. Indeed, reading became 'the universal habit of the bourgeois traveller and was put within the means even of the lower middle class by the appearance of 'cheap railway libraries'.[51] Aside from the pleasures of newspapers and books, 'reading', as associated with the train, invariably meant the indispensable though perpetually challenging *Bradshaw's Railway Guide* (illus. 28).[52]

Bradshaw provided a compendium of the practical workings of 'railway time'. Up until the introduction of railways in the 1840s places kept time according to when the sun passed the meridian at noon. In November 1840 the Great Western Railway ordered that London time should be used in all its time-tables and at all stations; in 1847 a national railway time system based on Greenwich Mean Time was introduced.[53] It emerged owing to the necessity of having a single meridian. However, clocks were not synchronized over-night. From the start some railway companies used London time while others kept local time, so to coordinate rail journeys was no mean feat. In an attempt to help matters, some clocks in public places bore two minute hands, one registering local, and the other London, time. In this context, the possibilities for disruption to a journey caused by permutations in

28 *Bradshaw's Railway Guide* (February 1863).

time-keeping throw new light upon Carroll's well-known 'Two Clocks' paradox: 'I have two clocks: one doesn't go *at all*, and the other loses a minute a day: which would you prefer?'[54] The unexpected solution to the riddle, namely that the clock 'that doesn't go *at all*' (because it is invariably right twice a day) is preferable to the losing one, which is right 'only once in two years', perhaps makes topical sense in relation to the imponderables of station clocks. Carroll's stopped clock arguably affords a passenger a slightly better chance of synchronizing with the complexities of Bradshaw than a clock that 'loses a minute a day'.

It was in 1839 that George Bradshaw published his first railway timetable, priced at 6*d*. A year later he brought out an updated railway companion of all passenger train services in Britain in which, for one shilling, readers had access to the times of departure and fares of the railways in England and hackney carriage fares from the principal railway stations. The fact that many Victorians considered Bradshaw's *Railway Guide* 'the veritable Bible of the nineteenth-century traveller' demonstrates the extent to which daily life 'had come to be programmed, conditioned, and disciplined by the railway's demand for punctuality in its customers'.[55] Yet because the guide was a necessity for rail travellers, from fairly early on people were quick to mock Bradshaw for its unfathomable contents.[56] As John Pendleton notes:

> when after striving in vain for half an hour to ascertain really what time you will arrive at your destination, you alight, with your head in a fog and your eyes aching, on the encouraging words in italic 'see above' or 'vice versa' you feel inclined to fling 'Bradshaw' out of the window.[57]

Punch, not surprisingly, had something of a field day with Bradshaw, claiming it second in inscrutability only to the official catalogue of the Great Exhibition.[58]

Among the plays that Carroll wrote for his childhood marionette theatre is the little-known burlesque *La Guida di Bragia: A Ballad Opera for the Marionette Theatre*, performed on 31 July 1855 for his cousins, the Wilcoxes.[59] Carroll's only marionette play to survive, the entire action involves a railway station. While by the later Victorian period the name 'Bradshaw' had become synonymous with 'railway timetable',[60] Carroll's comic take on it provides a relatively early contribution to the discourse mocking the

authoritative tome. Peter Heath points out the strangeness of the neglect of the text as 'the sole extant copy of a Carrollian play'.[61] However, since it is a drama for marionettes, that neglect appears in part to be owing to a relative lack of interest in, or understanding of, the prominent place of the marionette theatre in Britain during the 1850s.

Split into three acts with musical interludes, the piece is primarily a slapstick comedy that takes place on a station platform. It features two ineffectual railway 'horficers', Mooney and Spooney, station-master and clerk, who create havoc around connections and lost luggage. In addition to these principal characters, the main cast comprises an aristocratic couple, Orlando and Sophonisba, and a woman named Mrs Muddle who, recalling both the 'erratic lexicon of Sheridan's Mrs Malaprop with the lower class mispronunciation of Dickens' Sairey Gamp',[62] introduces novel railway concepts such as, in the following interchange, life insurance:

> MOONEY: Now, mum, look sharp, if you please. Here's your train coming. Is all this your luggage?
> MRS. MUDDLE: Yes, sir, it be; but it's not the luggridge I cares for, no, nor the Baggridge neither. Young man.
> MOONEY: Madam.
> MRS. MUDDLE: I wishes you to – to – to ensnare my life I . . .
> MOONEY: Ensnare your life, ma'am!
> MRS. MUDDLE: Yes, Sir! What with all these collections and accidings as is so perpetually 'appening. I daren't go without you do![63]

Through such dialogue Carroll also deals with mid-nineteenth century anxiety around accidents and lost property on the railway. In a comic 'Air' sung to the tune of the aria 'Casta diva' from Vincenzo Bellini's opera *Norma*, Mrs Muddle additionally raises the spectre of theft from luggage:

> Oh, dear! Whatever can I do?
> 'Dear, whatever am I to do?
> Here's all my luggridge is gone,
> I haven't the least idea where to!
> There was three trunks and an oblong box
> And none of them had got any locks;
> And they'll be robbed on the way, as sure

As my name is Muddle, they will.
Oh, dear! Whatever am I to do?[64]

Central to Carroll's comic treatment of robbery and railway accidents is an anthropomorphized book. *Bradshaw* – the timetable, not its author – appears on legs at the beginning of Act II Scene 2.[65] And later Spooney thus refers back to the human 'guide': 'such an odd thing! To think of a book coming and talking Shakespeare like a human being – I never'. Orlando likewise explains how since 'Bradshaw was printed all wrong' he has lost all his luggage and 'been the sport of cruel fate. For every train I was too late!'[66] Confirming his suspicion, the play ends with the figure of Bradshaw claiming, in the following terms, that to avenge his servants' dissent he has purposely hijacked all the train times in his book:

BRADSHAW: Enter my minions all and hear my words:

I made a rule my servants were to sing,
That rule they disobeyed, and in revenge
I altered all the train-times in my book,
And made the world go wrong, what then? 'twas just;
And ever thus shall virtue be rewarded,
And vice be punished, ye that hear me now,[67]

With such key appearances by a human railway guide Carroll's juvenile drama anticipates absurdities that might arise were a shift in train times to occur. Creating around the commotion of railway travel a performance for marionettes, Carroll reveals a relatively early interest in the dramatic possibilities of railway connections.

La Guida di Bragia grew out of Carroll's childhood fascination for the train. It is well known that growing up at Croft he constructed in the Rectory Garden a working train out of a wheelbarrow, barrel and small truck that conveyed passengers between two stations. Perhaps less well known is the fact that each station had a refreshment room and, by all accounts, Carroll enjoyed staging train crashes. He also invented rules for 'the Railway Game', some of which survive and anticipate the humour of his marionette play.[68] In addition, Carroll continued to introduce *Bradshaw* in his later works. The railway guide puts in an appearance, for example, in his poem

'Phantasmagoria' (1869), which involves the comic visitation of a speaker by a ghost.[69] Yet it was not only in his fictional texts that the notorious railway timetable continued to emerge. In a letter to Gertrude Chataway written at Reading Station on 13 April 1878, en route to Guildford, Carroll explains:

> As I have to wait here for ½ an hour, I have been studying Bradshaw (most things, you know, ought to be studied: even a trunk is studded with nails) and the result is that it seems I could come, any day next week, to Winchfield, so as to arrive there about 1: and that, by leaving Winchfield again about ½ past 6, I could reach Guildford again for dinner.[70]

The homonyms 'studied' and 'studded' unite the cognitive and the material in the forms of timetable and trunk, familiar objects transformed by Carroll's granting to them proximity in the shared sound of the application (studied/studded). In a modified version of Carroll's celebrated portmanteau word, in which two separate words by partial omission of their letters gain a new rolled-in-to-one form, the wordplay here refigures the separate status of both objects 'timetable' and 'trunk'. Just as the conjoined terms 'slimy' and 'lithe', which make up the famous example of the portmanteau word 'Slithy', no longer remain the same when wrested from their conjoined state, the 'studied' timetable and 'studded' trunk become in Carroll's letter suddenly unfamiliar; in this case at a fundamentally visual level.

There is a further sense in which the portmanteau word emerges as a product of Carroll's train travel, or at least its name links imaginatively with the bag he carried on such journeys. In a diary entry of 22 December 1864, Carroll notes 'bought a new portmanteau of Messrs. Day & Son' (v, 37). Derived from this type of large travelling bag for clothing (from the French *porter*, to carry, and *manteau*, cloak), which folds back flat from the middle, the portmanteau word packs the sense and sound of two words into itself. Just as the bag keeps things neatly arranged and, where space is at a premium, allows more to be comfortably taken along than might otherwise be possible, the portmanteau word economically packs in extra. Unsurprisingly, perhaps, Carroll's fastidiousness regarding his portmanteau extended to wrapping individually each item of clothing before packing it. His actual portmanteau, like his portmanteau word, retained the integrity of discrete elements when they were packed into a tight space.

Not all of Carroll's thwarted train journeys arose from misreading Bradshaw. In a letter to the child Maud Standen, dated 1 September 1873, he explains how a trip to see her is differently hampered:

> My dear Maud,
> Do you mean 'Victoria *Place*' or 'Victoria *Square*'? Your letter says 'Place'. I had 1½ hours today in Reading from 12½ to 2 and tried in vain to find you. It was chiefly my own fault, for I had forgotten the number, and stupidly had left your letter behind . . . so I simply walked slowly up and down on the opposite side of the road from end to end, in hopes somebody would see me from the windows, and *then*, seeing no friendly faces, I walked back, sad but *not* broken-hearted, to the Railway Station.[71]

This fruitless rail journey resembles an earlier mix-up in September 1868 over the White Hart and the White Lion inns in Guildford. On that occasion, after leaving Doncaster 'by the 11.21 for London' and arriving in Guildford that evening, Carroll realizes he has opted for the wrong 'White'; for he had directed his post to the White Hart, only to find the White Lion was the hotel he had meant. However, discovering the White Lion to be 'a *very* commercial inn', he subsequently switches back to the White Hart. It is the process of his doing so that is of interest since, rather than simply having his belongings directed from the 'wrong' to the 'right' hotel, he first sends them back to the railway station as a kind of decoy: 'To avoid the unpleasantness of moving from one hotel to another, I sent my things down to the Railway, and got a ticket for them, and in the evening had them taken to the White Hart' (vi, 56). Covering for the fact that he is moving hotels within the same town, Carroll makes use of the indispensable left luggage facility, introduced in British stations in 1840. To avoid risking offence to hoteliers he sends his luggage to the neutral terminus to mask its recent place of departure.

Throughout the nineteenth century, unless a passenger was travelling from station to station on the same line, rail journeys were complicated because different companies owned different lines. As a result, in addition to short odds on selecting the wrong platform, there were all sorts of possibilities for error when changing between companies. Re-enacting

the platform perils voiced in *La Guida di Bragia*, Carroll's diaries record many such 'adventures' on the rail, some of them mundane. After visiting his family in Guildford on 14 November 1868, for example, Carroll includes the following diary entry for the next day, 15 November: 'Returned in the evening, but, by the mistake of going to the wrong platform at Reading I missed the train, so only got to Didcot, from whence I took a fly and got in about midnight' (vi, 60).

However, on other occasions long intervals between trains prove unexpectedly productive, such as a three-hour interlude spent in the Forbury Gardens at Reading that led to Carroll's acquaintance with the Standen family. As Maud Standen later recalled:

> [Carroll] was waiting for a train to Oxford, and we went and sat on the same seat. He began to talk to us, and showed us puzzles and the tiniest of tiny scissors, which fascinated me, I remember, and which he kept in his pocket book. He made us write down our names and address and then hurried off to catch his train.[72]

Here, then, the imperative of 'catching' a particular train, and the wait for a connection, provides an ideal opportunity for Carroll to strike up conversation with children. Moreover, as confirmed in his letter from Guildford to Isabel Standen on 22 August 1869, a brief acquaintance during a railway stopover is by definition better than no acquaintance at all: 'Though I have only been acquainted with you for fifteen minutes, yet, as there is no one else in Reading I have known so long, I hope you will not mind my troubling you.'[73] That 'acquaint[ance]' in turn leads Carroll to send to Maud, and her sister Isabel, *Alice* books; on two subsequent occasions they travelled to Oxford to be photographed.

The previous year Carroll had an unexpected meeting on a return journey from Guildford to Oxford via London. As he records in his diary entry for 17 January 1868:

> Came into Oxford by the 6.15 express in company with a lady going to Charlbury, with a nice little girl, a friend of hers. The lady was a native of Oxford, and a relation of Rigaud, so we made friends on that ground.
>
> Reached Ch. Ch. about 8. Oh that I may be better guided to flee from sin and love holiness than in terms gone by! (v, 380–81)

This is in many ways typical of Carroll's records of chance meetings on trains. Here, however, it is difficult not to connect the prayer for forgiveness that directly follows the factual record of a railway meeting with the meeting itself, or with knowledge on Carroll's part that he had become too heavily invested in such chance railway encounters. Such an interpretation is borne out by the fact that, as Donald Thomas notes, even when a meeting 'in a railway carriage did not lead to an exchange of names, [Carroll] was known to write to those whom he thought might be the parents of the children and ask for photographs of the girls, since he was a collector of such items and an amateur photographer'.[74]

This practice is evident in Carroll's letter of 1865 to an unidentified recipient:

> I travelled from Thirsk about a month ago with a family party, father and 2 children, and have been wishing to find them again in order to procure, if I could, photographs of the children, as I am a great collector of those works of art, and am an amateur photographer myself. My travelling companion said he had been many years in Darlington, and it has been suggested to me that perhaps you were he.[75]

In referring in this letter to photographs of children as 'works of art', Carroll is using something of a ruse. For while he might have described as artistic photographs by some of his contemporaries such as Oscar Rejlander and Clementina Hawarden – and arguably some of his own – he could not be certain that pictures he might receive on account of this letter would fall into such a category. Nonetheless, he was eager to have them even if at the time of his request he considered them stopgaps until he found an opportunity to photograph the children himself. Moreover, the lengths to which Carroll goes in attempting to secure photographs is striking: evidence, if any were needed, of a compulsion to 'procure', as Carroll himself calls it, likenesses of children unknown to him as well as ones known. The train provided a physical network by which to make contact with new photographic subjects; as Carroll's letters and diaries testify, the possibilities for such meetings prove endless.

To substitute 'sun' for 'rain' in *Rain, Steam and Speed*, J.M.W. Turner's iconic 1844 painting of a train on the Great Western Railway, would produce a very different image than the existing one of modernity as embodied by the railway.[76] Without rain, the elemental vortex around the engine would be lost but 'steam' would prevail, and so too would 'speed' as key to Turner's depiction of the train. While speed was a vital component of rail transport, for Carroll, 'steam', as 'the chorus of voices' in the compartment of *Through the Looking-Glass* makes plain, provided rich fictional possibilities: 'Why, the smoke alone is worth a thousand pounds a puff!'[77] Earlier, however, in *Wonderland* it is the seaside that Alice calls to mind when she falls into the pool of tears. The seaside invariably meant the train:

> 'and in that case I can go back by railway,' she said to herself. (Alice had been to the seaside once in her life, and had come to the general conclusion that, wherever you go to on the English coast, you find a number of bathing-machines in the sea, some children digging in the sand with wooden spades, then a row of lodging-houses, and behind them a railway-station.)[78]

Alice's highly visual progression of thought here captures the enduring association of the railway with the seaside that, for many Victorians, Carroll included, was a destination primarily associated with children. He regularly took the train to the seaside. From 1873 to 1876 he spent his annual summer holidays on the Isle of Wight and, from 1877 until his death, he moved them to Eastbourne.

Setting out on an earlier trip to the Isle of Wight on 26 July 1864, however, Carroll records in his diary: 'Left by the 3 p.m. express for Freshwater, which I reached about 8, and put up, as usual, at Plumbley's Hotel' (IV, 343). In *Tennyson's Gift*, her hilarious fictional portrayal of a week in Freshwater, Lynne Truss immortalized Carroll's Isle of Wight capers.[79] There, she has him risking all embarrassment in his photographic pursuit of Tennyson and little girls. But the Isle of Wight is significant here as a rail destination that induced Carroll to send for his photographic equipment. Having not taken his camera with him on this particular trip of 1864, such was the glut of photographic child subjects that, after toying with the idea of having it sent, he finally went ahead and did so, recording its arrival on 12 August (IV, 352).

29 Lewis Carroll (C. L. Dodgson), *Farringford from the Field*,
14 August 1864, from *Photographs*, vol. III, albumen print.

Promptly dispatching the camera to Farringford, Tennyson's house, he began the next day taking photographs there. This relatively early visit to Freshwater became a memorable one for Carroll because, in addition to spending time with the Tennysons, he visited Julia Margaret Cameron.[80] He explains in a letter to his sister Louisa, dated 3 August 1864, how originally, without his camera, he had asked Cameron if 'she would photograph for me (in focus) the prettiest two' children. In so doing, Carroll draws his sister's attention to a 'little unknown child – such a little gipsy beauty, rich brown complexion and black eyes' that he had come across on the beach, explaining how he had finally been able to find out she was the daughter of a Colonel Franklin who commanded the fort near Freshwater.[81]

Although on this occasion Carroll took at least fifteen photographs at Farringford, only five are known to have survived. Carroll's diary entry for 15 August singles out 'two good pictures', one a view of the house from the field (illus. 29) and the other a large one of *Mrs Franklin and Rose* (IV, 352–3). Both of these images are included in Album III. The latter (illus. 30) pictures an intimate and loving connection between mother and daughter. Rose Franklin, located next to her seated mother, leans into her body and rests her head awkwardly on her shoulder. The child's dependent status is evident in her stance. Positioned outdoors, beside a window of the house, neither of Carroll's subjects looks at the camera: Mrs Lucy Franklin clasps her daughter's hand gazing to the left while Rose looks down, her head in profile. Compositionally it is an effective image. The woman's white collar and sleeves break the tonal mass of her dress and jacket, drawing the eye up to the faces of the figures. The child's plaid clothing is set against the blurred ivy leaves that climb the wall, together with an indistinct interior glimpsed through the window. As a photographic portrait it is also typical of Carroll's work in the sense that it is difficult to gather from it what might distinguish for him this child, or indeed this mother and daughter, from a range of subjects he had already taken. At the same time, the image is important in this very sense of demonstrating an impulse to photograph a particular child that exceeds, or is not entirely explicable in terms of, its final material outcome. Carroll pronounced it a successful photograph, but the story of the 'little gipsy beauty' as related in correspondence with his sister is not easily readable from it. Neither is the significance to him of the seaside context in which he 'found' her. Yet Carroll deemed significant this photographic incarnation as facilitated by rail travel.

30 Lewis Carroll (C. L. Dodgson), *Mrs Franklin and Rose*,
14 August 1864, from *Photographs*, vol. III, albumen print.

It is what he refers to as an 'uneventful' return rail trip from the seaside that prompts the following postscript to Carroll's letter to the child Edith Argles on 29 September 1869: 'If I have left any property behind me (which I think possible) it may be kept till I come "next time"!'[82] Carroll had spent a week in Babbacombe, close to Torquay, at the home of the child's family and, as he notes in his diary on 5 October, 'most of the time there went in photography and walks among the wonderfully beautiful coastal scenery'. 'Uneventful' though the return journey may have been, it generated a spectacular double acrostic. As Morton Cohen indicates, this particular acrostic is ingenious for the distinctive way in which it works, beginning with stanza three and moving to the end with each of the stanzas defining a word. Moreover, 'by listing these words from top to bottom, then reading downwards the first letters of the words and then the last letters, one gets *Babbacombe Friendship*.'[83] Stanzas eight and nine of the acrostic refer to the photographic sitting:

> Let lens and tripod be unslung!
> 'Dolly!' 's the word on every tongue:
> Dolly must sit, for she is young!
>
> Photography shall change her face,
> Distort it with uncouth grimace –
> Make her blood-thirsty, fierce, and base.
>
> I end my song while scarce begun;
> For I shall want, ere all was done,
> Four weeks to tell the tale of one:
>
> And I should need as large a hand,
> To paint a scene so wild and grand,
> As his, who traversed Egypt's land.
>
> What say you, Edith? Will it suit ye?
> Reject it, if it fails in beauty:
> You know your literary duty!
>
> On the rail between Torquay and Guildford, September 28, 1869.[84]

In the physical and conceptual links Carroll here makes between the railway and his photography, the precise 'event' of the rail journey itself generates an acrostic commemorating a photographic session. Indeed, playful linguistic celebration of photography arises owing to the unique space for reflection and invention guaranteed by the train. More emphatically, since in this instance, as in many others, none of Carroll's photographs of the Argles family have survived, the acrostic comes to substitute for the material objects of the photographs themselves. The motive, as elsewhere, for unpacking 'lens and tripod' is to photograph the ideal subject, a female child: "Dolly must sit, for she is young!" But Carroll playfully calls up a natural correspondence between child and photograph in the context of the medium's potential for metamorphosis in the physical 'distor[tion]' of an 'uncouth grimace'. Significantly, the signature to the poem records not only the time of its creation but its more elusive place, in transit: 'on the rail between Torquay and Guildford'.

❧ LEFT LUGGAGE ❧

Pairs of Concrete propositions, proposed as Premises: Conclusions to be Found

10. Umbrellas are useful on a journey;
 What is useless on a journey should be left behind.
Answer: Some things, that are not umbrellas, should be left behind on a journey.[85]

As in the case of Carroll's camera dispatched by train to Freshwater, and taken with him to Babbacombe, trains proved invaluable in transporting property. But they also enabled things to go astray. Carroll's concrete proposition from *Symbolic Logic* – 'Umbrellas are useful on a journey: What is useless on a journey should be left behind' – chimes with Hippolyte Taine's observation of the rail-going English public 'provided with so many kinds of field and perspective glasses, umbrellas and iron-tipped sticks, capes, woollens, waterproofs and greatcoats, with so many necessaries, utensils, books and newspapers, that in their place I should have stayed at home'.[86] Yet Carroll's 'answer' to the proposition ('Some things, that are not umbrellas, should be left behind on a journey') conjures a potential plethora of

portable gadgets, such as a collapsible drinking cup and the folding scissors that he himself found useful. At the same time, 'leaving things behind' may also denote 'losing' them and, on a number of occasions, Carroll appears to manifest both conscious and unconscious wishes to 'lose' things.

Writing to the eleven-year-old Dymphna Ellis on 29 July 1865 from the Great Northern Hotel, King's Cross, Carroll explains:

> Of course I left something behind – always do: this time it was my album of photographs (and autographs). And we also forgot to get your names written in it. So will you please turn 2 or 3 pages on after 'Mary Millais', and then sign your name in the same place in the page that she did, only about half an inch lower down, and then get Mary, Bertha, and Katie to do the same thing in the 3 following pages. And then will you send it by train to Croft Rectory, Darlington. Thank you – much obliged.[87]

His diary indicates that Carroll had travelled with his camera to Windsor four days earlier on 25 July to visit the Ellis family at Cranbourne, where their father Conyngham was Rector. Carroll recorded beginning photography on 25 July 'with a good picture of Dymphna' and then the following day: 'photographs all day' (v, 99). The above instructions to the child about how to enter her autograph in the album, prior to her photograph, show the extent to which for Carroll photographs and autographs – the face and the hand – produce an ideal combination. As the letter reveals, he had already conceived of the order of the entries for the album and, although the photographs did not yet exist as prints, he had envisaged the exact sequence of their placement.

Yet, rather differently from the first part, detailing his forgotten album, the final section of Carroll's letter to Dymphna Ellis introduces a reverse scenario: that of precisely *not* having left behind what he had intended in the form of commonplace 'cloths' used for photography. Carroll thereby plays upon unintentional and intentional actions prioritizing in this context his embarrassment at those 'cloths' wet with tears he chose *not* to 'leave behind':

> I didn't leave many cloths behind, as I had meant to do – fact was, I cried so much while packing up my photographing things, that the cloths were all dripping wet with my tears, and I was ashamed to leave them behind. Of course you won't mention it to any one.[88]

Here, as elsewhere, especially in the realm of his letters, Carroll enjoys writing about the significance of 'leaving things behind', imagining the possibilities and circumstances of subsequently retrieving them. Umbrellas are certainly 'useful on a journey', as Carroll proposes, and in that case one might wish to avoid forgetting them en route. Yet photographic 'cloths' are also useful items. However, when used to mop tears rather than chemicals, they are suddenly out of place. As embarrassing evidence of Carroll's sadness at packing up his photographic equipment, the cloths, he claims, have only been divulged to the child. As happens on other occasions in his correspondence with children, he thereby invites intimacy over a banal secret while at the same time fooling with his own 'pairs of concrete propositions' regarding 'usefulness' and 'uselessness' on journeys.

When Freud quotes Ernest Jones in *The Psychopathology of Everyday Life*, claiming that 'one can almost measure the success with which a physician is practicing psychotherapy ... by the size of the collection of umbrellas, handkerchiefs, purses, and so on, that he could make in a month',[89] not only does he evoke a mini railway lost property office, but he appears to be thinking aloud a version of Carroll's own marker of success when travelling by train to photographic sittings: the more items of personal property he forgets, the better he has spent his time. In some cases, as in that of the 'cloths', Carroll goes as far as interpreting as symptomatic his own unconscious motivations for leaving behind items of personal property. In the *Introductory Lectures* Freud writes:

> *Losing and mislaying* are of particular interest to us owing to the many meanings they have – owing ... that is, to the multiplicity of purposes that can be served by these parapraxes. All cases have in common the fact that there was a wish to lose something; they differ in the basis and aim of that wish. We lose a thing when it is worn out, when we intend to replace it by a better one, when we no longer like it, when it originates from someone with whom we are no longer on good terms or when we acquired it in circumstances we no longer want to recall.[90]

Anna Freud, in her essay 'About Losing and Being Lost', written in 1946 and published in 1967, takes up her father's work on parapraxes. In that essay she considers an 'error' such as 'losing' on the basis of a conscious intention being interfered with by a wish which arises from the

unconscious'.[91] She is interested in the fact that 'in the case of losing a thing we have the unconscious desire to discard something which consciously we wish to retain'.[92] However, Anna Freud further maintains that 'losing possessions reminds one of that originary childhood dejection of being alone and the ways one displaces this feeling through the personification of an object; "It got lost", and not, "I am lost without it"'.[93] Thus she offers an example of the doubleness of identification: both with the passivity of the lost object and with the aggression of the actor who seems to discard it. Noting the complexity of the example, Deborah Britzman recognizes 'the structure of ambivalence' in such a circumstance in which 'the loser's identifications are split between the object of loss and the subject who loses it'.[94]

Carroll appears to engage both aspects of losing objects: as providing a reason to return to a place of attachment and as a means of discarding an object no longer wanted, or acquired in circumstances he wishes to forget. But in playfully anticipating leaving things behind he appears a step ahead of the game. As readily available and nondescript objects, Carroll's 'cloths' for photography fall into Freud's category of things 'worn out' or 'used up' that might be replaced by better ones. However, by alluding to a mundane item as a cloth as 'dripping wet with tears', Carroll complicates the fantasy. Confused with handkerchiefs – wiping away tears instead of photographic chemicals – rudimentary cloths find their value transformed. As a consequence, ambivalence attaches to the prospect of losing them.

With regard to the incident of the photograph album Carroll writes again to Dymphna Ellis on 3 August 1865 thanking her for its safe receipt:

> The photograph-album arrived safe, autographs and all – only the Railway-people (who had carefully read it) said that *your* signature made the book 'above £10 in value' and that 'it ought to have been registered.' I told the clerk that was nonsense, and that down at Cranbourne your signature wasn't thought worth 2*d.*, but he shook his head gravely, and said 'he knew better than that.'[95]

Carroll packs into two sentences the risk attached to sending an unregistered parcel along with the wonderful conceit of railway porters 'carefully read[ing]' a photograph album and attributing considerable value to a particular child's signature. Replete with four extra signatures of the

31 Front cover of Lewis Carroll's album *Photographs*, vol. III.

Ellis sisters, the book is indeed all the more valuable to him on its return journey by rail; the unconscious pretext for leaving it was to secure with ease the children's signatures. What is more, once reunited with his album Carroll is able to make the child who dispatched it to him feel valued while admonishing her for failing to register the parcel. He thereby discloses in the form of an amusing railway scenario his own considerable investment in the album. The album in question contained the aforementioned photographs, including *Mrs Franklin and Rose*, taken the previous summer at Farringford.

Happily, that album (*Photographs*, vol. III) survived its illustrious solo rail journey back from Cranbourne to Oxford to be eventually bought at auction by Helmut Gernsheim, and deposited in the Gernsheim Collection at the University of Texas (illus. 31).[96] Preserved in it is Carroll's 'good photograph' of Dymphna Ellis (illus. 32) cut to oval format above her

beautifully executed signature. She appears outdoors, her face in profile in a three-quarters-length pose, perched on a wooden stepladder, her hands positioned awkwardly one on top of the other. As in many of Carroll's photographs the child's apparent absorption belongs to a place beyond the locale of the photograph. He employs the medium of photography to distil an inner life for the child that denies a certain reciprocity between her and the viewing subject.[97] She is pictured engaged beyond the frame, suspended, as it were, inviting and foreclosing a viewer's relationship to her.

In the group portrait with her sisters, taken on the same occasion, Dymphna's look mixes the serene with the quizzical (illus. 33).[98] In that composition, draped with a shawl and wearing a hat and boots, she is seated at the centre. Two of her three younger sisters flank her in what aspires to a pastoral scene created by the girls' clothing and the bare feet of the younger two. That quality is broken, however, by the odd visual effect of the scrub-like foreground and the awkwardness of the children's poses. One rests her head upon Dymphna's lap while the other leans against a tree-trunk to her right. Moreover, Dymphna's hands are clasped rather heavily upon her sister's head and there appears little connection between the figures. But the interest of the photograph, in which each child appears separately absorbed in reverie, lies precisely in its communication of interiority. Only the recumbent child looks directly into the camera lens, her gaze calling to mind that of the semi-supine figure in Millais's *Spring* of 1859, a painting of which Carroll kept a photograph.[99]

But what becomes especially apparent when considering the creation of these photographs alongside Carroll's description of the album's escapade by rail is a heightened sense of the materiality of the likeness, increased, as it is, when positioned adjacent to the child's signature. As was the case with all his albums, the value of this one for Carroll lodged in its interweave of photographic mementos, the results of expeditions for photography made possible by the train. For, as evident on this occasion of his forgetting it, a photograph album is not simply a repository of precious images, or a vital record of 'sittings', but an object of attachment that evokes a tapestry of occasions on which photographs were taken and processed. Indeed, it is to these aspects of the process, at the other end of the scale from the aesthetic properties of the resulting images themselves, that in Carroll's interchange with Dymphna Ellis the rudimentary 'cloths' call attention. Since the process of taking photographic negatives

Dymphna Ellis.

32 Lewis Carroll (C. L. Dodgson), *Dymphna Ellis*, 1865, from *Photographs*, vol. III, albumen print.

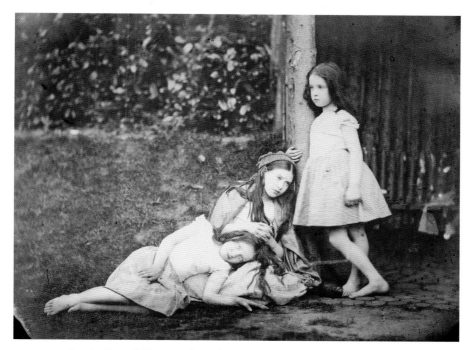

33 Lewis Carroll (C. L. Dodgson), *Dymphna Ellis and her Sisters* (1865),
albumen print.

is a time-consuming and messy one, to leave behind an album is not only
to 'lose' an object containing a high degree of aesthetic investment, it is to
be without physical triggers for remembering the event.

A different account of loss from that of the aforementioned album
appears in Carroll's letter to Margaret Cunnynghame, who had visited him
at the Residence, Ripon. Missing a glove following her visit, he sends the
child a bill for it. He addresses her as 'Debtor to Mr C. L. Dodgson' and seeks
to retrieve not simply the cost of 'one kid glove' but also compensation
for 'pain', 'annoyance', and 'vexation' 'felt at loss', together with one shil-
ling and sixpence for the 'time spent hunting [the] thief'.[100] Here, the 'lost'
glove offers a pretext for further communication with the child. Of course,
the symbolic potential of a misplaced glove was well known in the period
and Carroll would have been aware of established iconographic meanings
that attached to gloves. Often it is women's gloves that are dropped or
lost but, as evidenced in William Holman Hunt's well-known painting *The
Awakening Conscience* (1853–4), in which a seducer has carelessly cast his

34 Advertisement for umbrellas, *Pike's Eastbourne Blue Book & Local Directory for 1890–91.*

glove on the floor as he plays the piano to his mistress, the gloves of men may have similar iconographic significance.[101]

Specifically for Carroll, however, along with a pocket-watch, kid gloves are conspicuous attributes of the White Rabbit in *Wonderland* as well as articles generally carried by railway travellers. His misplaced gloves offer a pretext for the Rabbit to mistake Alice for Mary Ann, his maid: 'Run home this moment, and fetch me a pair of gloves and a fan!'[102] But more specifically in relation to photography, following the 'eat me' 'drink me' episodes, when Alice looks down at her hands and is 'surprised to see that she had put on one of the rabbit's little white kid-gloves while she was talking', the glove functions as a measure of Alice's size.[103] Her very capacity to wear the glove means she 'must be growing small again'.

But a glove was also the most frequently 'lost' item of personal property in the period, as testified to by the numbers languishing in the lost property offices of railway stations of the time. During a twelve-month period 'a firm acting for the Great Eastern Railway company' auctioned a total of 3,350 gloves along with '2,280 umbrellas, 1,150 sticks, 1,000 hats, 770 collars and cuffs, 510 pipes, 320 socks and stockings, 300 boots, 260 handkerchiefs, 150 aprons, 120 boas and muffs, 110 coats and jackets, 64 vests, 38 trousers, 9 chains, 8 rings, and 3 revolvers'.[104] Given the frequency of his train travel, it would not have been surprising to find that one or two of Carroll's gloves, or indeed one of his umbrellas (illus. 34), had ended up in one of the Lost Property Offices that featured at all large stations. Distinct, though, from 'forgetting' a precious photograph album, the common loss of gloves and umbrellas returns us to the familiar paraphernalia of rail travel that especially comprised the load of those passengers making use of the new railway excursion. Lost tickets, left luggage, Bradshaw, chance encounters, combined to create the experience of rail travel that fascinated Carroll. He was one of the first Victorians to celebrate locomotion, and the betwixt and between context of the journey itself. He found the train carriage, as well as the train journey, an imaginatively enabling space and one in sync with his photographic aspirations.

3

The Play House: Carroll at the Theatre in London

'Aedes Christi' – 'House of God': 'the House'
The auditorium of a theatre: 'the House'

WHILE THE TRAIN FACILITATED such one-off trips for photography to the Isle of Wight and Devon, it also enabled Carroll to travel regularly from Christ Church to London to attend exhibitions, to buy photographs and photographic supplies. On 31 July 1863, for example, he ordered chemicals at Thomas's and left negatives for printing at Cundall's (IV, 229) while, on 6 April 1866, he recorded 'looking over' and buying 'a few' of 'Rejlander's photographs from De La Rue's' (V, 137). In June 1866 he even made enquiries, 'without success', about renting a photographic studio in the capital (V, 162). Going up to town was as much a part of Carroll's life as attending events in Oxford. But it was especially the theatre – and many kinds of theatrical performance – that prompted him to take the train to the capital either for the day or, when his university duties allowed, for several days at a time.

Focusing upon theatrical events and performers from the 1860s and '70s, this chapter explores the emergent and increasingly significant closeness for Carroll between photography and theatre in its myriad forms. It is framed by two performances: the first in 1867 by the Living Miniatures and the other in 1871 by the celebrated acrobat Lulu. Both were significant for Carroll in their relationship to photography. In visual terms, he prized the miniature performer's costumed body and, in so doing, as Carolyn Steedman's *Strange Dislocations* has demonstrated, he was not alone in the period.[1] In her study of Mignon, the 'strange, deformed and piercingly beautiful child acrobat' from Goethe's *Wilhelm Meister's Apprenticeship*, Steedman explores ways in which, from the eighteenth century onwards, the figure of the child acrobat was constantly rewritten and reshaped as an 'idea or concept of the self' and an irretrievable past.[2] Intrinsic to

the acrobat figure is an idea of 'littleness' and, as Steedman points out, for Goethe's Wilhelm 'what had delighted the child-in-memory' was the diminutive size of the puppet figures he had played with.[3] For Carroll, whether she was a fairy, an equestrian entertainer, or an acrobat, the small performer he enjoyed watching became changed both actually and conceptually into a photograph. Yet, while photography was the miniaturizing technology par excellence, the process of metamorphosis from stage to photographic plate was a complex one in which the inanimate figures of dolls and marionettes played an intermediate role. By fusing London theatre with other kinds of spectacle, real-life performers with toys, Carroll inhabits a space anticipating that which Henri Bergson in his study of laughter calls a 'zone of artifice, midway between nature and art'.[4]

Carroll's passion for the stage had begun in childhood when he masterminded ingenious amusements for his siblings. At the Old Rectory at Croft-on-Tees, he had invented puzzles, magic tricks, along with humorous copy for domestic magazines. In addition, he choreographed charades and dramatic productions for the marionette theatre he constructed with the help of a carpenter from the village (1, 19). With seven sisters and three brothers – eight of them younger – Carroll was rarely short of actors in his scenarios. Yet the matter of attending a public theatre was never straightforward since he had to negotiate his passion for such entertainment in relation to the absolute injunction, upheld by his father and his good friend Henry Parry Liddon, against attending the theatre. Archdeacon Dodgson's prohibition, however, did not prevent Carroll from enjoying performances whenever the opportunity arose, but it may explain the fact that, as Richard Foulkes indicates, Carroll attended few theatrical productions in Oxford.[5] There his presence in an auditorium would have been conspicuous.

Since theatre visits to London meant mixing with people from all social classes, they demonstrate the limitations of portraying Carroll as a cleric divorced from contemporary nineteenth-century social concerns. Indeed, theatre and pornography, historically sharing the same districts in the capital, remained closely linked in the Victorian period and, given the location of some of the theatres, Carroll sometimes stayed at hotels in areas known for prostitution. As Donald Thomas points out, Carroll's visits to the Olympic Theatre in Wych Street brought him within the vicinity of three shops dealing in pornographic prints, while the neighbouring

Holywell Street was a notorious location of 'the mid-Victorian trade in pornography'.[6] From exposure to this location alone, Carroll could not 'have been unaware of the less agreeable uses of the camera, even before the 1870s', and his personal library indicates 'he had read up on London "vice", and was fully aware of those locations in which one was most likely to encounter it and the specific forms it might take'.[7]

It is in this context that Carroll's life-long interest in the theatre has led biographers to conclude that his eventual decision not to proceed to full ordination was in part owing to his unwillingness to give it up.[8] Certainly, the timing in 1862 of his choice not to take full Holy Orders makes it difficult not to connect his theatre-going, and his accompanying passion for photography, with expressions of guilt attached to time wasting especially fulsomely expressed in his diaries of the period.[9] In spite of such self-reproach, however, during the 1860s and '70s, frequenting the London homes of literary and artistic families such as George and Louisa MacDonald, Benjamin and Sarah Terry, John Everett and Effie Millais, Carroll divided his time between photographing and attending the theatre.[10] Since the MacDonalds, and especially the Terrys, were theatrical families, his friendship with them gave him regular access to productions and opportunities to photograph actors. However, theatre and photography did not simply dovetail in practical ways. Photography *was* 'theatre' for Carroll in the sense that he increasingly came to conceive it. In formal terms, through the miraculous capture of costumes, gestures and effects, a photograph had the potential to arrest character, as put on. Most obviously in the mechanically reproducible form of photographs, viewers might experience over and again the stilled scenarios of theatrical tableaux.

At the same time, the increasing availability in the 1860s of *cartes de visite* of contemporary actors resulted in a new cult of celebrity. It is at the expense of the more conceptual relationship of photography to performance, though, that critics have tended to focus on the place in commodity culture of such commercial photographs of actors. They have barely begun to address more subtle ways in which Carroll's interest in photographs was bound to his attachment to the stage. Courting conceptual complexities of all kinds, he was drawn to the fundamental difference between the medium of photography as a silent and two-dimensional form and theatre as an animated three-dimensional spectacle. This is not to say that he did not relish buying *cartes* of actors (he clearly did and prized them as additions

to his albums), or that he failed to delight in humdrum entertainments. Indeed, he made few bones about doing so. Yet in habitually wanting to attend performances, often the same ones more than once, Carroll enjoyed theatre in ways similar to those in which he enjoyed repetition of a photographic take. At a formal level the proscenium arch and the camera lens contained visually immediate scenes. And Carroll enjoyed the immediacy of theatre just as he enjoyed the direct imprint of a photographic image. In both cases, however, he also took particular pleasure in knowing that such immediacy came to him in a mediated form.

Especially fond of drama aimed at juveniles, Carroll never lost his taste for pantomime and burlesque. But he was not unique among adults in the period in frequenting productions acted by, and aimed at, children. Indeed, for many in Victorian Britain, the annual pantomime that began on Boxing Day and ran for several months was a seasonal draw. With its carnivalesque humour, its mixture of wordplay and inversion, together with visual splendour and audience participation, pantomime embodied all the things Carroll had loved as a child and continued to prize as an adult. Writing, thereby, on 11 February 1877 to thirteen-year-old Gertrude Chataway enquiring: 'I wonder if you have ever seen a Pantomime at all?', he was not being entirely facetious in claiming, 'if not, your education is *quite* incomplete'.[11] But not only did Carroll delight in watching child actors perform, he enjoyed being among audiences comprising children, sharing their spontaneous responses to theatre of different types. His fondness for attending the same production several times – in the case of Edward Blanchard's *Robin Hood and his Merry Little Men* at the Adelphi a total of six – migrated to his photographic practice in which he liked to take different children in the same costume. By repeating fundamental elements of staging and set up, he utilized photographic repetition in a way that echoed the experience of multiple performances of the same theatrical production.

The variety of shows Carroll enjoyed is nowhere more evident than in the following reminiscence of Greville MacDonald, the son of Carroll's good friends the novelist George MacDonald and his wife, Louisa:

> Our annual treat was Uncle Dodgson's taking us to the Polytechnic for the entrancing 'dissolving views' of fairy tales, or to go down in the diving bell, or watch the mechanical athlete *Leotard*. There was also the Coliseum in

INTERIOR OF THE POLYTECHNIC INSTITUTION, SHOWING THE DIVING BELL.

35 Interior of the Polytechnic Institute with diving bell, 1850, engraving.

Albany Street, with its storms by land and sea on a wonderful stage, and its great panorama of London. And there was Cremer's toyshop in Regent Street . . . all associated in my memory with the adorable writer of *Alice*.[12]

For Greville MacDonald the peculiar pleasures of Carroll's company bring to mind a range of engaging spectacles in addition to plays and pantomimes. To remember the optical intrigue of a 'dissolving view' is to throw into heightened relief the subterranean mystery of a ride in the diving bell at the Polytechnic Institute in Regent Street (illus. 35). That attraction, in turn, conjures the ingenious toy, the mechanical *Leotard* manufactured in the 1860s, which, by a process of shifting sand, activated a model of the celebrated French trapeze artist. Equally, Greville MacDonald's indelible memory of 'Cremer's toyshop' emerges alongside the monumental context of the panorama. Promising more than simply 'toys', W. H. Cremer's saloon of magic at 210 Regent Street[13] specialized in 'Illusions, Magic, Optics' and had 'a platform like a small stage one end where tricks were demonstrated by a resident magician'.[14] It was a place of performance just as powerful in its own way as those grander illusionistic spaces of London

theatres. In bringing together such variously miraculous spectacles, Greville MacDonald's vivid memoir provides a reminder that Carroll's fondness for theatre was throughout his life bound up with other kinds of attachment: to magic, and illusionism, to acrobatics, toys, and new-fangled gadgets of all kinds. London provided a wealth of all of these.

<div align="center">❧ THE LIVING MINIATURES ❧</div>

On 24 January 1867 Carroll took two of the MacDonald children to the Theatre Royal, Haymarket, to see the Living Miniatures, a troupe of 27 exclusively child actors, in an anonymous extravaganza, *Littletop's Christmas Party*, and an alliteratively titled burlesque by Reginald Moore, *Sylvius, or The Peril, the Pelf and the Pearl* (illus. 36). The performers, ranging in height from thirty to fifty inches, were managed by Thomas Coe,

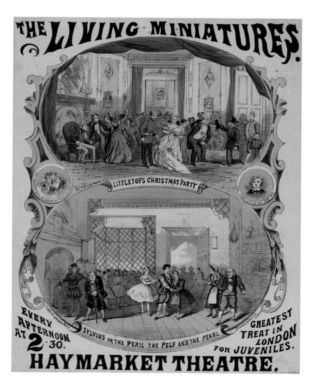

36 Alfred Concanen, *The Living Miniatures*,
1867, colour lithograph.

Stage Director at the Haymarket, actor and acting teacher.[15] In his diary for that date Carroll notes: 'the whole performance was far beyond anything I have yet seen done by children' (v, 193). Reviews in the popular press of the time confirmed Carroll's high opinion of the Living Miniatures. A reviewer in *The Era*, for example, described the company as a troupe of 27 juveniles 'accomplished in a triple sense . . . as actors and actresses, singers, and dancers', claiming that most child actors 'have not a tithe of the talent shown by this Lilliputian company'.[16] The *Sporting Gazette* similarly noted: 'Altogether the juvenile troupe go through their parts with much spirit, and in some of them considerable cleverness is shown.'[17]

On 2 March 1867 Carroll went a second time to see the Living Miniatures. On this occasion, he wrote a long and detailed account of the event in his diary. Unique to this visit was an opportunity to venture behind the scenes, to experience the workings of a theatre and to meet a cast made up entirely of children. Afforded privileged access to the staging, Carroll appreciated observing the child actors as they interacted both with their peers and with adult directors. And in documenting the experience he remarks upon the relative degrees of the children's beauty as witnessed from the auditorium and close to:

> I was agreeably surprised to see how pretty some of them were, even with all the disadvantage of daylight and rouge . . . The one of the actresses whom I had thought prettiest on the last occasion, is not so pretty when seen close – J. Henri: she is consumptive, Mr Coe tells me, and looks almost too delicate for the work – Mrs Coe soon joined me in the prompter's box, carrying with her the dear little Annette, who seemed to be a general pet, and also throughout the performance was trotting about just where she liked, as were all of the children, but without ever being in any one's way, or *out* of the way when wanted (v, 202–3).

While 'the disadvantage of daylight and rouge' does not mar the appearance of many of the children it does mean that 'the prettiest', 'J. Henri', is not so when seen close up. Moreover, when Carroll discovers this particular child is consumptive, he registers, albeit in passing, a question of the appropriateness of the profession for a sick child.

Such concern for the physical well-being and working conditions of child performers would become increasingly a matter of public discussion,

culminating in 1889 in legislation in the form of the Prevention of Cruelty to Children Act.[18] Consistent with his interest during the 1880s in age of consent legislation, Carroll was fully involved in this debate. Yet, while later political discussion would focus on definitions of 'labour' and working conditions of child performers, what he witnessed in the 1860s of the backstage circumstances of the Living Miniatures confirmed for him their appropriateness for child actors. From a backstage perspective Carroll was taken with a sense that performing 'did not seem to be work to any of the children: they evidently enjoyed it thoroughly' (v, 203). Reassured that the Living Miniatures were not being coerced into their labour, Carroll goes on to equate acting with 'play' as a legitimate activity of childhood. At the same time, in remarking upon the children's maturity, organization and resourcefulness in remembering their cues without adult intervention, he is also struck by their 'clock-work' regularity (v, 203). The metaphor is telling, for, in the form of the mechanism that animates it, he connects the miniature actor, her uniformity and guarantee of repetition, to the child's toy. These were qualities Carroll celebrated not only in this troupe of child actors but in child performers more generally.

Of the two shows he saw by the Living Miniatures, Carroll notes 'the burlesque was much prettier to see from behind than the comedy, as the children looked so much prettier in burlesque dresses – especially J. Henri as "Sylvius", Lillie Lee, and two little fairies, twins, of the name of Lacy' (v, 203). Costumes, always a draw for Carroll, were heightened by such a backstage view. Tracy Davis has explored ways in which in adult burlesque, as in 'opera bouffe, pantomime, music hall, musical comedy, ballet and extravaganza, conventions of costume, gesture, and theatrical mis-en-scène ensured that the most banal material was infused with sensuality' and 'deliberately manipulated to result in the erotic arousal of male spectators'.[19] In this context, the behind-the-scenes encounter was important in exposing what was 'normally hidden'.[20] While it would be simplifying Carroll's response to read it exclusively in this regard, it is important to consider ways in which such theatrically encoded erotic effects, for Davis 'invisible and unintelligible to many spectators', might be differently inflected in the context of child performers.[21] Carroll's visit to the Living Miniatures raises issues of voyeurism as sanctioned by different strands of Victorian theatre. But, in addition to a chance to see things usually hidden, his behind-the-scenes encounter offered an attractive

physical inversion. Akin to a 'looking-glass' perspective, it gave a sense of peering back from the depths of the mirror. As his diary entry of 12 January 1869 reveals, Carroll's first title for *Through the Looking-Glass* was '*Behind the Looking-Glass, and what Alice saw there*' (vi, 76), thereby designating not simply a world previously invisible on the other side of the fireplace, but a position 'behind' the glass from which to look back to the familiar side. The French translation of *Through the Looking-Glass – L'Autre côté du mirroir* – retains this important dimension of the experience.[22] In a letter to his brother Edwin regarding the Living Miniatures, Carroll mentions in particular a 'snow-storm' enhanced by an inverted vantage point from which he was able to watch: 'cut paper being showered down by a man on the top of a pair of steps'.[23]

An additional attraction of viewing the Living Miniatures from behind was in occupying the position of a child performer looking out from the stage into the auditorium. From backstage, Carroll enjoys a dual movement in which he may look at children without being noticed while at the same time identifying with their skills in performing to an audience. Identifying also with what he reads as the 'pleasure' of child performers, he is drawn to the linguistic accomplishment of child actors – their enunciation, sharp diction and timing in delivery of their lines and their capacity to learn long and often sophisticated scripts. These were qualities with which he was perpetually concerned in his experience of speech as difficult and hesitant, and his longing to correct it. As chapter Five will demonstrate, Carroll's enduring interest in the speech of children was not unrelated to his stammer and, in theatrical contexts, comedy in the form of wordplay and puns celebrated – sanctioned even – forms of irregular speech.

Acknowledging that Victorian adult spectators, male and female alike, were fascinated by the ability of child actors to deliver their lines with impeccable fluency, recent work has taken up the 'precocity' of stage children to correct what it regards as an overemphasis on voyeurism on the part of adult male viewers including 'child lovers' such as Carroll and Ernest Dowson.[24] Marah Gubar challenges seminal texts such as Jacqueline Rose's *The Case of Peter Pan*, which focus upon the voyeuristic nature of the Victorians' interest in the child's body, claiming Victorian stage children successfully 'blur[red] the line between innocence and experience'. In contending that 'precocious competence' was a key draw for audiences, she calls for readers 'to reconsider whether the cult of the

child was really about freezing the child in place as the embodiment of artless innocence'.[25]

Yet, while Victorian audiences undoubtedly relished seeing clever children perform with the facility and poise of adults, a question arises as to the extent to which a concept of precocity shifts emphasis, as Guber intends, from a child's body to her acting abilities. The term 'precocious', from the Latin meaning 'prematurely ripe', precisely confirms the proximity of a concept of 'cleverness' to questions of the child's physicality. Implying sexual readiness in advance of its time, and a potential to go to waste, the word 'precocity' retains a sexual connotation of 'ripeness'. Thus, while Gubar calls for 'a more balanced view on stage children',[26] when, in the period, adult audiences enjoyed watching minors performing in advance the feats that generally belonged to majors, they did not celebrate exclusively linguistic or cognitive prematurity, for those feats of linguistic virtuosity emerged from immature bodies. Victorian adults precisely enjoyed watching childish frames transformed by adult potentialities. In praising child actors, Carroll and some of his contemporaries appeared to respond to a capacity for metamorphosis, or physical transformation, of a child's body as she performed in such a way. It was a quality that photography came close to capturing.

Costumes and staging were at the heart of such transformation and key to Carroll's attraction to the Living Miniatures. What becomes apparent in the lengthy record of his visit to Coe's company is that it is not the children per se, devoid of costume and props, in which he is most interested, but the children *in* costume. As he further notes: 'If I take my camera to town this summer, I shall certainly get some of the children to photograph – though there is little chance of the costumes then being in existence.' Out of costume, the miniature performers are simply not as attractive to him for photography. While one might reduce his comment to a wish to photograph children's bodies in the most revealing clothing of their stage roles, it would be grossly oversimplifying his response to assume that this would be the case. Clothing clearly functions in the capacity of fetish here, as it did for others. However, both as material objects, and preserved in photographs of children wearing them, costumes in complex ways come to stand in the larger whole of a theatrical event.

In *Romantic Imprisonment: Women and Other Classified Outcasts* Nina Auerbach identifies a key connection between the child performer and

photography that remains important to an understanding of Carroll's longing to marry the two: 'To elicit the essence of his sitters Carroll seems to have encouraged them to act, thus releasing the metaphoric potential he saw coiled within little girls: the hallmarks of his photographs is the use of costumes, props, and the imaginative intensity of an improvised scene caught at midpoint.'[27] While he did not so much encourage them to 'act' as dress them up to resemble actors, a quality of improvisation was key to Carroll's photographic practice. For Auerbach, a sense of captured animation in 'an improvised scene caught at midpoint' connects Carroll's photographs with theatre. But, while the camera petrifies what it represents, part of its perpetual magic lies also in its capacity to suggest innate movement within that stilled form of the photographic image. As 'stills', as it were, related to previously moving spectacles, photographs of child performers in particular provided a repository of the imaginative intensity of such scenes.

In the case of the Living Miniatures, such intensity is evident in their willingness to 'play' beyond the requirements of their role that recalls Charles Baudelaire's understanding of child's play as indicative of children's 'great capacity for abstraction and their high imaginative power'.[28] Referring, in his 'Morale du joujou' ('Philosophy of Toys', 1853), to a child's ability to turn a mundane object into a grand or unlikely one, Baudelaire remarks upon what he calls the 'the eternal drama of the *diligence* played with chairs!'[29] He is drawn, in particular, to a child's transformation of a static object into a moving one, a horse or a carriage, to produce a quality of 'scorching speed' by which to 'devour' what he calls the 'fictive spaces' of a room.[30] While Carroll similarly savours childish invention as revealed through games, on occasion in photographing children he contrived their metamorphosis into playthings. That is to say, picturing a child's resemblance to a doll or a marionette, the camera facilitated visual transformation in a manner resembling live performance.

When theatricality and photography came together for Carroll the result was compelling. A child's simulation of action through static objects is at the heart of Carroll's photograph of *St George and the Dragon*, 1875 (illus. 37). In the staged tableau blatantly fictional props testify to the inventive capacity of child's play. But those props also signal a photographer's recreation of the blandness to an adult eye of that mundane adult space that in Baudelaire's terms is only 'fictive' to the child. *St George and*

37 Lewis Carroll (C. L. Dodgson), *St George and the Dragon*, 1875, albumen print.

the Dragon is one of a small number of photographs in which Carroll tells a story with 'actors'.[31] Xie Kitchin, along with her three brothers, poses in a mythological tableau. Brooke Taylor as St George rides the large rocking horse; George Herbert in a heap on the floor represents the defeated knight, while Hugh Bridges plays the Dragon. But what is striking about this photograph is the way in which it does not simply reveal its artifice, but also revels in doing so. The leopard skin barely covers the child's crouching body and the sword, shields and other props are half-heartedly deployed. However, this is precisely the point. For Carroll exposes the dissembling that produces the event. He seeks to fix it in order to be able to revisit it, when displayed in an album, in such terms of visible imperfection.

Contriving a form of illusionism uniquely credible to a child, *St George and the Dragon* is on a par with the fabrication of snow from shredded paper that Carroll had earlier enjoyed in the performance of the Living Miniatures. In the photograph Carroll concocts a faulty theatrical spectacle in which anomalies of scale – the large sword and child-size armour

– register the visual imperfection he wishes to celebrate. Not surprisingly, perhaps, the drama leaves untouched the princess, Xie, in her nightdress and foil crown. Positioned on the edge of the composition, uninvolved in the spectacle, she directs her gaze straight at the camera. In this fictional scenario that resembles a dreamscape, Xie is the dreamer and stand-in for Carroll, who observes himself in the detached figure of the little girl who 'acts'.

The Miniature and Toys

In stressing the artifice of children adopting roles in theatrical tableaux, Carroll also defamiliarizes the child, visually demonstrating his, but more usually 'her', resemblance to the doll. But he does not simply connect the photographed child with the toy by a process of miniaturization, but also by one of arrested motion and its perpetual promise in the form of clockwork. Like a dependable actor, a mechanical toy guarantees repetition of the same performance: it appears to deliver its virtuosity ad infinitum. According to Susan Stewart in *On Longing*, 'the inanimate toy repeats the still life's theme of arrested life'. However, once the toy springs into action, 'it initiates another world, the world of the daydream'.[32] While Stewart's account does not deal with photography, her explanation of the fluctuation between arrested life and the world of 'fantasy'[33] articulates what was for Carroll played out in a three-way connection between the toy, the child and the photograph. Indeed, part of the allure for him of a photograph was that, rather like the mechanism of the animated toy, it held the capacity to unlock 'an interior world, lending itself to fantasy and privacy'.[34] As Stewart explains, the 'narrative time' of the wind-up toy does not extend daily life. Instead, it unlocks a 'world parallel to (and hence never intersecting) the world of everyday reality'.[35] For Carroll, a photograph of a miniature performer offered access to this otherworldly realm. Like the mechanism of a toy, via photography the life of the performer may be interrupted, restarted and stopped again. In practice, however, a clockwork toy relies on a mechanism that must eventually wear down.

Carroll was fascinated by the potential for the inanimate form to be wound into life as evident in his passion for clockwork toys and musical boxes. It is well known from the reminiscence of his 'child friend' Ethel

Arnold that his cupboards at Christ Church held 'wondrous treasures' in the forms of 'mechanical bears, dancing-dolls, toys and puzzles of every description'.[36] Moreover, sometimes Carroll 'liked to play his musical boxes backwards for relaxation',[37] anticipating aspects of the mechanical toy that Stewart explores:

> On the one hand, we have the mechanical toy speaking a repetition and closure that the everyday world finds impossible. The mechanical toy threatens an infinite pleasure; it does not tire or feel, it simply works or doesn't work. On the other hand, we have the actual place of toys in the world of the dead. As part of the general inversions which the world presents, the inanimate comes to life. But more than this, just as the world of objects is always a kind of 'dead among us', the toy ensures the continuation, in miniature, of the world of life 'on the other side'.[38]

Entertained by repetitive action, as Baudelaire has noted, it is not unusual from time to time for a child to make a toy 'restart its mechanical motions, sometimes in the opposite direction', such that 'its marvellous life comes to a stop'.

In this realm of stop motion, the conspicuous adjective 'living' in the name 'the Living Miniatures' clearly appealed to Carroll's larger fascination for miniature life. That fascination found a number of other outlets. A striking and seemingly anachronistic one begins to make sense in the context of the small theatre troupe, namely Carroll's scheme in 1872, five years after seeing the Living Miniatures, to secure a child-sized mannequin with the dimensions of the eight-year-old Julia Arnold (4 feet 3 inches) in order to clothe and photograph it. I have previously considered the significance of this plan in relation to the function of height more generally in Carroll's photographic aesthetic.[39] But, in addition to preserving in a lay figure the measurements of the child, he wishes to capture her resemblance to a toy. In the event, Carroll's plan to create a sort of theatrical trick with photography was thwarted by the fact that, as his diary entry for 2 April 1872 indicates, all affordable models were of adult proportions:

> Then to Lechertier, Barbe and Co. (60 Regent St.) to see lay figures. I came to the conclusion that stuffed would be the only kind of any use to me, but the price is too high to venture on. (Wooden would be about £4, but they

38 Charles Roberson & Co., 'Child No. 98',
artist's lay figure, 'Parisian stuffed', 19th century.

are all adult proportions, Papier-mâché would be £6 or so, but there are
none the size I want. While stuffed would be £30!) (VI, 206).

The lay figure, as Carroll's diary entry reveals, is a curious object. In
the period there existed small-scale beech-wood figures with ball-jointed
bodies, but also extremely elaborate life-size stuffed ones with canvas
bodies (illus. 38). Some of them came with papier mâché faces and suits
of clothes making them distinct from the familiar jointed wooden and
faceless figures. Weighing up the various materials and prices of those lay
figures available, he decides against 'stuffed' on account of the price while
realizing that the inferior alternatives are not the right size. On his death,
however, two artist's lay figures were listed in his personal effects.[40] What
was Carroll aspiring to in this strangely conceived scheme? In one sense,

he wishes to produce a life-sized replica of Julia Arnold to be looked at as actors are. Inanimate, the desired duplicate would resemble a toy – a doll – and in this capacity would provide a connection to childhood passions and forms of attachment. But, in another sense, photographed, the inanimate costumed mannequin of Julia Arnold would paradoxically suggest concealed life or motion. A photograph of an actual child, by comparison, in arresting movement, may evoke the stopped motion of a wind-up toy. At a conceptual level, then, Carroll invites a connection between the stop/start mechanism of a clockwork toy and the miraculous movement latent in a static photograph. Fascinated by the paradox of arrested life, he is drawn to the idea that an inanimate form, such as a lay figure or a doll, may be made to live in a photograph.

PHOTOGRAPHS AS TOYS

Lechertier Barbe & Co., the artists' colourmen and supplier of lay figures, crops up in a related fashion in the second of the four chapters that form the journalist George Sala's 'Travels in Regent Street', where as a child an 'effigy' he had regularly seen in the shop window fixed itself upon his mind like a toy on display.[41] Reflecting back from 1894 upon the constants of Regent Street, Sala acknowledges that he remembers the figure, in part, because it is grotesque. He attributes the brilliance of his mental image, however, to the frequency with which he passed it as a child displayed among the mysterious 'lay' figures at 'Barbe's', those lifelike, in some cases life-sized, figures somewhere between humans and automata.

For Sala, as for Carroll, the London arcades, especially the toys in the famous Lowther's Arcade in the Strand, were a particular draw. As Leslie Daiken points out, Lowther's 'was regarded as one of the sights of London, [and] was continually thronged with children and their attendants buying toys'.[42] Practically 200 feet in length, the Arcade contained a wide variety of toys from Switzerland, Germany and France together with some from China and Japan.[43] In particular, it held the miniature forms of dolls' houses and tea-sets, along with 'red-handled carpenters' tools'[44] resembling the child-size set of tools Carroll made for his sister Elizabeth in 1846. Such shops, along with the spectacle of their windows, as Colin Campbell has pointed out, contributed to the increasing use of 'cultural artefacts as the

material for daydreams, a form of projected illusory enjoyment'.[45] The sight of such objects that often gave greater pleasure than 'ownership' of them might be 'brought to mind in the future, and repeatedly re-used and adapted' in the creation of 'personal fantasies'.[46]

For Baudelaire, it is his childhood experience of the incomparable plenitude of the toyshop that he remembers. At the beginning of 'A Philosophy of Toys', he harks back to the occasion when, on a visit with his mother to Madame Panckoucke – who held a literary salon in Paris – he was invited to choose a toy from a 'truly fairylike spectacle of offerings'. Presented with 'a whole world of toys of all kinds, from the most costly to the most trifling, from the simplest to the most complicated',[47] Baudelaire explains how he selected the most lavish and expensive toy in the woman's collection. However, deterred by his mother from taking it, he has to settle instead for a compromise, a toy somewhere in the middle and plainly disappointing. Baudelaire attributes to this formative occasion his inability in later life to pass by the spectacle of the window of a toyshop without staring into it. That fascination derives from the glut of miniature riches that produce a world 'far more highly coloured, sparkling and polished than real life'.[48] As he goes on to explain, since 'All children talk to their toys they become actors in the great drama of life, reduced in size by the *camera obscura* of their little brains'.[49] In so doing, toys make an indelible imprint upon the aesthetic sensibility of the child. But while Baudelaire claims 'the toy is the child's earliest initiation to art', he concludes that with maturity 'perfected examples will not give his mind the same feelings of warmth, nor the same enthusiasms, nor the same sense of conviction'.[50] Most importantly, for my purposes, what Baudelaire identifies as lost in the setting aside for art of childish playthings captures, in effect, Carroll's lifelong attachment to toys of all kinds and especially mechanical ones. Indeed, Baudelaire might have been thinking of Carroll when, in the same essay, he also notes that toys sometimes 'dominate' children: 'It would hardly be surprising if a child of that kind, to whom his parents chiefly gave toy-theatres so that he could continue by himself the pleasure that he had had from stage-shows and marionettes, should grow used to regarding the theatre as the most delicious form of Beauty'.[51]

For Carroll a love of theatre had its origins in his childhood marionette puppets activated by strings and he regularly staged productions suitable both for marionettes and children. With his marionettes, Carroll sought to

39 Tiller Family Marionette Co., wire walker
marionette, Lincolnshire, 1870–1900.

depict realistic spectacles and his reference to 'about 20 figures' – twelve
was the standard – indicates he was staging quite elaborate shows.[52] Since,
in the period, marionette plays were often interchangeable with those
for human adult actors, they aimed for comparable realism in costumes
and props. Furthermore, unlike the 'patent unreality of the glove puppet',
the attempt at verisimilitude in the case of marionettes lent to them 'an
extraordinary degree of ambivalence'.[53] In popular Victorian fairground
shows, marionettes had a close relationship to waxworks, 'rope-dancing
and acrobatics, performing monkeys and bears, conjuring tricks and peep-
shows' (illus. 39).[54] But some marionette shows 'occupied a middle ground
between automata and waxworks', sometimes introducing clockwork
mechanisms to give a further 'semblance of life'.[55]

In his passion for staging marionette performances in which children might substitute for puppets, Carroll also establishes an early connection to photographic sittings. That connection comes about through small dimensions and qualities of grace, both attributes of Carroll's ideal performer and his ideal photographic model. But as well as celebrating performativity as manifest in the puppet, Carroll recognized the important function of the toy more generally as an object of attachment for a child, one that might hold significance as what would later come to be known as a transitional object. In this regard, Carroll's legendary toy cupboards at Christ Church may not have simply functioned to amuse his child visitors. They may have served to delight and comfort him.

A Doll Called 'Tim'

In attaching in peculiar ways to those objects they represent, photographs offer nostalgic connection to the past and triggers for fantasy. In so doing, photographs, like toys, may function as transitional objects. We find a relic of Carroll's childhood attachment to toys immortalized in a photograph of his 'family' doll (illus. 40) taken in 1858. Although the image is simply identified in Carroll's hand as *Tim*, the ivy-clad background, closely resembling that in his well-known photograph *Agnes Grace Weld as 'Little Red Riding Hood'*, taken the year before, suggests the same location: his home at Croft Rectory. Immediately striking is the difficulty of estimating the size of the doll in the photograph, for the picture of 'Tim', seated on an appropriately sized polished wooden chair, raises a question of whether the chair is Lilliputian or the doll life-size. In a conceit anticipating anomalies of scale that would come to characterize the *Alice* books, this seemingly innocuous and delightfully commonplace photograph is, for a budding amateur photographer, rather curious. Situated in front of the lens, 'Tim' the doll occupies the place that figures of children will increasingly come to occupy in Carroll's work. Retrospectively, sat before the camera, 'Tim' the doll anticipates the child as photographic model. In so doing the image raises the question of what difference it would make to pose a doll in place of a child.

Tim appears to be made of wood with a papier mâché face and painted eyes. The soles of the doll's shoes indicate the relatively low angle from

40 Lewis Carroll (C. L. Dodgson), *Tim*, 1858, albumen print.

which Carroll took the photograph. While the name 'Tim' suggests a male doll, 'his' clothing is somewhat androgynous. Moreover, the image is not without a hint of humour as the hat lends the figure resemblance to a scarecrow. In spite of its oddity, however, critics have largely dismissed the photograph. To be sure, it is very different from those more predictable photographs Carroll took of girls holding dolls. Edward Wakeling claims that nothing is known about the doll 'Tim' and that the photograph was taken when most of Carroll's siblings would no longer have played with it as children. Yet this claim simply adds to, rather than dismisses, the curiosity of the picture. To justify a photographic 'sitting' in 1858 'Tim' must

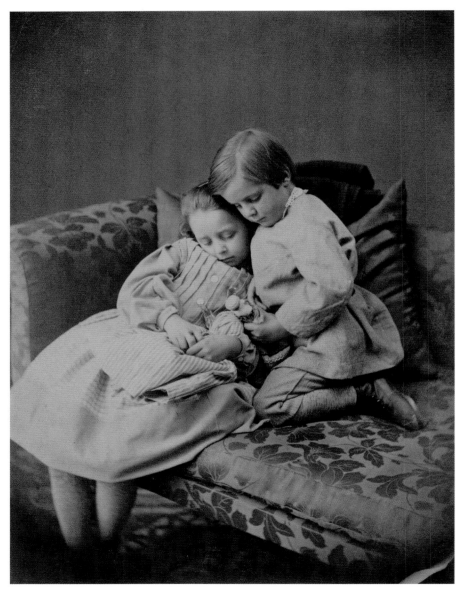

41 Lewis Carroll (C. L. Dodgson), *Ella Chlora Monier-Williams and a Younger Brother*, 1866, albumen print.

have remained significant to Carroll. That significance is commemorated in the capacity of the medium to capture, in miniature, an object of attachment to home as a space of sanctioned play and invention. But, as *Tim* also anticipates Carroll's photographic fascination with dressed-up girls seated on chairs, his miniaturized plaid clothes and knitted jacket resemble larger ones worn by Sarah Hobson in Carroll's photograph of her taken around the same time. The connection appears more than accidental. The doll, though inanimate, is captured by photography, a medium able to suggest life in a 'dead' subject. Just as a photograph may restore to life a dead loved one, it may make a doll 'live'.

While 'Tim' is unusual in being pictured without an owner, Carroll also took a number of photographs in which children pose with their dolls. In his 1866 photograph of *Ella Chlora Monier-Williams and a Younger Brother* (illus. 41), for example, taken at his rented studio in Badcock's Yard, the

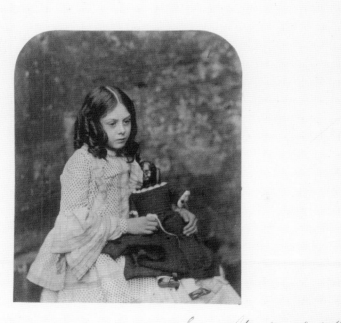

42 Lewis Carroll (C. L. Dodgson), *Lorina Liddell* [holding a black doll], 1858, albumen print.

two children are pictured nestled together on a sofa looking down at the dolls they hold. While Ella Monier-Williams slouches against the arm of the sofa with her head against the cushion, her brother perches above her on his knees – his temple and cheek against her hair – resting his doll against hers. The alertness of his body, appearing to have suddenly come to rest in its pose, is silently confirmed by the way his knee catches the hem of his sister's dress; the scuff on the toe of his left boot suggests he has arrived from more active play to fleetingly join her more settled position. Carroll captures intimacy between the siblings through their physical closeness but also by their shared concentration upon the toys they hold. A viewer is drawn firstly to the faces of the children and then to the centre of the image in which their hands and the fabric of the dolls' and their own clothing form a kind of nest.

Here Carroll achieves his wish to capture a natural positioning of hands in a photograph as outlined in a note he made to himself after visiting the Exhibition of British Artists in London in 1857.[56] Taken from above, the photograph sacrifices some of the detail of the boy's jacket to the intermediate tones of his and his sister's face and hands, and of the dolls themselves, contrasted against the darker embossed floral motif of the sofa. It is a poignant image not least because the affection the children appear to be showing to the toys they hold would not be lost on an animate presence; substitute a creature such as a dove or, as in Carroll's photograph of *Bessie Slatter* (1862), a pet guinea pig, and the sentiment portrayed would remain the same.

Comparing *Ella Chlora Monier-Williams and a Younger Brother* with Carroll's earlier photograph *Lorina Liddell* [holding a black doll] (illus. 42), taken in the Deanery garden in 1858, reveals a more conventionally posed image of a girl in a maternal role with her toy. Yet the photograph again signals both the child's distance from, and closeness to, the doll she holds. Seated upon the same chair on which her younger sister Alice sat for what has become a familiar picture of her in profile, Lorina Liddell cradles the doll upon her lap. But rather than looking at it she looks off to her left as if lost in thought. The presence of a black doll in a photograph is unusual in the period. Such dolls were by no means common in Britain in the 1850s. German and French companies dominated the market in doll manufacturing in the period but some wealthy children would have had black dolls. As Robin Bernstein indicates, since 'many European black dolls were

made from the same molds as white dolls' they therefore 'shared the same features'.[57] Correcting to some extent the homogenization of features, the monochrome of photography here stresses the blackness of the doll and thereby its ethnic difference from its owner.

In a letter dated 13 November 1873 to Beatrice Hatch, Carroll brings a doll to life. He relates his extraordinary meeting with one he had given to the child as a present. Beatrice Hatch recalls the wax doll, named 'Alice', 'had fair hair brushed back from its forehead . . . and when pinched would emit plaintive cries of "Pappa" and "Mamma"'.[58] In Carroll's comic account, 'Alice' the doll, abandoned by her owner, turns up 'just outside Tom Gate' at Christ Church with 'two waxy tears . . . running down her cheeks' and he takes her to his College rooms to comfort her where amusing scenarios ensue.[59] Here, a doll is again interchangeable with a child. Indeed, the treatment she receives in Carroll's Christ Church rooms is precisely that enjoyed by her owner Beatrice Hatch.

Carroll found further photographic interest in the theme of an abandoned doll. His photographs move from that of his doll 'Tim', through various depictions of girls holding dolls, to the figure of a child photographed *as* a doll. On 5 July 1870, in the studio he rented at Badcock's Yard, Carroll took Xie Kitchin in a photograph entitled *The Prettiest Doll in the World* (illus. 43). It was based on the poem 'The Lost Doll', sung to Tom and other water babies by Mrs Doasyouwouldbedoneby in chapter Five of Charles Kingsley's *The Water Babies* (1863):

I once had a sweet little doll, dears,
The prettiest doll in the world;
Her cheeks were so red and white, dears,
And her hair was so charmingly curled.
But I lost my poor little doll, dears,
As I played in the heath one day;
And I cried for her more than a week, dears,
But I never could find where she lay.

I found my poor little doll, dears,
As I played in the heath one day;
Folks say she is terribly changed, dears,
For her paint is all washed away,

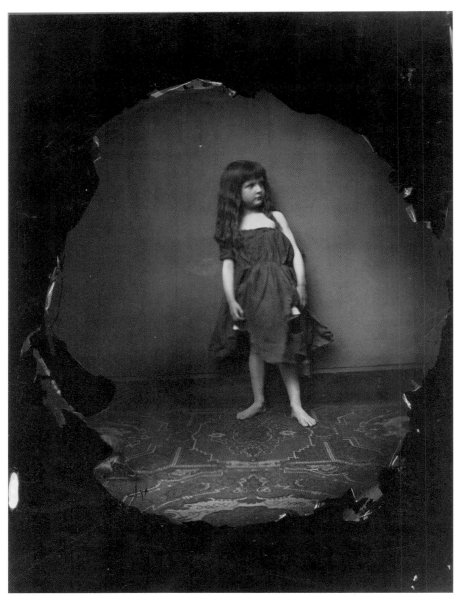

43 Lewis Carroll (C. L. Dodgson), *The Prettiest Doll in the World*, 5 July 1870, albumen print.

And her arms trodden off by the cows, dears,
And her hair not the least bit curled.
Yet for old sakes' sake, she is still, dears,
The prettiest doll in the world.

Kingsley's child chimney-sweep Tom declares 'what a silly song for a fairy to sing!', but the verse clearly appealed to Carroll for its speaker's memory of attachment to a lost and ruined doll. In his photograph Xie Kitchin appears in a dark ragged dress, with bare legs and arms. She is posed in an active attitude, looking off to her left, as if the movement of her body has been suddenly arrested. Damage to the negative gives the impression of perceiving the child through a peephole. This sensation further connects her with the doll she emulates, adding to the miniaturizing effect of the photographic medium.

Carroll makes a nostalgic gesture in naming a photograph of Xie Kitchin after Kingsley's fictional doll from a verse in *The Water Babies*. In so doing he also voices, as he often does in quotations or captions accompanying photographs, complex forms of attachment as facilitated by the medium of photography: Kingsley's doll is not only a 'lost' object, she loses her beauty. Stripped of all attractive artifice, almost unrecognizable but resistant to destruction, she remains for her owner for 'old sakes' sake' a profound object of affinity. Commemorating Kingsley's doll in a photograph Carroll dramatizes, here as elsewhere, photography as an apt medium by which to focus such loss. More generally, in repeatedly photographing little girls in fictional roles Carroll rehearses the loss that every photograph potentially embodies, which is also an eventual return of the subject via the image itself. In this sense, Carroll's photograph *The Prettiest Doll in the World* exemplifies that more fundamental process of 'lost' and 'found' that photography ingeniously facilitates.

In his essay *Laughter: An Essay on the Meaning of the Comic* (1911) Henri Bergson, in claiming that 'we are too apt to ignore the childish element . . . located in our most joyful emotions',[60] makes direct connection to a child's fascination for dolls and puppets:

one thing is certain: there can be no break in continuum between the child's delight in games and that of the grown-up person. Now, comedy is a game, a game that imitates life. And since, in the games of the

child when working its dolls and puppets, many of the movements are produced by strings, ought we not to find these same strings, somewhat frayed by wear, reappearing as the threads that knot together the situations in a comedy? Let us, then, start with the games of a child, and follow the imperceptible process by which, as he grows himself, he makes his puppets grow, inspires them with life, and finally brings them to an ambiguous state in which, without ceasing to be puppets, they have yet become human beings.[61]

In thus showing the genesis in children's toys of certain comic types, Bergson concludes that 'any arrangement of acts and events is comic which gives us, in a single combination, the illusion of life and the distinct impression of a mechanical arrangement.'[62] For Carroll, photography highlights such a juxtaposition of lifelikeness and the mechanical. The photograph preserves the child as both natural and artificially animate.

∾ LULU AND PHOTOGRAPHIC REPRESENTATION ∾

At the most extreme end of Carroll's interest in animated miniatures, mechanical toys and London theatre of the period is his attraction to child acrobats. On 19 June 1871 Carroll attended the Holborn Royal Amphitheatre to see the celebrated acrobat Lulu perform. Originally known as El Niño Farini, 'the boy' and biologically male child had his first international recognition in the 1860s as the young 'son' of the showman William Hunt (the Great Farini). An orphan adopted by Hunt, the boy named Samuel Wasgatt (1855–1939) made his debut in 1866 as a male performer. However, in 1870 Farini re-branded his protégé as 'Lulu', a female acrobat. Intrigue attached to Lulu's gender until 1876 when she was apparently outed as male. Carroll's diary entry for 19 June 1871 reads:

> Went to town to go with John T. Faussett to the Holborn Amphitheatre . . . The Holborn performance was very good, partly circus, partly the 'spectacle' of *Cinderella*, which was very prettily acted in dumb show by about 50 children. The acrobatic feats of 'Lulu' were most wonderful of all: her 'bound' (where she is shot 25 feet up by machinery) was quite extraordinary (VI, 156).

44 Unidentified photographer, *Lulu*, 1870, albumen print.

He was not alone in remarking upon Lulu's phenomenal acrobatic feats; 'she' was marketed as 'the Eighth Wonder of the World' in the popular press.[63]

In different ways, the following two images stage Lulu's transformation from an androgynous ten-year-old to an apparently female sixteen-year-old performer. In the *carte de visite* photograph from 1871 (illus. 44), she is suspended by two wires that blend quite convincingly into the draped backcloth. Lulu clasps her hands behind her waist, such that her elbows form a 90-degree angle to her body. Her feet, by distinction, are drawn together and pointed. With chin raised, head poised and turned in three-quarter profile, Lulu looks off to her right with her fair curls drawn away from her face. She wears an all-in-one costume combining shorts and a low-cut bodice characteristic of circus attire of the period. The tonal contrast of the photographic image reveals the satin fabric of her costume against which her pale legs glow in their flesh-coloured tights.

The colour lithographed playbill by Alfred Concanen (illus. 45), by contrast, depicts Lulu as if in flight, a full-length figure hovering in a sky that, with crescent moon and emerging stars, conveys twilight. The logo 'LuLu', with its compact symmetry, is picked out centrally in bright emerald green at the top of the playbill: the lower case 'u' suspended trapeze-like above the capital 'L' that supports it. These decorative features, along with the advertisement of the days and times of the shows that runs along each side of the border, testify to the pedigree of her performance as confirmed in the caption at the bottom: 'As she appeared before Their Royal Highnesses, The Prince & Princess of Wales, Feb[y] 20th 1871'.

But the image also readily offers up details, most essentially those of colour, lost to the monochromatic photograph. Lulu's indelibly green outfit – trimmed with white ruche – together with her emerald slippers allow a viewer a glimpse of the polychromatic spectacle of the performance. In other words, the playbill supplements colour, alien to the photograph. At the same time, the undeniable match-up of costume in the lithograph and the photograph assures a viewer to some extent of the visual 'authenticity' of Lulu's stage persona: the long curly hair, the curve of her breasts and line of her waist as emphasized by the frills on the bodice confirm the photograph must be 'her'. Yet, in a bold lie by a camera reputedly incapable of subterfuge, the 'her' turns out to be a 'him'. Such travesty, arguably easy to detect in the photograph, is not so in the lithograph.

45 Alfred Concanen, *LuLu*, playbill, 1871, lithograph.

In both the playbill and photograph Lulu appears suspended. Her feet do not touch the ground. Yet while the former conveys Lulu's weightlessness, the latter emphasizes her body as subject to gravity. The lithographed playbill turns her into a weightless sylph. In the photograph, by comparison, with her body drawn in, Lulu appears to hang rather than to fly. Accentuating the strength of her cross-dressed form, her pose encodes her as an acrobat. Thus, while the lithograph emphasizes Lulu's ethereal nature, the photograph makes no attempt to contextualize her presence.

Lulu's fabled bound evokes the capacity of dreams to launch a subject into flight. In 'The Dream-work' in *The Interpretation of Dreams*, referring to 'the second group of typical', Freud focuses upon those commonplace dreams in which 'the dreamer flies or floats in the air'.[64] While he maintains that the meaning of such dreams is different in every instance, that 'it is only the raw material of sensations contained in them which is derived from the same source', Freud importantly finds that such dreams 'reproduce impressions of childhood'. More specifically, 'they relate, that is, to games involving movement, which are extraordinarily attractive to children'.[65] In the following quotation it is tempting to read for 'uncle' the avuncular Lewis Carroll fond of the rough and tumble of child's play:

> There cannot be a single uncle who has not shown a child how to fly by rushing across a room with him in his outstretched arms, or who has not played at letting him fall by riding him on his knee and then suddenly stretching out his leg . . . Children are delighted by such experiences and never tire of asking to have them repeated, especially if there is something about them that causes a little fright or giddiness. In after years they repeat these experiences in dreams; but in the dreams they leave out the hands which held them up, so that they float or fall unsupported. The delight taken by young children in games of this kind (as well as in swings and see-saws) is well known; when they come to see acrobatic feats in a circus their memory of such games is revived.[66]

Photographs hold the capacity to represent the circumstances of such play, of acrobatic spectacle, for example, as reviving in the adult memory a child's delight in flying or being floated into the air. In *See-saw*, Carroll's 1860 photograph of Alice and Lorina Liddell (illus. 46), Alice is pictured elevated while her younger sister Edith, who appears to be providing the

Alice Pleasance Liddell. Lorina Charlotte Liddell.

46 Lewis Carroll (C. L. Dodgson), *Lorina and Alice Liddell, 'See-saw'*, 1860, albumen print.

weighted end, has been cut by cropping to an oval format. Such photographic staging of children's play cannot present the sensation of motion in the manner of a dream but the medium may, along with the adult's experience of acrobatic feats, generate opportunities to 'revive' in memory such childish games. While a desire for pleasurable experiences of movement works itself out in repetition in dreams, Carroll's and others' marvel at Lulu's brave feat of being catapulted high into the air is in part a response to unconscious triggers for such 'play'.

Yet Carroll was not simply fascinated by the spectacle of Lulu's virtuosity. He was attracted to acrobats' clothing for photography. Jennifer Forrest cites Yoram S. Carmels, who notes that 'even when circus people

are photographed or portrayed in their off-stage mode, they are still always on stage'.[67] In acquiring photographs of acrobats, and in dressing up children in acrobats' clothing to photograph, Carroll simulates ways in which such performers bring the stage with them. A photograph of Lulu, therefore, evokes not only her miraculous 'bound' but the supporting 'dumb show' of Cinderella and the audience's long 'wait' for, and anticipation of, the main act. Photographs of acrobats arrest the memory of a compound spectacle.

Nevertheless, the sight of Lulu had a practical impact upon Carroll's photography. No longer remaining simply content with capturing children in acrobats' costumes in static poses, Carroll was prompted to attempt to capture their movement. Vitally important in this respect is his diary entry for 27 June 1871, made shortly after seeing Lulu: 'Then I called on Faulkner, the photographer, and agreed to buy his machine for taking children quickly' (VI, 161). Robert Faulkner & Co., photographer, had premises at 46 Kensington Gardens Square, Westbourne Grove, until the end of 1876 and then at 21 Baker Street, Portman Square, and is remembered for his portraits of young children. The spectacle of Lulu the previous week was directly responsible for Carroll's wish to obtain such a camera. Furthermore, Carroll's desire for a camera dedicated to capturing movement confirms his specific interest in the animation of the small weightless performer.

But Lulu's graceful aerialist feats that miraculously defy gravity are also crucially bound to gender via cross-dressing. Transformed from androgynous boy to girl acrobat, Lulu incites the added thrill on the part of the spectator of seeing a 'girl' performing physically dangerous actions. As Jennifer Forrest points out: 'Travesty is an old circus tradition, and the travesty of a male as a female occurs most often, perhaps for the purpose of enhancing the spectator's gendered perception of the perils to which the acrobat exposes him/herself.'[68] Yet, as Forrest further indicates, it tended to be customary for 'most male travesties [to] eventually reveal their identities', most commonly at the end of a performance, but:

> Miss LuLu, who debuted in Paris in 1870, never did settle the question of her true sexuality. The degree of difficulty of her aerial feats – the *saut en fusée* ('rocket jump') at twenty three feet above the ground, and possibly even the triple *saut périlleux*, on the flying trapeze . . . – suggested she was a male acrobat.[69]

Indeed, 'every contemporary critic who discussed Miss LuLu – and anyone who saw photographs of her, for that matter – remained convinced, however, that she was a man'.[70] There existed, therefore, a kind of open secret about Lulu's biological gender that photography was apparently able to reveal. It was a 'truth' easily disguised for the naked eye. Yet the ample evidence confirming the camera eye did not disclose details unavailable to a discerning unmediated eye, thus complicating a view that the camera possessed a capacity to see 'through' such dissembling.

A columnist in the *Sporting Times*, for example, takes liberty in exploiting to comic effect attempts to conceal Lulu's gender: 'if Lulu the Beautiful be not El Niño Farini, there is no more truth in manhood in me than a stewed prune'. He continues to relish the opportunity for innuendo:

> It is no use to point out to me that – well – much development has taken place in various portions of the young person's anatomy since he – or she – swung and bounded as a boy at the Alhambra. Age will do much. Wadding will do more. Rotundity and grace are new matters of art, to be bought like blushes or eyebrows; very soon, probably, to be let out like dress suits and rout chairs, for the evening ... In the meantime I assert Lulu and El Niño to be one, whether she was a boy, or he was a girl, or – but these wild speculations are dangerous and not decorous.[71]

Given Lulu's sensationalism as a source of comic speculation and sexual innuendo, it might appear odd that Carroll sought to go to see her. Lulu was so popular, commanding multiple classified advertisements, that it would have been impossible for him to overlook the fact that she approached the limit of what he regarded as respectable entertainment.

It is well known that acrobats' costumes, in particular flesh-coloured tights that gave the appearance of naked legs, revealed their bodies in ways not normally available to public view.[72] There was a fine line, therefore, between a spectacle such as Lulu's at the Amphitheatre and those of ballet girls at the Alhambra with their offshoot photographs offered for sale at print sellers. Owing to its lowbrow entertainment, and the nature of its clientele, Carroll famously drew the line at the music hall, professing never to have entered one. However, in the context of his interest in Lulu, such a distinction is somewhat ironic since some individual acts of virtuosity originating in the theatre subsequently migrated to the music hall.

Yet, in further significant ways, the celebrated 'Lulu' highlights Carroll's wider interest in acrobats and the cross-dressing of girls as boys, while reminding us that disguise of boys as girls is more easily undone than, in their burlesque garb of breeches, girls disguised as boys. Carroll's interest in Lulu throws light onto his frequently cited remark of 5 August 1888 to Henry Savile Clarke that while he did not admire boys cross-dressed as girls – 'boys must never be dressed as girls' – 'girls make charming boys'.[73] Anne Varty cites the theatre reformer of the late century, Ellen Barlee, who she claims 'thought that cross-dressing disguised neither sex nor gender, but emphasized both'.[74] But if, in this context, Carroll's reason for admiring cross-dressed girls was that male costume emphasized their biological gender, doesn't the case of Lulu confirm that, provided he was unaware of the dissembling, a cross-dressed boy might work just as well?

'MADEMOISELLE ELLA' AND CONNIE GILCHRIST

Carroll's astonishment at Lulu was not without precedent, for he had earlier enjoyed 'Mademoiselle Ella', an extraordinary female rider with The Grand Equestrian American Circus. Indeed on 1 July 1857 he notes having gone with his brother Skeffington to the circus at Drury Lane specifically 'to see "the little Ella again": She is no longer little, but as active and graceful as ever. We did not stay out the performance, which was only average in quality' (III, 76–7). In watching her perform, Carroll was among audiences thrilled by a combination of grace, bravery and physical virtuosity.

'Mademoiselle Ella' was later described by Edward Stirling as surprising spectators by 'her marvellous evolutions on two, three, and four horses running at full speed round the ring. The leaps that fair equestrian took, clearing four horses at a time, astonished and attracted large audiences.'[75] Anticipating the later Lulu, however, he goes on to elaborate: 'It was whispered abroad that mademoiselle was not really a *mademoiselle* at all but a monsieur in disguise. Certainly few persons ever saw the lady's features in the day: they were always closely veiled.'[76] In the 'monsieur' masquerading as a 'mademoiselle', her biological gender links the performer 'Little Ella', as Carroll tellingly calls her, with the later 'Lulu'. Anticipating the reinvention of El Niño as Lulu, the gender of 'Little Ella' is rumoured to be male.

Carroll enjoyed on other occasions the types of aerialist and equestrian feats performed by Lulu and Mademoiselle Ella; at a much later date he attended the somewhat unlikely extravaganza of Laura Saigeman's swimming entertainments in Eastbourne. However, six years after seeing Lulu, in 1877, Carroll remarked upon his first sight of the child actress Connie Gilchrist (1865–1946) at the Adelphi on 13 January in the pantomime *Goody Two-Shoes*, enacted entirely by children: 'the Harlequin was a little girl named Gilchrist, one of the most beautiful children, in face and figure, that I have ever seen, I must get an opportunity of photographing her' (VII, 13–14). Connie Gilchrist became a well-known actress specializing in burlesque. In seeing her perform what became her fabled 'skipping rope dance', Carroll immediately documents a desire to photograph her. On 3 March he records: 'Heard from Mrs Gilchrist, mother of the "Harlequin", accepting my offer of *Alice*, and sending the name – "Constance MacDonald Gilchrist," born Jan. 23 1865. I sent one with acrostic verses on "Constance" (VII, 22). As a preface to photographing the child, forever afterwards present to him as 'the Harlequin', Carroll requests Connie Gilchrist's full name in order that he may record her presence in the pattern of an acrostic. Here, the encoded form of the acrostic serves as shorthand for recording, and a prelude to photographing the child.

In the light of Carroll's response to the Living Miniatures and Lulu, Connie Gilchrist provides a case study of a London performer who became meaningful to him at this period of his life because, by way of contemporary painting, she connected theatre with photography. As a model for painters she was not exempt from the disreputable associations for a woman of such an occupation. Gilchrist crossed the class divide of respectability. Frederic Leighton painted her on many occasions; she modelled for him from the age of six, later appearing as *Little Fatima* (1875); as the model for all the young girl figures in the chorus of *The Daphnephoria* (1876); in *The Music Lesson* and *Study: At a Reading Desk* (both 1877); and in *Winding the Skein* (1878). Carroll enjoyed her metamorphosis from canvas to stage. James Abbott McNeill Whistler also famously painted Connie Gilchrist in her fabled 'skipping rope' role. In a life-size portrait entitled *A Girl in Gold*, later changed to *Harmony in Yellow and Gold*, he depicts her aged twelve in the short yellow tunic and high boots worn in her 'skipping rope dance' at the Gaiety (illus. 47). The child's roles as stage performer and artist's model increased her desirability as a model for photography.

47 James Abbott McNeill Whistler, *Harmony in Yellow and Gold:*
The Gold Girl – Connie Gilchrist, 1876–7, oil on canvas.

Significant in this regard is Carroll's record of taking Connie Gilchrist to the Royal Academy on 2 July 1877 to see Leighton's paintings of her, *The Music Lesson*, in which she modelled as a girl learning to play a Turkish *saz*, and *Study: At a Reading Desk*, in which the child pores over a copy of the Qu'ran. In a real-life version of his dream of taking Polly Terry to see her older self perform, Carroll enjoys witnessing Gilchrist's pleasure in seeing herself visually represented. In a sense, her narcissistic enjoyment justifies his wish to photograph her that, as he acknowledged in his diary, ran to excess. Indeed, referring to Connie Gilchrist a second time, he claims she is 'about the most gloriously beautiful child (both face and figure) that I ever saw. One would like to do 100 photographs of her' (VII, 29). Multiples of photographs represent the most reliable method Carroll knows of capturing what it means to watch Connie Gilchrist perform.

Yet a little over a year later, on 2 October 1878, Carroll comments in his diary upon a change in her appearance: 'saw *Little Dr Faust* at the Gaiety: Connie Gilchrist was "Siebel": she is losing her beauty, and can't act – but she did the old skipping-rope dance superbly' (VII, 140). She was thirteen at this point and, given the context, it is difficult not to read in terms of the onset of puberty what Carroll refers to as her loss of beauty. And yet in his rejoinder, 'she did the old skipping-rope dance superbly', Carroll's claim rings with a sort of relief that, in spite of an inevitable loss of beauty, Gilchrist's animated form as encoded in the dance will remain unaffected by physical maturity. Carroll extracts the highlight, Gilchrist's skipping rope dance, from the entire performance. Animation is key to the appeal of the winning routine. It does not simply show off the child's beautiful body. It shows her body moving in particular ways.

There is no verifiable photograph of Connie Gilchrist by Carroll, although many *cartes de visite* taken of the actress in professional studios survive. The following images give a sense of Carroll's investment in her. The first *carte* shows a pared-down shot of her face in close-up (illus. 48). In the second publicity studio shot the young actress is pictured in elaborate attire, with the wooden handles of her signature skipping rope dangling from a table on the left-hand side of the image (illus. 49). This is Connie Gilchrist as Carroll would have seen her; the photograph conveys the elaborate nature of one of her get-ups that reveals parts of her body to androgynous effect.

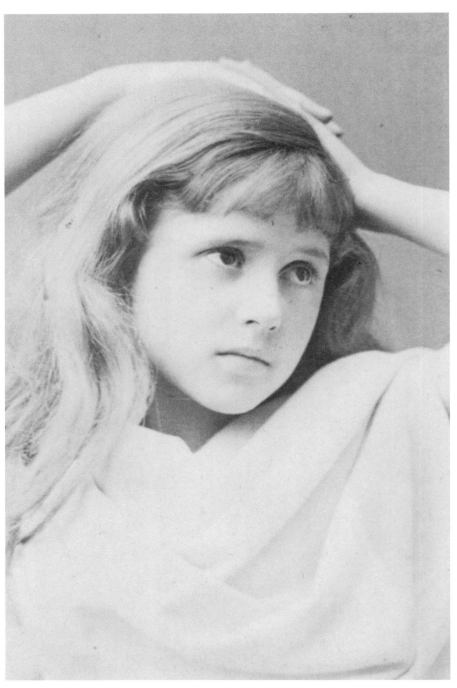

48 Elliott & Fry, *Connie Gilchrist*, 1870s, albumen *carte de visite*.

49 Unidentified photographer, *Connie Gilchrist*, 1870s.

When Carroll's personal effects were auctioned following his death, theatrical costumes featured in the list. Some were acquired by the Art and Antique Agency, 41 High Street, Oxford, and the following were advertised in its catalogue: 'Fancy Dress, Used by Lewis Carroll's Child Friends'. These included two 'Fairy Prince Suits' (one green satin and one crimson velvet); 'Turkish Maiden Suit'; 'Georgian Court Dress'; 'Chinese Mandarin's Robe'; 'Red Fez'; 'Basket of Flowers, two muslin caps, blue serge bodice, red and white cotton skirt (some being part of Dolly Varden costume)'.[77] As this record and others testify, in a palpable sense, as photographs do, costumes serve as memorials to individual child performers and theatrical events. Indeed, they are in certain ways interchangeable. But they also preserve qualities lost to the photograph, most notably colour. The skirt, worn by Xie Kitchin as 'Penelope Boothby', is 'red and white cotton'.

On several occasions Carroll had women friends, or the mothers of his child friends, make costumes specifically for him. While not unusual among painters, such practice further demonstrates how carefully he contrived and stage-managed in advance roles for his child 'sitters'. Thus, on 26 June 1878 Carroll notes: 'called on Mrs Coote, and borrowed Carrie . . . Took her home and arranged with Mrs Coote to sell me three old theatrical dresses of Carrie's besides the new prince's dress she is making for me' (VII, 118). Moreover, since he often sought to reproduce roles that were interchangeable, a photographic session was very much about inhabiting costumes. For example, on 5 June 1871 Carroll refers to Chinese dress, borrowed from Mary Foster née Prickett, formerly governess to the Liddell children. On 21 March of the following year he notes: 'called on Mrs Price to see the Greek dress she has made for me' (VI, 205). Three girls were photographed in it: Beatrice Fearon on 3 May 1872, Julia Arnold on 20 May 1872, Xie Kitchin on 14 May 1873 (VI, 205). While it has been suggested Carroll bought such clothing 'for use by models in his photographs to enhance the dramatic authenticity of his work',[78] as I have shown, Carroll invests in theatrical costumes in nuanced ways, some of them at a remove from 'dramatic authenticity'.

But Carroll also became attached to items of clothing worn by particular performers. Functioning as keepsakes, binding powerful memories, costumes additionally operate like photographs. Indeed, Carroll's

enthusiasm for costumes increased in the 1870s and this was the period in which he produced the largest number of costume photographs. In a letter of 13 February 1878 to the mother of Sallie Sinclair, whom he had seen as Cupid in the pantomime *Robin Hood* at the Adelphi on 8, 10, 15 and 17 January of that year, after expressing the hope the child will 'escape the self-consciousness and thirst for admiration which so entirely spoils the naturalness and attractiveness of some beauties', Carroll changes tack:

> I take this opportunity of asking one more question. Is the 'Cupid' dress your own? And shall you have it in usable condition (say) at about Easter? And do you think you could then manage to bring her to Oxford for a day? I should very much like to get her into my studio, and take a lot of photographs of her, as 'Cupid' and in any ways you liked. I sometimes use glasses 10 inches by 8, and so could do a large picture of her.[79]

That question burgeons into three. It is not simply about a particular piece of theatrical clothing but also about what has come to attach to it. Crucially, Carroll stresses his wish 'to take a lot' of photographs of the child in this garb. His motive for creating such photographs becomes clear when he writes again to Mrs Sinclair with a different scheme in mind: 'I have thought of a plan by which I can at once do you a photograph of Sallie, if you don't mind the trouble of taking her to Haverstock Hill.'[80] The suggestion is that the artist A. B. Frost 'would make a drawing of "Cupid"' and that Carroll would subsequently photograph it since, as he reasons, 'drawings generally photograph extremely well'. The costume is vital to the representation: 'If you consent to this, could you take her (and the 'Cupid' dress) on Saturday'.[81]

The intricacy of this proposed arrangement suggests an urgency to Carroll's wish to have Sallie pictured photographically in the 'Cupid' dress. To that end, even a visual image at one remove from Carroll's photograph will suffice. Moreover, by suggesting that he photograph a drawing of the child in the costume, Carroll is plainly most interested in harnessing the reproductive capacity of photography to commemorate the dress. While there exists no record of this photograph, another child, Arthur Hatch, appeared as 'Cupid' in an earlier photograph by Carroll.[82]

In the complex correspondence of theatre and photography, major importance accrues to the small body of the child in costume. On certain

occasions, as I have demonstrated, the figure of a diminutive performer undergoes curious conceptual metamorphosis into the form of a doll or a clockwork toy. Moreover, it is specifically by means of the agency of photography that Carroll explores potential similarities between child performers and toys. Moving in reverse order from Sallie Sinclair, Connie Gilchrist, through 'Little Ella' and 'Lulu' to the Living Miniatures, the child inhabits a range of roles. Cross-dressed as a boy, a girl, an acrobat and in fairy garb, each of these examples from the London stage demonstrates the significance for Carroll of the child in theatrical costume. In an important regard costumes serve as props for his photography. It is conceivable, therefore, that once visually recorded, their physical existence no longer required, costumes might be discarded. But this was not the case. Nor did costumes lose significance when Carroll was no longer taking photographs in his Christ Church studio. Instead, he held on to them. Although like photographs, costumes would eventually fade, as material objects in their own right they preserved those imaginary and fantasy worlds to which they were originally connected. Not simply props for photographs but complementing them, retrospectively for Carroll costumes attached both to theatrical events and to those photographs subsequently generated to commemorate those events. As Carroll enjoyed the conceptual oscillation between the animate (performing) and inanimate (photographed) child performer, her costume itself embodied for him profound attachment to both photography and theatre.

Although the London theatre was a hugely important part of Carroll's life, the miniature performer in the range of guises explored was one of its biggest draws. And she was so in large part because Carroll saw in her the capacity to be turned into a photograph. However, that transformation was an intricate one. Carroll did not aspire to simply take photographs of stage children in their roles. Instead, his wish to photograph them was mediated by their capacity to resemble a number of inanimate miniature forms such as dolls. While his childhood doll 'Tim' remained an object of childhood attachment worthy of a photographic portrait, an artist's lay figure suggested a life-sized replica of a child to photograph. Carroll was equally fascinated by the graceful animation of the marionette and the very different stop/start mechanism of the clockwork toy. As I've shown, the medium of photography provided a means of capturing them. But the notion of 'capture' here is no simple matter. For Carroll creates complex

processes of visual metamorphosis from stage to photographic print in which so much more is being represented in the child donning costumes than a theatrical scenario. Indeed, in its relation to the theatre, as in other aspects of his quotidian existence, Carroll invested the camera with a magical capacity to encode in both animate and inanimate miniature forms fluctuation between motion and stasis. With its paradoxical potential for metamorphosis, the 'still' photographic image became oddly commensurate with the vitality of the child performer. Photography preserved the coiled spring of motion ready to be reactivated at some future moment.

4

Carroll in Russia: Shopping for Photographs and Icons

TWO CHILDREN IN IDENTICAL Chinese dress pose outdoors in front of a canvas backdrop (illus. 50). The elder, standing with her left foot raised on a wooden block, supports an open adult-sized parasol that rests over the back of a chair upholstered in Paisley fabric. Her sister sits squarely in the seat, legs drawn up under her. A potted geranium intrudes into the left-hand side of the print; so too does part of a stone wall that has escaped the cover of the backdrop. Stowed under the chair, a spare cushion further discloses the makeshift studio space just as the ruffled silk of one of the Manchu hats, conspicuously lacking a brim, compromises the authenticity of the Chinese costume. Taken in the spring of 1860, in the Deanery garden at Christ Church, *Lorina and Alice Liddell in Chinese Dress* took pride of place as the second photograph in Carroll's large album A(ii).[1]

From March 1872 Carroll produced in the unadorned space of his 'glass-house' at Christ Church an increasing number of photographs of children masquerading in ethnic costumes.[2] However, such 'costume' portraits from the 1870s were not simply owing to that purpose-built space, or the presence of theatrical and artistic influences he experienced in London. They were also the result of a monumental trip he made by train in the summer of 1867. Visiting Russia between July and September of that year, on what would be his only time abroad (and accompanied by his life-long friend, the renowned preacher Henry Parry Liddon), Carroll encountered in close proximity a diverse range of ethnic groups, alongside representations in contemporary *cartes de visite*, that shaped his subsequent photographic work. He did not take his camera with him on the Russian visit. Although his state-of-the-art portable Ottewill was comparatively small, the cumbersome nature of the accompanying equipment and chemicals would have made extended journeys by railway difficult.[3] In Russia, in the absence of his own camera, Carroll hunted for photographs and recorded a wish to buy them. Indeed, on the lookout

Lorina and Alice Liddell,
daughters of the Dean of Ch. Ch.

50 Lewis Carroll (C. L. Dodgson), *Lorina and Alice Liddell in Chinese Dress*, 1860,
albumen print.

for *cartes de visite* at every opportunity, he frequently, if briefly, recorded their presence in the journal he kept in two notebooks.[4] Liddon also kept a diary of the visit and on more than one occasion, sometimes with a sense of mild irritation, noted his travelling companion's regular habit of 'shopping for photographs'.[5]

None of the photographs Carroll bought on the Russian trip are known to have survived. Along with most other purchases they remain only as references in the diary. On his return home, however, distinctive aspects of the Russian experience combine in the staging of his photographs. Not only does Carroll increasingly dress up children for photography in costumes of those ethnic and national identities encountered on the visit, but he produces photographs embodying formal elements of contemporary nineteenth-century Russian *cartes de visite*. In addition, having encountered such photographs for sale alongside copies of Russian Orthodox icons, Carroll incorporates into his work post-Russia the suggestive proximity of

the two types of souvenir. More emphatically, the shared capacity of ancient icons and popular *cartes* to generate physical traces of their referents newly informed Carroll's attachment to metaphysical properties of the photographic medium.

While critics have paid little attention to Carroll's Russian visit, maintaining it had little impact upon him since he never again travelled abroad,[6] the rich visual experience of religious icon and secular photographic 'type' meant that after 1867, in revisiting Chinese and other costume photographs, Carroll contrived scenarios both formally and conceptually different from that realized in *Lorina and Alice Liddell* of 1860. Most noticeably he combined the distinctive material forms and metaphysical resonances of 'photograph' and 'icon'. He did so in his increasing preference for photographing individual female children dressed in ethnic costume in interiors devoid of the decorative trappings of nineteenth-century studios.[7]

Carroll set out on his Russian visit on 12 July 1867, meeting Liddon at Dover to sail to Calais the following morning. En route the tour took in the cities of Brussels, Cologne, Berlin, Leipzig, Warsaw and Paris, where Carroll and Liddon visited the International Exhibition. The pair arrived in St Petersburg on 27 July, remaining in the city before catching the train to Moscow on 2 August. On 19 August they set off back to St Petersburg, where they remained until 26 August. Permanently poised between Asia and Europe, with its complex history of being invaded from east and west, the Russia that Carroll encountered comprised more than a hundred different ethnic groups. Moreover, it represented, as he himself claimed, an 'ambitious' destination for someone 'who ha[d] never yet left England' (v, 253). Liddon's visit had a distinctly religious purpose: to experience at first hand the power of Eastern Orthodoxy. Along with William Palmer (1811–1879), Robert Eden (1804–1886) and Frederick George Lee (1832–1902), Liddon was a member of the Eastern Church Association, founded in 1863.[8] Travelling at a time when the Russian Orthodox Church had become a key point of focus for church historians, the trip enabled him to conduct an unofficial inquiry into the issue of reunification. Carroll, on the other hand, in spite of having been ordained Deacon in 1861, had made his decision in 1862 not to proceed to full Holy Orders. Although not holding the High Church sympathies of his friend, Carroll was curious, however, about those aspects of ritualism with which he himself was at odds, and he went along with Liddon on many Orthodox Church visits.

Carroll's Russian diaries function in important ways to negotiate his status as a 'foreign' traveller in a country undergoing profound political and demographic change. Closer to his fictional writing than the spare prose of his regular diaries, Carroll's Russian memoir records the scrapes of the monolingual English tourist. Intrepid *droshkie* drivers and hotel waiters – unrelentingly promising 'ze cold ham' and 'catching at the word [coffee] as if it were a really original idea' – bear the weight of his sarcasm, marking the pages with a light-heartedness often found in Carroll's letters (v, 275). Enjoying the rail journey, he is fascinated by the 'elaborate conjuring trick[s]' (v, 299) of train guards who produce beds from seatbacks and, equally, by the contortions of the language. On conversing with an English gentleman on the train from Königsberg to St Petersburg, Carroll notes an 'extraordinarily long' and 'alarming' Russian word, the English transliteration of which – 'zashtsheeshtshayoushtsheekhsya' – confirms his 'rather dismal prospects' of 'pronouncing the language' (v, 282–3). Moreover, the journal includes the occasional spontaneous sketch, such as the 'cruet-stand' formation of a church, to impress the superiority of hieroglyphics over speech.

The trip was fascinating for both men, not least for its timing. In 1861, just six years earlier, the Liberation of the Serfs had occurred in Russia, an event that had a major social and political impact upon the fabric of life. The emancipation of more than twenty million peasants was visibly evident throughout the country as itinerant workers searched for labour. Especially conspicuous to a European traveller was the influx of former serfs to the major cities of Moscow and St Petersburg. Yet Carroll travelled to Russia not only at a key moment of political reform but at a point at which major cities more generally were seeing massive physical transformation. St Petersburg and Moscow both presented remarkable examples of metropolitan centres with their mixture of peoples and particular cultural institutions. Although very different cities – St Petersburg, Peter the Great's 'window onto the West', active as the main capital, and Moscow historically Slavophile – Carroll found them equally captivating. By the 1860s the building of the centre of St Petersburg was largely completed 'plac[ing it] and Russia [architecturally] in the vanguard of the entire neoclassical movement'.[9] Moscow, on the other hand, had 'no clear pattern to the streets' and it retained buildings and monuments 'that linked the nineteenth century with the medieval past'.[10]

Carroll pronounced Moscow 'a wonderful city':

> of white houses and green roofs, of conical towers that rise one out of
> another like a fore-shortened telescope; of bulging gilded domes, in
> which you see as in a looking-glass, distorted pictures of the city; of
> churches which look, outside, like bunches of variegated cactus . . . and
> which, inside, are hung all round with Eikons and lamps, and lined with
> illuminated pictures up to the very roof (v, 300–301).

In a sentence likening the architectural wonders of Moscow to the physical
appearance of a telescope (and he carried his telescope with him on the
trip), Carroll employs the simile of 'a looking-glass' to detail the mediating
wonders of those 'bulging gilded domes' that produce 'distorted pictures of
the city'. Thus, recalling the 'shutting-up' reflex of the telescope from *Alice's
Adventures in Wonderland* (1865), the simile metamorphoses to antici-
pate the looking-glass 'pictures' of *Through the Looking-Glass* published
four years after the Russian visit. At the same time, visually conspicuous
churches assume a metaphysical brilliance: their magical external effects
anticipate the imagined visual treats awaiting a traveller on the inside, a
plethora of icons burning in their dark interiors.

By contrast, but equally significantly, the formidable architectural
presence of St Petersburg – the biggest port and one of the most important
industrial, trade and financial centres of the country – profoundly affected
Carroll. On first arriving there after an epic train journey of more than 28
hours, he notes the 'wonder' and 'novelty' of the monumental city: 'the
enormous width of the streets (the secondary ones seem to be broader
than anything in London)' (v, 284).

∽ A SERF ON THE STAGE ∽

While, prior to the visit, Carroll had not expressed a particular interest
in Russian history or culture, his approach to Russian life was refracted
through the prism of contemporary British theatre, in the form of Tom
Taylor's *The Serf, or Love Levels All*, which he went to see at the Olympic
three times during July 1865.[11] That drama was itself commemorated
photographically in contemporary *cartes de visite* that Carroll bought.

51 London Stereoscopic Company, *Kate Terry and Henry Neville in 'The Serf'*, July 1865, albumen print.

A drama in three acts with Henry Neville, Kate Terry, Horace Wigan and H. H. Vincent in the principal roles, *The Serf* portrays Russia prior to the emancipation of the serfs, exploring themes of enslavement and peasant uprising. In a diary entry for 3 July 1865 Carroll comments on enjoying *The Serf,* while pronouncing the moral 'very hazy' (v, 85). On this day Carroll also ordered several photographs of the Terrys at Southwell's shop. Theatricality regularly spoke to Carroll's interest in purchasing photographs and, although there exists no record that those images he bought captured Kate Terry in her role from *The Serf,* a number of studio images of her in that 1865 performance survive (illus. 51).[12] Moreover, as exemplified by Carroll's wish to buy *cartes* of Kate Terry, the relationship of photographic portrait to dramatic spectacle is for him a complex one whereby the photograph supplements the theatrical experience and vice versa. Carroll went to see *The Serf* once more on 15 July, and again on 19 July, when he claims in his diary: 'I like *The Serf* better every time I see it' (v, 97).

While, as already noted in the previous chapter, Carroll frequently saw the same theatrical production on more than one occasion, *The Serf* becomes retrospectively significant following his documentation of the Russian tour that assimilates topographical and conceptual concerns of the drama. Indeed, the documentation in Carroll's journal of village churches with their characteristic 'dome and stars'[13] might be straight out of *The Serf.* So, too, might be Carroll's diary record of 'the occasional apparition of a peasant in the usual fur cap, tunic and belt' as marking the only interest in the 'flat' landscape from 'the Russian frontier to Petersburg' (v, 283). The play traces the eponymous 'Serf', Ivan Khorvitch, who, having disguised his identity, becomes an artist in Paris and falls in love with a Countess, Madame de Mauleon. His Russian nationality is soon revealed to the vengeful Karateff, however, who plots to undo him by exposing his enslaved state. At the point where his serfdom threatens to thwart his love, however, Ivan is revealed to have been a prince all along and Carroll consequently called into question whether, with the Serf restored to noble birth, any 'levelling' had in fact taken place.

Carroll's Russian journal entries, which disclose a wish to record cultural differences visually, find precedent in the drama. In Act II of *The Serf* the Countess's ethnographic curiosity about visiting an 'authentic' peasant cottage marks an important point in the plot that is mimicked in a visit Carroll records in detail in his diary for 15 August. In both cases the

occasion attracts the eye of the artist desiring a picturesque subject, and the perspective of the ethnographer cataloguing visible difference. Madame de Mauleon, 'curious', as she claims, 'to penetrate one of the serf's huts', demands her servant make a 'sketch' of the 'cabins'.[14] Carroll, by comparison, en route to the Church of the Holy Sepulchre, or 'New Jerusalem', is so intent on sketching the scene of 'a peasant's cottage' to which he and Liddon had applied 'for bread and milk' – as a pretext for seeing the interior and their 'mode of life' – that Liddon becomes perturbed at 'losing ¾ of an hour' in their onward journey to Voskresensk.[15] After 'two sketches', one of the inside and one of the outside with the family group of 'six of the boys and a little girl', Carroll notes 'it was very interesting to be able to realise for oneself the home of the Russian peasant' (v, 326). Nevertheless, to sketch the scene turns out not to be enough; Carroll bemoans his lack of a camera, pronouncing the group a 'capital' subject 'for photography' but 'rather beyond [his] powers of drawing'.

While Carroll's attempted act of drawing reminds him of his attachment to photographing, *The Serf* vocalizes fundamental differences of photography from the hand-generated medium of painting when Ivan in his Paris studio, surveying the portrait of his model, claims 'I could pitch brushes and palette to the devil when I measure what they can do with the face I carry in my heart.' However, as the disguised Serf further contrasts the action of photography with his inability to convey the face of the beloved – 'Oh! If I could only paint as the sun does, with a flash, and strike her living image from my soul upon the canvas! But I must toil, and toil, and feel her loveliness farther and farther beyond my reach'[16] – he does not simply lament a likeness lost to his inferior powers of painting. He also recognizes the ability of photographic 'sun' painting to bring the original near, to realize 'with a flash . . . the living image' and transfer its metaphysical qualities to physical form. While travelling abroad Carroll experienced afresh the miraculous agency of photography.

∽ SHOPPING FOR *CARTES* ∽

In Russia Carroll substituted a perpetual impulse to 'buy' photographs for a lack of opportunity to 'take' them. In part, while enjoying the unique material and spiritual experiences of Moscow and St Petersburg, Carroll

shops for photographs – as one might expect a typical nineteenth-century traveller to do – as mementos of those sights and works of art seen. Indeed shops, with their 'enormous illuminated signboards', are clearly a draw for Carroll in Russia as they had regularly become in London. His attraction to them resembles Leigh Hunt's earlier fascination in which he likens the variety of London retailers to the bazaars of the 'Arabian Nights'.[17]

Armed with a map and 'a little dictionary and vocabulary' (v, 289), Carroll strolled tirelessly around St Petersburg, an activity he claimed was 'like walking about in a city of giants' (v, 292). He pronounced the city 'so utterly unlike anything [he] had ever seen' that he 'could (and) should be content to do nothing for many days than roam about it' (v, 288). His 'roam[ing]' took him to the city's many photographic studios. Indeed, as Charles Piazzi Smyth, Scotland's Astronomer Royal and amateur photographer, noted eight years earlier in 1859 when visiting St Petersburg: 'there is scarcely a more frequent sign to be met with along the principal streets than PHOTOGRAPHER; and all the specimens exhibited outside the studios, chiefly large-sized portraits, were amongst the finest things we have ever seen in that line'.[18] Smyth's reference to the display of photographs 'outside' the studios chimes with J. G. Köhl's earlier observations of the city in *Panorama of St Petersburg* (1852). Köhl claims that, unlike Paris and London where 'placards and colossal letters' advertise to passers-by the wares of particular shops, St Petersburg with its 'extremely limited reading public' relies largely on 'an abundance of pictorial illustrations' to advertise its wares.[19] Contemporary nineteenth-century Russian newspapers and journals document that by 1859, 'in St. Petersburg alone', the large number of photographers made them 'difficult to name'.[20]

Prominent among those photographic images available were studies of Russian peasants by the Scottish photographer William Carrick (1827–1878), whose name was transliterated as B. Kappuk. It is likely that Carroll encountered examples of the photographic series of 'Russian Types', pictured according to their professions, that Carrick produced in *carte de visite* format between 1859 and 1878.[21] Carrick's studio was 'on the top floor of number 19' Petite Morskoi, a main thoroughfare in the centre of St Petersburg, and 'a stone's throw from St. Isaac's Cathedral'.[22] He had established the premises in 1859, and a letter from his mother notes that by February 1860, in addition to her son's studio, there were 'about a dozen other new photographers begun' on the Petite Morskoi 'and on the Nevsky'.[23]

CARRICK, 19, Petite Morskoï

52 William Carrick's *Chimney Sweep*, St Petersburg, 1860s, albumen print.

On 20 August Liddon writes that he and Carroll 'dined at a restaurant on the Morskoi, and afterwards went about the streets and got our photographs'.[24] Their diaries indicate that both men were regularly in the vicinity of Carrick's studio in the Petite Morskoi. Moreover, Carrick not only sold his *cartes* from his premises but offered them for sale in the main thoroughfare of the Nevsky Prospect.[25] Carrick's 'types' may be located within the tradition of Henry Mayhew's *London Labour and the London Poor* (1851–2) and John Thomson's *Street Life in London* (1877),[26] both initially published in serial form, but also, as Julie Lawson indicates, in the context of examples of 'the "Cries" of St Petersburg . . . depicted in numerous illustrated books produced in Russia and in Western Europe in the eighteenth and nineteenth centuries'.[27] Lawson is right to suggest the influence upon Carrick of 'the tradition' of works by J. B. Le Prince and John Atkinson illustrated respectively by engravings and coloured lithographs. As Elena Barkhatova points out, 'lithographic "russeries", as well as "turqueries" or "chinoiseries", were popular commodities for tourists'.[28] In addition, Carrick's interest in creating Russian 'types' shared characteristics of contemporary mid-nineteenth-century photographers working in St Petersburg and Moscow, such as Alfred Lorens, Jean Monstein and H. Laurent.[29] Each of these photographers produced versions of Russian peasant subjects taken from the street into the studio to display to the camera the visible signs of their occupation. In both conception and staging such photographs anticipate Carroll's subsequent costume pieces using child models.

Many of Carrick's photographs aim to distil the individual trades of itinerant peasants who regularly flocked to the city from outside to provide services or hawk commodities. Knife-grinders, glaziers and coopers appear alongside fishmongers, glove and stocking sellers. Among this group Carrick's *Chimney Sweep* (illus. 52) (1860s) serves as a modified Western archetype for the émigré photographer. With his kneed trousers, turned-out feet and startled look, emphasized by the prominent whites of his eyes, the 'Sweep' resembles a contemporary caricature from *Punch*. His symbolic and literary associations identify him as part of an established Western visual economy of poor manual labourers. For Dickens such workers were a regular peril to visitors to London who should 'be on their guard against' a sweep's dangerously protruding 'brush'.[30] In terms of photographic monochrome the principally black and (a little) white sweep provides a subject perfect for displaying those contrasts required

by the medium, contrasts especially welcome in Russia where the dark winters and relative lack of good photographic light during much of the year meant technical struggle for photographers. This Russian 'type' of sweep, however, who carries the distinctively European 'ball and brush' tools of the trade, appears initially incongruous located in a sequence of more ethnographically displayed 'types'. At the same time, though, the soot-blackened persona of the sweep, like that of his compatriot the shoe-black, is also a fundamentally racialized one. As English photographers of the period turned their cameras to figures of the urban poor whose dirty trades marked their bodies in racialized terms, 'Russian' photographers took up subjects whose ethnicity was apparently transformed by the dirt of a manual trade. In Russia, this practice achieves a different register by the use of the term 'black people', which according to Köhl explicitly linked dirt with race.[31]

Other photographs by Carrick stress the trade of their subjects by those commodities pictured. Thus, for example, *An Abacus Seller* (1860s; illus. 53) shows a boy posed centrally in the frame as if stepping out. His head turned to three-quarters profile, he displays his wares to, and gazes directly at, the camera. A large shallow basket hangs from tapes around his neck at an angle to best display the variety of abacuses contained within it. In addition, the boy shows off in each hand examples of the visually distinctive form of his commodity. Of varying sizes within the basket, the stiff wooden frames of the abacuses, patterned by regular rows of beads, provide considerable visual interest within a monochromatic scheme. Likewise does the peak of his cap, together with the folds of his leather knee-high boots, which catch the light against the neutral ground. Like many of Carrick's subjects, the *Abacus Seller* is laden with those commodities he sells and visually distinguishable by them. His purposeful look, and movement arrested in mid-flow, is set off by the very simple background and the line where the floor meets the wall suggesting, albeit very subtly, an indoor shot.

Neither *Chimney Sweep* nor *An Abacus Seller* leaves uncertainty about the studio setting; very rarely does the photographer attempt to mask, or transform, the interior in these images from the 1860s. Prominent in such photographs circulating for the tourist trade are visual signatures of the pared-down, neutral studio setting. As a consequence, the placement of itinerant figures into the relative novelty of the photographic studio space

53 William Carrick, *An Abacus Seller*, St Petersburg, 1860s, albumen print.

grants to unlikely details a certain visual insistence. So, for example, some of Carrick's shots register, in an otherwise unadorned studio, the seemingly inconsequential detail of a narrow but indelible skirting board that foregrounds decorative aspects of those costumes and commodities pictured.

The familiar look of such Russian *cartes* anticipates the increasingly pared-down scene of Carroll's costume photographs of the 1870s in which the same costumes and set-ups surface time and again. On his return home from Russia, Carroll becomes more insistent in his pursuit of costume photographs that, like Carrick's, combine both ethnographic and theatrical elements. What is more, in leaving unadorned the studio space, those photographs Carroll began taking in the spring of 1872 in his Christ Church studio further resemble Carrick's photographic 'types' of

54 Lewis Carroll (C. L. Dodgson), *Beatrice Hatch*, 16 June 1877, albumen print.

the 1860s. They do so in compositions in which a relatively barren space intrudes upon the fictional set-up in sometimes subtle, sometimes more overt, but nonetheless significant, ways. Moreover, even though none of Carroll's extant prints, or recorded 'sittings', specify 'Russian' types, along with many specified nationalities, they incorporate generic shawls and scarves that suggest the multi-ethnic context that Carroll encountered in Russia.

Beatrice Hatch (illus. 54), photographed in the studio on 16 June 1877, appears in costume that may be Russian. While Carroll does not identify

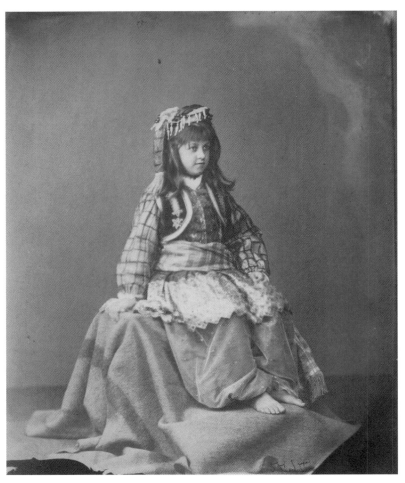

55 Lewis Carroll (C. L. Dodgson), *Ethel Hatch in Turkish Dress*,
16 June 1877, albumen print.

her clothing, the headscarf and leather boots she wears are distinct from the costume worn by her sister, and designated as Turkish, in two photographs of *Ethel Hatch in Turkish Dress,* in both standing and seated versions, (illus. 55), taken on the same day. Moreover, both sisters resemble Carrick's photographic subjects. Carroll also produced the seated version of Ethel in *carte de visite* format. In each photograph the child is positioned in a plain interior accentuating ethnic identity as evident in her clothing. In addition, the off-frame destination of each child's look further suggests the photographic 'type' as an object of scrutiny. However, such photographs also recall other visual commodities Carroll purchased in Russia, most notably Orthodox icons. And while ancient icons are distinct from the modern forms of photographs, in their ontological status as images made by non-human agency – engaging the invisible as well as the visible – icons fundamentally anticipate them.[32] Furthermore, for Carroll, as physical traces guaranteeing the magical presence of child subjects, photographs harbour the potential to incite devotion in a manner similar to icons.

ORTHODOX ICONS

In Russia, Carroll regularly combined the purchase of photographs with the purchase of icons. Liddon, too, recorded the purchase of photographs alongside icons and crosses.[33] While the process of desire always exceeds its immediate object, in the Russian context, Carroll's desire to buy photographs in the absence of being able to take them becomes entangled with an attraction to icons. Obliquely anticipating Carroll's repetition of photographic subjects, nineteenth-century icon painters in Russia worked to patterns in the mass production of those Orthodox icons frequently sold alongside photographs. In the celebrated studios of icon painters individual workers engaged in piecework, each contributing a particular component of the composition. During his first days exploring St Petersburg, Carroll records his visit to the market principally in order to survey the 'dozens' of 'little shops . . . devoted to the sale of Eikons': 'ranging from little rough paintings an inch or two in length, up to elaborate pictures a foot or more in length, where all but the faces and hands consisted of gold'. He promptly concludes 'they will be no easy things to buy, as we are told shop-keepers in that quarter speak nothing but Russian' (v, 291).

Typical of the replicas Carroll would have encountered, and one of the most commonly painted, was the *Theotokos Kazan* (Our Lady of Kazan; illus. 56), a holy icon of the highest stature within the Orthodox Church, brought to the new Kazan Cathedral in 1821 and considered the Holy Protector of St Petersburg.[34] As Köhl points out, in St Petersburg the consumption of copies of sacred images is so 'enormous' and widespread that in the market 'the little brass crosses, and the Virgins, the St Johns, the St Georges, and other amulets, may be seen piled up in boxes like gingerbread nuts at a fair'.[35] Furthermore, purchasers routinely 'buy a few scores at a time, as necessary to the fitting up of a new house, for in every room a few of these holy little articles must be nailed up against a wall'.[36]

Icons, like photographs, thus have the virtue of being both public and private objects. One may address one's veneration to a saint in public while, since they occupy pride of place in Orthodox homes, one may also secretly devote emotion to an icon in private. Traditionally, icons were hung draped in the right-hand corner of the room 'to be reverentially greeted by visitors'.[37] But there were also many types of portable icons, including ones that folded, which merchants carried, for example, to be set up wherever they stayed on their travels. And in this quality of portability – to be treasured and opened for display when desired – icons anticipate one of the key virtues of the photograph as keepsake.

In Eastern Orthodoxy the icon is a manifestation of the divine, an imprint rather than a representation, and its status as a direct imprint emerges with the story of the Mandylion of Abgar, a piece of cloth bearing the miraculous image of Christ's face imprinted upon it.[38] Analogously, the photograph, as theorized in the nineteenth century, is miraculous in its physical trace of, and causal connection to, a referent. But as Geoffrey Batchen has demonstrated in the work of William Henry Fox Talbot, there occur vital questions concerning the nature of that 'mode of inscription' with which 'nature reproduce[s] herself as a photographic image'.[39]

For Julia Kristeva, contrasting the Orthodox experience with the crisis of the modern European subject, the icon, which does not reveal all visibly to the eye, reflects 'the exaltation of an ineffable religious inwardness'.[40] In her discussion 'Icon versus Image', she particularly identifies the icon as 'inscrib[ing being] rather than manifesting it'.[41] Moreover, it is the icon's status as 'a *graphein*, a sensible trace, not a spectacle'[42] that thereby, in Kristeva's terms, distinguishes the 'fixity' of 'the iconic – Byzantine

56 *Theotokos Kazan* (Our Lady of Kazan),
19th century, Orthodox icon, tempera on wood.

economy' of images from what she calls the greater 'figurative flourishing of Catholicism'. Most crucially, as Kristeva understands it, an icon 'is not limited to the gaze alone but engages our entire affectivity'.[43]

For Carroll, the Orthodox experience as he observes it in 1867, especially its engagement of the senses, enriches his own understanding of both religious and secular devotion. As early as his first visit to St Isaac's Cathedral on 28 July, Carroll had been struck by the power, *in situ*, of the icons. 'There are so few windows', he writes, 'it would be nearly dark inside, if it were not for the many Eikons that are hung round it with candles burning before them' (v, 286). Icons in this way serve as lights literally illuminated by candles in the dark interiors of churches. Acknowledging as crucial to their meaning the conditions in which they were viewed, scholars have explored 'vision' in the context of icons in the Byzantine period as 'more tolerant of uncertainty and obscurity' than in the later Renaissance.[44] They have shown how a vital element of the power of an Orthodox icon resided in its qualities of obscurity involved in the viewing

experience itself. On visiting 'the Cathedral Church in the fortress' on 30 July, Carroll is again fascinated by the many icons 'with candles burning in front of them'. On this occasion he sees 'one poor woman go up to the picture of St Peter, with her sick baby in her arms' and begin the process of 'a long series of bowing and crossing herself' as she addresses prayer to the saint. He is particularly struck both by the veneration with which she treats the icon and also by the visible weight of her conviction the saint will intercede on her behalf: 'one could almost read in her worn, anxious face, that she believed what she was doing would in some way propitiate St Peter to help her child' (v, 292).[45]

In a diary entry for 12 August regarding a visit to the Troitska Monastery, Carroll records having observed the work of boys who 'are taught the two arts of painting and photography':

> In the painting-room we found so many exquisite Eikons, done some on wood, and some on mother-of-pearl, that the difficulty was to decide, not so much what to buy, as what to leave unbought. We ultimately left with three each, the limit being produced by shortness of time rather than any prudential considerations (v, 319).

The difficulty Carroll feels in having to leave some objects 'unbought' resembles the difficulty he finds in 'leaving' photographs. Newly confronted with such opportunities to buy Orthodox icons, Carroll is willing, as he is with photographs, to cast aside discretion. Even on a visit to 'the Monastery of "New Jerusalem"' on 15 August, after a monk has shown him and Liddon 'all over the "Church of the Holy Sepulchre", and out through the woods to see the "Hermitage" to which Nikon retreated during his voluntary banishment', Carroll records:

> On our way out, we bought at a sort of shop at the entrance, kept by the monks, small copies of the 'Madonna of the three hands' . . . painted to commemorate a vision of the Virgin Mary, seen in the way represented in the Icon, with a third hand and arm coming in from below (v, 328–9).

This is the only icon to which Carroll refers by name; perhaps he notes it because the 'third hand' is incongruous among the usual Virgins and St Peters.[46] But he mentions it alongside reference to a curious optical toy,

'an imitation ostrich-egg': 'On looking through it at the light, through a hole in one end, one saw a coloured representation, which looked almost solid, of a female kneeling before a cross' (v, 328). This optical conceit, whereby a modern viewing mechanism of the popular peepshow discloses a sacred image, precisely dramatizes the implicit entanglement of ancient and modern, icon and photograph.

Not only did the material entanglement that characterized Carroll's encounter with Russian culture influence his photographic practice, but it influenced his conceptual investment in the medium of photography. In their forms as treasured physical objects, souvenirs twinned with photographs, icons affected Carroll's attachment to, and heightened his understanding of, the invisible power of the photographic medium.[47] While the ancient painted form of an icon is distinct from the technological modernity of a photograph, nevertheless, on the Russian trip the two come together in curious ways as objects to which Carroll may address his fascination. Encountered in Russia, with their combination of touch and sight – their qualities of 'traces' and as 'images' – and thereby evading the distance of other forms of representation, icons and photographs both function for Carroll to guarantee a miraculous quality of presence that triggers memory, simultaneously evoking the anterior future tense.[48] Carroll is therefore drawn to the very different material forms of photograph and icon both as imprints of extant 'things' and also as readily available commodities.

Carroll's relation to the souvenir does not so much resemble what Susan Stewart describes as its capacity to signal 'the nostalgia that all narrative reveals – the longing for its place of origin',[49] as it does 'the romance of contraband', in 'its removal from its natural location'.[50] At the same time, his intense wish to possess in portable form an indexical and easily reproducible portrait image represents a desire to experience 'the icon's oscillation between visible and invisible'.[51] In Russia Carroll responds to the Orthodox icon as a spiritual imprint that allows the subject 'an affective participation in divinity that remains outside of language'.[52] While, for Kristeva, the icon animates cultural memory, for Carroll the ancient form of the icon confirms his investment in the modern function of the photograph to activate personal memory. More specifically, as Carroll witnesses the ardour with which Russians treat their icons, he identifies in a complex way with a version of that passion he himself feels towards treasured photographs.

In the manner of copies, icons, like photographs, 'enabl[e] individuals and communities to identify with a well-known image' to which they might 'attach their own stories'.[53] For Carroll, the affective engagement elicited by an icon realizes and, by extension, legitimizes the type of engagement a photograph invites.

⤳ Nizhni Novgorod: 'A Peep at the East' ⤳

Icons and photographs were especially thrown into vivid relief for Carroll in the multi-ethnic context of the annual World's Fair at Nizhni Novgorod that 'brought together some twenty thousand merchants and one hundred thousand visitors from the four corners of the earth'.[54] Following a three-day visit to Moscow, Carroll and Liddon set off for Nizhni on 6 August, and the former records the experience in detail, outlining especially the different ethnic types found there:

> It was a wonderful place. Besides there being distinct quarters for the Persians, the Chinese, and others, we were constantly meeting strange beings, with unwholesome complexions and unheard-of costumes. The Persians, with their gentle intelligent faces, the long eyes set wide apart, the black hair, and yellow brown skin, crowned with a black woollen fez something like a grenadier, were about the most picturesque we met (v, 309).

The largest fair in Europe, as S. Frederick Starr points out, like other fairs in Russia 'that dominated rural trade', Nizhni Novgorod juxtaposed 'peasant crafts and cheap western style goods to meet the traditional tastes of the local populace'.[55] Its unprecedented mix of ethnicities and displays of commodities provided a context in which Carroll might not only situate the subjects of *cartes de visite* purchased in St Petersburg and Moscow but witness what he calls those 'unheard-of costumes', costumes he would subsequently contrive to reproduce in his photographic studio.[56] In addition, the fair set modern photographs (such as Carrick's peasant 'types') alongside ancient icons in a place that felt more Eastern than any other he and Liddon visited on the trip.

Carroll records spending 'most of the afternoon [7 August] wandering through the fair, and buying Eikons etc.' (v, 309) while Liddon captures the

Xie Kitchin.

57 Lewis Carroll (C. L. Dodgson), *Xie Kitchin as 'Tea Merchant' 'On Duty'*, 1873,
albumen print.

momentous effect upon himself of the Asian peoples and their customs when he notes in his diary: 'I am delighted to *have been* at Nijni Novgorod. It is a peep at the East – the only one I have ever had in my life.'[57] Liddon's 'peep at the East' was, for Carroll, differently manifest in the form of dramatic spectacle. For on the evening of 7 August, while Liddon retired to bed, Carroll attended the Nizhni Theatre, 'the plainest [theatre he] ever saw'. The play was *Aladdin*:

> The performance, being entirely in Russian, was a little beyond us, but by working away diligently at the play bill, with a pocket-dictionary, at all intervals, we got a tolerable idea of what it was all about. The first, and best, piece was *Aladdin and his Wonderful Lamp*, a burlesque that contained some really first-rate acting, and very fair singing and dancing. I have never seen actors who attended more thoroughly to the drama and the other actors, and looked less at the audience (v, 311).

Carroll was intrigued by seeing *Aladdin* in the context of Nizhni Novgorod for the tale, added by Antoine Gallard to the original collection of *One Thousand and One Nights*, is Middle Eastern, but its story set in China. John O'Keefe dramatized the tale for the Theatre Royal in Covent Garden in 1788, and Carroll saw various British productions of *Aladdin*.[58] The experience of the play in the multi-ethnic context of the World's Fair prompted him, late that same night and without any ink to hand, to write in pencil to his sister Louisa: 'the whole place swarms with Greeks, Jews, Armenians, Persians, Chinamen etc., besides the native Russians.'[59]

The ethnic and religious groups encountered at Nizhni are precisely those Carroll created photographically on his return home in the miniature forms of dressed-up child models. His particular interest in Chinese subjects found expression in two of the first costume photographs he took in his Christ Church studio: *Xie Kitchin as 'Tea Merchant'* 'On' and 'Off Duty' (1873). In these images Carroll uses tea chests for props as he signals ethnicity through occupation as well as dress. The staging in 'On Duty' (illus. 57) corresponds with one of Carrick's 'types' as the tea merchant poses with her commodity against an interior wall marked by a skirting board. 'Off Duty' (illus. 58), by comparison, with chests in disarray, pictures the child figure of the merchant in relaxed pose. Although the costumes are the same as those worn by Lorina and Alice Liddell twelve years before,

Xie Kitchin.

58 Lewis Carroll (C. L. Dodgson), *Xie Kitchin as 'Tea Merchant'*
'Off Duty', 1873, albumen print.

the conception and staging of the photographs is markedly different. Xie
Kitchin represents a 'type', not only as designated by her costume, but by
the nature of her labour; to this end the tea chests form an important part
of the composition.[60] Gone is the generic chair of the 'Chinese' composi-
tion of 1860; in its place are 'authentic' props used in a manner reminiscent
of those in Russian photographic *cartes* by Carrick and his contemporaries
such as Laurent.

Following the Russian trip, Carroll took a number of other images
using Chinese costume. In particular he made an extended visit (from 5 to
14 July 1875) to photograph at Oak Tree House, Hampstead, the home of
the artist Henry Holiday, resulting in an album of 24 photographs presented

to Holiday.[61] On this occasion Carroll borrowed a Chinese costume from Heatherley's Art School and the robe did the rounds of several models.[62] A photograph of 10 July 1875 entitled *A Chinese Bazaar* (illus. 59) shows Daisy Whiteside taken at Oak Tree House. The daughter of William Whiteside, a merchant and farmer in India, the child appears in a frontal full-length portrait in the aforementioned Chinese dress against a plain backdrop. Her right hand rests on a vase displayed on a lacquerware box, while in her left she holds a fan. The commodity of tea is here replaced by Chinese porcelain and, in an attempt at a version of a pidgin English market cry he may have heard at Nizhni, Carroll's inscription in his signature violet ink in the bottom, left of centre, reads: 'Me givee you good piecey bargin'.

59 Lewis Carroll (C. L. Dodgson),
A Chinese Bazaar, 1875, albumen print.

"Which we had a small game,
 And Ah-Sin took a hand:
It was euchre — the same
 He did not understand;
But he smiled as he sat by the table
 A smile that was child-like and bland."

60 Lewis Carroll (C. L. Dodgson), *Rose Laurie as 'the Heathen Chinee'*, 1875,
albumen print.

As in *Xie Kitchin as Tea Merchant* 'On' and 'Off Duty', props – here vase and lacquerware box – together with caption, clearly denote a mercantile context. Such contextualization according to a 'type' of occupation was not something Carroll had contrived before the Russian trip. Furthermore, on the same day Carroll photographed Daisy Whiteside, he took *Rose Laurie as 'the Heathen Chinee'* (illus. 60) in the same costume, sitting beside the same props with a quote from Bret Harte's poem 'Plain Language from Truthful James or the Heathen Chinee'.[63] A token reference to cheating at gambling appears in the card the child holds in her left hand and the deck spilled in her lap.

Carroll's photograph of *Honor Brooke as 'a Modern Greek'* (illus. 61), taken on 13 July 1875 on the same visit, stages those Greek subjects he had encountered alongside Chinese ones at Nizhni, but its oval format emphasizing the face of the sitter creates a different visual register. As the child subject sits cross-legged looking intensely at the camera, her body appears swathed in ethnic costume such that only her face, bare feet and hands are revealed. However, a closer look identifies the Chinese costume and fan from those shots of Whiteside and Laurie taken three days before. Transferring costumes in such a way from one child to another, from one 'type' or nationality to another, Carroll indicates not so much an ethnographic but a generic look. In addition, though, the format of the print, accentuating the girl's look as requiring a return, resembles that of an icon.

Yet there is a different sense in which all three of these photographs from Carroll's Holiday Album fix their child figures with a regularity characteristic of the icon. Moreover, in '*A Modern Greek*' as in A *Chinese Bazaar*, an inscription forms an integral part of the image; a quotation in Greek reads ('My life, I love you') from Byron's well-known 'Maid of Athens'.[64] In this image, the combination of the masquerading child with calligraphy – the photographic medium juxtaposed with the devotional nature of the text – recalls not only the visual effects of orthodox icons but their incorporation of inscription.

While it was common for Carroll to include such inscriptions in his albums of photographs, following his Russian visit, he increasingly supplements his photographs with inscriptions reminiscent of the presence of textual elements encountered in icons. Indeed, Carroll's photographs of the 1870s recall examples both of Russian types and of Orthodox icons bought during the trip. By sleight of camera, the direct and earnest look

"Ζωή μᾶ., θᾶς ἀγαπῶ."

61 Lewis Carroll (C. L. Dodgson), *Honor Brooke as 'a Modern Greek'*, 1875, albumen print.

in the eyes of a saint, with bare face and hands offset by elaborate but uniform compositional elements, translates into an analogously elaborate and repeatedly staged photographed figure of a child. Set against plain grounds, the faces and directions of the looks of Carroll's costume 'types' seared into the photographic emulsion resemble the sacred figures of icons imprinted onto their gold grounds. As images not produced by hands, Carroll's photographs of child-sized 'China merchants', Greeks, Turks and more generically represented nationalities convey qualities of presence comparable to those of icons.

∾ A Lost Photograph ∾

On 23 August, close to the end of his stay in Russia, having returned to St Petersburg via Moscow following his time at the fair at Nizhni Novgorod, Carroll made the following extended entry on the left-hand side of pages 15 and 16 in his journal:

> In our wanderings, I noticed a beautiful photograph of a child, and bought a copy, small size, at the same time ordering a full length to be printed, as they had none unmounted. Afterwards, I called to ask the name of the original, and found that they had already printed the full length but were in great doubt about what to do, as they had asked the father of the child about it, and found he disapproved of the sale. Of course there was nothing to do but return the carte I had bought: at the same time I left a written statement that I had done so, expressing a hope that I might still be allowed to purchase it (v, 345).

This fifteen-line record, separated from the narrative run of his Russian diary as a whole, appears in a place normally reserved for items added at later dates. The note details a complex, and what would become an increasingly familiar, situation in the case of Carroll's photographs of other people's children, namely negotiation around an image. He sees a 'beautiful photograph' of an unknown child – in a sense for him the same as a photograph of 'a beautiful child', since medium and subject are in some ways commensurate – and he wishes to own copies of it. Carroll enters into conversation with the photographer regarding the logistics of ordering

'a full length print' because there are 'none unmounted' – the mount presumably making it more difficult to incorporate it into an album – but then returns to ask the name of 'the original'.

On requesting the child's name, Carroll encounters a hurdle: the studio 'were in great doubt about what to do' since, he confides, the photographer had consulted the father who 'disapproved of the sale'. While in his regular diaries and letters comparable requests are fairly common – Carroll asks the permission of parents to take photographs of their children, or to gain a copy of a photograph, sometimes after having 'seen' them only once – there is a difference here. For Carroll deals with a Russian photographer over the image of a child, not only previously 'unknown' to him, but 'unseen' by him other than in the form of a likeness.

This incident details the circumstances of a photographic transaction in a way distinct from other entries in the Russian journal that simply record 'shopping for' photographs.[65] Indeed, Carroll's attempt to purchase this particular photograph stands in for the all-pervasive nature of his attachment to photographs of children. Significantly, just as on his visits in England Carroll desires to know the names of those children he meets, and in representations he uses the formulation 'the original' to refer to a child subject, in Russia the practice remains the same. At one level to want to know the sitter's name is a gesture at making 'respectable' the wish to own the photograph; there is a sense in which an anonymous child is troubling to Carroll. At another, Carroll's desire to put a name to the face represents the inverse of his request to his publisher Macmillan, two years later at the time of the German and French translations of *Alice*, to invite each child reader of all subsequent editions to put a face to a name by sending a photograph of herself. Macmillan promptly put a stop to that impulsive gesture by pointing out with considerable irony the prospect of a 'Shower Bath filled a-top with bricks instead of water' as equivalent to the unwieldy number of 'cart-loads' of '*cartes*' Carroll would duly receive.[66] Yet, in a sense, cart-loads of photographs are precisely what Carroll wants. There can never be too many and, as the Russian trip testifies, they need not be photographs he has taken himself. Such is the miraculous lure for him of the photographic image, in particular the image of a child.

It has proved impossible to determine the identity of the child in the St Petersburg photograph or the studio from which Carroll purchased it. Moreover, it is only possible to speculate how, at the mercy of his

'vocabulary', Carroll might have conducted what appears to have been a fairly elaborate transaction unless, of course, the photographer spoke English. Carroll may have come across the photograph in the window of the photographer's or, as was more likely the case, singled it out from the albums of prints available to view inside; this was his common practice when visiting studios in London. However, regardless of how Carroll 'noticed' the image, his comment reveals the importance to him of securing prints.[67]

A subsequent note in his journal of 26 August provides a satisfactory resolution to the earlier uncertainty regarding the photograph: 'the photographer called ("артистический фотография" at No. 4 Great Morskoi) to bring the pictures, as the father, Prince Golicen (?), had given them leave to sell them to me' (v, 349) Critics have not translated the two words in Cyrillic that Carroll records in the entry for 26 August.[68] At first glance they appear to indicate the name of the photographer but instead the transliteration: 'Artisticheskaya Photographiya' means 'Artistic Photograph' or 'Artistic Photography'.[69] Thus, Carroll's note most likely preserves the name of the studio from which he bought the photographs (the sign advertising the premises at 4 Great Morskoi), or the name-stamp on the prints. While the inverted commas suggest a proper name, from his status as amateur Carroll may be ironically drawing attention to the 'high' art aspirations of the photographer. The title 'Artistic Photography' may equally refer to the types of 'theatrical' photographs that Carroll coveted in London thereby indicating the material difference of this particular establishment from the many regular *carte de visite* studios in St Petersburg. Whatever the case, this comparatively brief entry three days after the first would remain elliptical without the earlier gloss on the involved history of the transaction.

Carroll's note of 23 August, retrospectively anticipating the arrival of the photographs on 26 August – in the nick of time since that day he and Liddon finally left St Petersburg for good – is thus distinctive, but its purpose is far from clear. In practical terms, the record of the photograph may operate to remind Carroll of the previously dependable role of humility in securing desired photographic sittings. Yet, while the reference resembles an addendum, an examination of the ink indicates it was most likely written at the same time as the rest of the entry. In purposefully separating it from the body of the text, therefore, Carroll makes the first entry bear the weight of the larger importance of photographs to memory in his experience of

Russia. In this context, the note for 23 August resembles an aide-mémoire for Carroll recalling the aesthetic impact of the 'beautiful photograph' discovered on one of many shopping ventures in St Petersburg. But, essentially, read in sequence the first reference to the photograph anticipates, and the second commemorates, a momentous purchase.

Yet there exists no description of the 'beauty' of the photograph. Instead, rather like the elusive 'Winter Garden photograph' of Roland Barthes's mother that Barthes claims not to reproduce because it would remain meaningless to anyone but himself, Carroll's lost photograph gains power from its material absence, from its phantom status in the text.[70] Furthermore, Carroll's words that hold the photograph as allusion also powerfully trigger that which, like an icon, is beyond language. In so doing, they signal afresh the significance of the Russian visit to his investment in the photographic medium.

It is not surprising that the singled-out photograph of a child from 1867 is missing since the majority of photographs Carroll bought in his lifetime, along with many of those he took himself, were either lost or destroyed after his death. Yet since the circumstances of the purchase of this particular photograph would have remained unknown without the diary entry, this itself substitutes for all those unnamed photographs Carroll bought on the trip to Russia. Its very presence raises larger questions about Carroll's desire for photographs in the Russian context, especially as they relate to the form of the icon. In a sense, a reader is required to imagine (for Carroll to remember) the lost photograph, but not in any simple visual conjuring of the image of a child subject. Rather, the record of the photograph functions in a manner analogous to the visually identifiable and familiar image of a saint in an icon. It guarantees a reassuring, because miraculously generated, sameness.[71] For Carroll, the singled-out photograph alludes to a body of photographs of children he has by this time begun to amass, while at the same time pointing forward to those photographs he will more insistently create on his return.

It is in these terms, along with its assignment to an exclusive space on the verso of the entry for 22 August, that the diary entry indicates the lengths Carroll was prepared to go to secure photographic souvenirs. In turn, the unidentified photograph is a reminder that, in Russia in the 1860s, Carroll encountered photographs intricately bound with other commodities, most specifically portable copies of icons. Moreover, the

connection between photographs and icons was essentially more than a material one. It was not simply because photographs were precious reproducible commodities to adorn private spaces that for Carroll they resembled Orthodox icons. Yet neither does the connection rest entirely with the fact that, like an icon-painter, a photographer is distinguished from an artist as 'one who "reveals" (*raskryvayet*) an already extant image and the truths it embodies'.[72] Fundamentally for Carroll, as sacred objects, icons elicit legitimate reverence in ways he would like photographs to do and, consequently, in Russia he buys icons, and wants to buy them, with an enthusiasm he usually reserves for photographs.

Understandably, witnessing devotion to an icon affected Carroll and Liddon differently. While Liddon was impelled to compare with his knowledge of the Catholic Church what he experienced in Russia, Carroll was in part affected by the passionate spirituality of the Orthodox faith because the devotion to icons he witnessed everywhere resonated with the power of a treasured photographic portrait. But, of course, icons are problematic when they become idols, and iconoclasm perpetually concerns Liddon as he tries to understand the Eastern Church in relation to the Roman. Indeed, so impressed is Liddon by the 'Great Celebrations in St Isaac's Cathedral' that he thus writes to the Reverend William Bright, Professor of Ecclesiastical History at Oxford: 'of course, the ritual was elaborately complex – bewildering – indeed, to an English mind. But there was an aroma of the fourth century about the whole which was quite marvellous.'[73] Liddon is especially struck by 'the troops of infants in arms [who] were brought by their mothers and soldier fathers to kiss the Icons' and, in identifying the exuberance of the people's devotion to the Eastern Church, Liddon claims:

> to the outward eye she is at least as imposing as the Roman. To call her a petrification here in Russia would be a simple folly. That on the other hand she reinforces Rome in the Cultus of the Blessed Virgin Mary and other matters, is too plain to be disputed.[74]

Yet, Carroll, on the other hand, is attracted to what he calls the 'gorgeous services' precisely for 'their many appeals to the senses', although he reacts negatively to some aspects of Orthodox ritual, claiming on one occasion it makes him 'love' the 'plain, but to [his] mind far more real service of the English Church' (v, 288).

Xie Kitchin.

62 Lewis Carroll (C. L. Dodgson), *Xie Kitchin as 'Dane'*, albumen print, 1873.

Carroll is simultaneously fascinated by the icon as venerated object and as modern commodity to be carried off in a suitcase. Indeed, along with various unspecified photographs, he leaves Russia with 'a beautiful photograph of a child' and a range of Orthodox icons. But popular *cartes de visite* and popular Orthodox icons conceptually intervolved throughout the trip did not subsequently become entirely discrete entities for Carroll. Rather, on his return, he rehearsed the conceptual entanglement and complex congruence of the two indexical forms of representation in his developing preference for photographing a female child in a bare interior, her face emphasized against elaborate costume. In addition to those 'costume' photographs already considered, such correspondence is most apparent in *Xie Kitchin as 'Dane'* (1873; illus. 62) in which Carroll's favourite child model returns the gaze of the viewer in a way suggestive of the intensity and direct visual contact of an icon while approximating, in direct frontal pose, one of Carrick's 'types'. This photograph was a personal favourite of his, and Carroll reprinted it many times, even having special coloured enamelled versions made to give as gifts.[75] Indeed, part of the attraction of this photograph for Carroll resided in its design for show in a domestic setting; the pleasure it afforded him to distribute the portable treasured image to friends to display in their homes in the manner of an icon.

Throughout his visit to Russia, Carroll thereby connected the affective power upon Russian subjects of their icons with what he had come to recognize as his own intense investment in particular photographs. While an Orthodox Russian's relationship to the 'mystery' of Mary was very different from his own participation in the effective 'mystery' of a photographic subject, nonetheless the photograph of a female child seemed to ensure for Carroll a version of what according to Kristeva the 'mystery of Mary' offered a 'believer', that is, 'an almost infinite sensory freedom'.[76] Moreover, in Russia Carroll's experience of reverence to the spiritual imprint of an icon offered him a precedent for, and in a certain sense sanctioned, his increasingly insistent engagement with photographs. Perpetually troubled during the 1860s by being at odds with his father's beliefs, and regularly recording in his diaries extreme guilt in neglecting his clerical and academic duties for the pleasures of photography and the theatre,[77] Carroll reacted to the spiritual devotion to icons in part because it allowed him to understand afresh – and to some extent legitimize – the compelling nature of a photograph as an imprint and not simply a representation.

Many Orthodox icons increase in power according to their slow erasure by kisses of the devout. They are carefully preserved. There exist unwritten laws against their destruction. But just as icons are 'embraced' and 'kiss[ed] with the eyes' to be 'taken into the memory',[78] photographs bring together vision and touch to nourish memory. Carroll treasures photographs because, as emanations of their referents, they afford a corresponding synaesthetic response. Acknowledging as approximate to rapture the response he feels in the presence of the image, Carroll would like to kiss a photograph as an Orthodox Russian kisses an icon. Indeed, increasingly after 1867, the photograph of a child incites Carroll to embrace with his eyes, and take in with his memory, a sensible trace of presence. St Petersburg, with its readily available *cartes* and equally plentiful icons 'piled up like gingerbread nuts at a fair', newly and distinctively endorses Carroll's fascination with the indexical power of photography.

5

Ore House, Hastings: Stammering, Speech Therapy and the Voice of Infancy

THE EXPERIENCE OF RUSSIA, as I have charted it, involved for Carroll a coming together of sight and touch in a correspondence between the modern form of the photograph and the ancient one of the Orthodox icon. Aside from all the other cultural benefits he took from it, in these terms alone, the Russian trip demonstrates the larger significance of photography to Carroll's experience. Not only was he fascinated by the relationship of visual images to touch, as realized on his foreign tour by the icon, but from early in his photographic career Carroll recognized and embraced a relationship of the medium of photography to speech. A correspondence between the photographic and the verbal took many forms in his work, but it found particular expression in the relationship of photography to his own speech as perpetually flawed.

Throughout his life the author of the *Alice* books was dogged by a stammer. Carroll's personal writings document, from time to time, the persistence of the condition for which he sought help and advice at various periods. From 1857 Carroll consulted the speech therapist James Hunt at his clinic at Ore House near Hastings (illus. 63), and from 1870 he saw Henry Frederick Rivers, who took over the practice following Hunt's death. The south coast of England thereby figured large in Carroll's attempts to treat his pathology that, so integral to his habitual experience, held a fundamental relationship to his photography.

From the first, speech was an important component in Carroll's practice of taking photographs. Indeed, a novel conjunction of visual and verbal characterized the photographic sitting as Carroll both conceived and engineered it. That verbal space of the photographic sitting, the playful banter he enjoyed with a model, was in turn itself shaped by his idiosyncratic experience of speech as hesitant and imperfect. Speech was a perpetual cause of anxiety for Carroll. His diaries and letters document an

63 'The Cottage', previously Ore House, The Ridge, near Hastings, before demolition in 2010.

ongoing pursuit of successful therapy, and his experience of stammering as a source of shame prompted Carroll's efforts to help various individuals who suffered from the condition, including six of his seven sisters. In a letter to Rivers of 2 February 1874 Carroll sets out the 'state of the case regarding [his] sisters' as follows:

1 does not stammer.
2 stammer very slightly (of these one is such an invalid, you
 are not likely ever to see her).
2 stammer a moderate amount (of these one is married and
 lives in the north of England – you will never see *her*).
2 stammer rather badly.[1]

However, the difficulty of speaking fluently, without succumbing to what he referred to as his 'hesitation', the stammerer's anticipation of what might come out of his mouth wrongly, or indeed not at all, enabled Carroll to explore new imaginative realms. It did so, not only in the most obvious sense of affording opportunities for fictional scenarios, and singular characters notable for their manner of speaking, but by newly informing

the nature of his photographic practice and those ways in which he understood it as a peculiarly magical form of representation.

In *Critique et clinique*, Gilles Deleuze, writing about literature as linked with the problematic of Life, refers to those writers who use stuttering 'to stretch language along an abstract and infinitely varied line', who 'make [it] take flight ... send [language] racing to ceaselessly [place] it in a state of disequilibrium'.[2] Dante, Deleuze notes, was admired for having 'listened to stammers and studied speech impediments not only to derive speech effects from them but in order to undertake a vast phonetic, lexical and even syntactic creation'.[3] And, for Deleuze, Dante's interest in defective speech supports the phenomenon that Marcel Proust identifies, namely, that 'great books are written in a kind of foreign language'.[4] It is in a related sense that a stammerer such as Carroll might be thought to occupy the role of a foreigner in his own language. But critics have celebrated the spheres of Carroll's fictional nonsense in which the nature of the stammer is overtly played out, the dodo of Dodgson in *Alice* being the most famous example, while largely neglecting the relationship of Carroll's speech impediment to his photographic practice. Such neglect is probably owing to the fact that, while it might seem natural to trace a relation between irregularity of speech and literary language, it requires a different type of conceptual turn to draw a connection between a visual practice (photography) and a phenomenon of speech (stammering). Carroll enables such a connection by fixing upon the body of a child. However, any attempt to reconsider his stammer in these terms precisely exposes the hesitant nature of such new theoretical spaces between visual and verbal forms of representation.

Prevailing critical opinion regards Carroll's stammer as compatible with his sensitive nature, and as a reason, in addition to the theatre, for his decision not to take up the priesthood. References among critics to the speech impediment otherwise detail a familiar scenario in which, in the company of his child friends, Carroll speaks without faltering. There persists a view that, in the manner of a stage actor adopting a persona, Carroll enjoyed a reprieve from his stammer in the performative realm of photographing little girls. While this is a rather compelling notion, since at least one of his young models, May Barber, recalls the occasion of Carroll's stammering as 'rather terrifying', it cannot be accepted as definitive: 'it wasn't exactly a stammer, because there was no noise, he just opened his mouth. But there was a wait, a very nervous wait from everybody's point of

view: it was very curious.'[5] There is little doubt that in spite of his stammer and its accompanying bodily contortion – the open mouth that offers up nothing – as here described by Barber, Carroll felt very comfortable among children. Yet a belief that Carroll's 'hesitation' was cured in the company of little girls mythologizes the nature of that association, which in turn fuels a line of argument promoting his reluctance or inability to mature. Such a view thereby obstructs ways of thinking about Carroll's stammer in its relationship both to photography as a visual practice, and also to that delicate balance he so openly strove to maintain between the private and public, and the psychic and social aspects of his life.

In an emphatic and revealing sense, the speech impediment cuts across the distinct personae of Carroll's public and private selves. A letter of 5 January 1898 to Henry Littlejohn Masters Walters, curate of Aust, Gloucestershire, one of three letters Carroll wrote just days before his sudden death from pneumonia, shows him declining an invitation to read prayers in a church owing to his lifelong stammer. This letter provides an intimate focus upon the personal in an account of his speech impediment, his 'hesitation' that, he says, 'is always worse in *reading* (when I can *see* difficult words before they come) than in speaking'.[6] Carroll earnestly explains the lifelong pain he has experienced in such public display and the fear that, if he were to read prayers, his 'hesitation' would distract the members of the congregation 'from what ought to be the *only* subject on their minds'.[7]

It is a poignant letter not simply because, as readers, we possess a prospective knowledge of its author's impending death but because at the age of 65 Carroll is still having to account for the public discomfort caused by his own stammer. He communicates a profound sense of the effects of the physiological upon the psychological in his life as expressed in a fear of the visualization of 'difficult' words in the act of reading. Moreover, as Carroll's comment on the reading process discloses, the stammer involves a disruption of the flow of speech in a movement forwards and backwards in time.

On a more specific level, however, the letter dramatizes a distinction between words as linguistic signs to be read, as visualized primarily, and words as sounds separated at the level of utterance from their significative value. In so doing, the missive invites a shift of emphasis such that the question of whether Carroll's speech impediment left him when he

spoke with little girls is of less consequence than how, in larger terms, the stammering adult might be differently tied (or bound) by his speech to the child. Clearly, the child's relationship to speech is enabling for Carroll. From the point of view of a desire 'to put language into flight', to recall Deleuze's phrase, Carroll's fascination for linguistic games celebrates that way in which all children might be said to stammer with their frequent grammatical irregularities, their evocative pauses and haunting repetitions. Carroll empathizes with the invariably 'imperfect' hesitant speech of childhood in which there yet remains a distinction between pronouncing a sound and using that sound for speaking sense. For in that distinction new conceptual possibilities open up. Such possibilities occur most meaningfully for Carroll in the process of photographing a child. In that encounter he is not afraid to acknowledge his stammer and thereby, at a certain level, dissolve his difference from the child by speaking her imperfect language, as it were. Furthermore, the temporality of photography is analogous to that of the stammer in the sense of inviting temporal disruption in the simultaneous experience of past, present and future.

It might seem somewhat contradictory that the act of photographing rendered mute those 'child friends' that Carroll courted especially for their linguistic ingenuity; that, time and time again, the magic medium silences upon a photographic plate the little girl as speaking subject. Yet by that very sleight of hand, the photographic process thereby envelops the hesitancy or stammering of speech by representing, as still, as voiceless, the perfect body of a child who as a speaking subject can never be perfect. In other words, it renders the imperfect body whole. This is distinct from other forms of mechanical reproduction because of a photograph's unique assault on temporality, that disarmingly simple yet irrefutable quality of the medium that enables a subject to occupy simultaneously more than one temporal moment: Walter Benjamin's notion, that is, of the eloquent subsistence of the future in the past if only we had known where to look for it.[8]

For Carroll, there exists an analogous quality to the medium of photography as showing forth that which is to come but yet has already been. And in the photographic encounter not only does Carroll identify with children as wonderfully uninhibited speaking subjects, but he welcomes the translation of their surfeit of speech into the calm of the photographic image. In photographic portraits, Carroll is able to hold the child without

64 Lewis Carroll (C. L. Dodgson), *Gertrude Chataway*, 1876, albumen print.

the flaw of language (his own hesitancy), hence the tremendous power upon him of the sleeping child, of the child photographed as if sleeping.[9]

Rather in the manner of Ruskin's compulsion to commemorate Rose La Touche in replicas of Vittore Carpaccio's *Dream of St Ursula*, Carroll privileges visual replicas of children as conduits to longed-for associations. Those associations are not only with particular children but with an unattainable condition of infancy as a state prior to language, a condition of speechlessness.[10] Carroll made several photographs of girls posed as if asleep. His portrait of *Gertrude Chataway* (1876; illus. 64) shows the child posed on a sofa in his Christ Church studio. It is a distinctive image for the way in which the figure appears in a haunting space illuminated with ghostly effect. Carroll achieves an odd perspective such that a viewer appears to look through an interposed medium. Gertrude Chataway's vulnerability in sleep is augmented by the indeterminacy of the interior and she appears to float almost as if occupying the space of a dream. Here,

then, the sleeping child is perfectly true to type, in an etymological sense that is, of infancy, 'infantia', as speechlessness.

The nature of the photographic encounter, as it brings together the linguistic and visual (as Carroll stage-managed it), suggests a number of enabling ways in which to begin to articulate a relationship of photography, stammering and infancy, together with the means by which visual and verbal realms might come together in that conjunction. Carroll's photographic 'sittings' frequently involved theatricality and masquerade, tools and props welcome to a stammerer as aids to adopting a protective persona. Such role-playing also reinforces those links between photography and magic that Carroll played up. But role-playing further allows us to dwell upon a condition of empathy involved in the photographer's placing the child subject in a position of relative powerlessness, of identifying with that particular form of disempowerment that children experience in having their likenesses 'taken'.

Carroll reads such powerlessness through a linguistic relationship of the child to himself, the child, like the stammerer, as existing as a kind of foreigner in her own language. A projected linguistic tie to the child again recalls the powerful equivalence between a state of infancy and an absence of language. It is also a reminder that when a child begins to speak he or she does not simply translate a wordless state into one of words, that we must consider that which might be lost or might resist translation from that babbling stage into speech. For Adam Phillips, because 'young children are apprentice, often dilettante speakers, amateurs of the sentence', they are uniquely placed 'to teach us what it is like not to be able to speak properly; and by showing us this they remind us not only of our inarticulate and virtually inarticulate selves, but also of our internal relationship with those buried, vestigial versions of ourselves'.[11] Thus, most crucially, the child learning language can restore to us 'the border in ourselves where we struggle or delight to articulate against powerful external and internal resistances'.[12]

In *Consciousness and the Acquisition of Language*, Maurice Merleau-Ponty offers several ways in which to consider, for the child learning to speak, a distinction that arises between pronouncing a sound and using that sound for speaking sense.[13] In Merleau-Ponty's discussion of Roman Jakobson's approach to language, phonemes are preferred over words as elements by which to pose the problem of language acquisition. Unlike words that

refer to certain concepts, phonemes, Jakobson argues, since they do not hold meaning, allow one 'to surpass the distinction between sign and concept'. Accordingly, in a child's 'transition from babbling to the articulation of words', there occurs a reduction such that 'suddenly the richness of babbling disappears' and 'the child who previously differentiated perfectly his [k]s, all of a sudden loses the possibility of differentiating them, although he recognizes them very well when an adult speaks them'.[14]

Jakobson identifies a 'moment' as soon as the child begins to speak at which he stops being able to utter sounds, not because he cannot physically articulate them or hear them, 'but because he temporarily ceases to be able to pronounce them as significative utterances because they are not yet part of his significant phonemic system'.[15] Merleau-Ponty takes issue with the rigidity of Jakobson's model, arguing that babbling finds yet a residual outlet in a child's continued use, when learning to speak, of 'onomatopoeia and interjections' that are not placed under the rules of Jakobson's phonemic system. Merleau-Ponty writes:

> For example, a child does not yet know how to pronounce an [r] in the context of language, but he uses it without any trouble when imitating bird songs. He knows how to pronounce it as long as he doesn't have to use it for speaking. This can be compared to the re-education of stutterers. They are provided with situations in which they become accustomed to pronouncing the [r] by imitating the turning over of a motor, for example. After that, they are encouraged to integrate it into their language.[16]

In the context of his own difficulties in pronouncing individual letters in particular combinations, Carroll voices a distinction equivalent to that of the sound of an 'r' in, say, birdsong and the sound of the same letter in a word. For example, writing on 1 September 1873 to the speech therapist Rivers, whom he consulted during that period, Carroll explains:

> I should like to see whether you can give me any further help as to my difficulties with 'p' in such combinations as 'impossible', 'them patience', 'the power', 'spake', which combinations have lately beaten me when trying to read in the presence of others, in spite of my feeling quite cool, and trying my best to do it 'on rule'.[17]

On 19 December of the same year, Carroll requests Rivers's 'most valuable superintendence and instruction', claiming:

> Just now I am in a bad way for speaking, and a good deal discouraged. I actually so entirely broke down, twice lately, over a hard 'C', that I had to spell the word! Once was in a shop, which made it more annoying; however it is an annoyance one must make up one's mind to bear, I suppose, now and then – especially when, as now, I have been rather hard worked.[18]

Eight days later he writes again to Rivers with feedback on his previous advice:

> Thanks for advice about hard 'C', which I acknowledge as my vanquisher in single-hand combat, at present. As to working the jaw more, your advice is in my power generally: but as to the direction to 'keep the back of the tongue down', *in the moment of difficulty*, I fear you might almost as well advise me to stand on my head![19]

Such bad periods, as recounted in the letters and diaries, tend to be followed by good ones and vice versa, thus confirming, in the manner of Carroll's final letter to Walters, that he could never sustain confidence in a long-term solution to the problem. The following postscript to a letter to Rivers of 2 February 1874, in which Carroll explains the varying degrees of his sisters' stammers, impresses the profound effect upon him of a reprieve from his own: 'I have been speaking lately with almost no hesitation and with great comfort to myself – with the consciousness that the breath was flowing out in an unbroken stream – being *decidedly* better since my last visit with you.'[20] Two years later, on 22 January 1876, Carroll communicates the unrivalled joy he feels in being once again distinctively better than he had been a month or so previously: 'Twice I got through family prayers, including a chapter, without a *single* hitch – a thing that has not happened before, in my recollection, more than once perhaps in many years.'[21] He continues: 'Also I have more than once *expected* to stick fast and not done it – which is a new and delightful sensation to me. It generally happened to me by saying to myself, "Stick or not, at any rate the lip *shall* be kept in, and the breath *shall* flow out"'.[22]

In spite of such very specific references it remains difficult to trace in Carroll's writing a coherent narrative of his speech impediment. The artist Gertrude Thomson, who made drawings for him in the later part of his career, recalls that although Carroll 'deplored [his stammer] himself, it added a certain piquancy, especially if he was uttering any whimsicality'.[23] Yet mention of that condition so deplored by him is significantly intermittent in his correspondence. The stammer haunts the letters and diaries as a preoccupation sometimes transferred to related physiological concerns. What is certain, though, is that, prior to beginning treatment with Rivers in 1870, Carroll had been treated by the speech therapist James Hunt at his clinic at Ore House near Hastings. Carroll had family connections with Hastings since two of his aunts lived there and he was familiar with the town from visiting them. Hunt, better known as an anthropologist and founder of the Anthropological Society of London, published in 1854 his influential *Stammering and Stuttering, Their Nature and Treatment*, which went through seven editions before 1871.[24] It is a history of 'impeded utterance' from the ancients to the contemporary that asserts the popular nineteenth-century study of physiology as a key to the eradication of what Hunt calls 'any misuse of the organs of speech'.[25] That text, a source of therapy for Carroll, testifies to the extreme stigma attached to stammering, which, in the male in which it was more common, was linked with effeminacy, masturbation, indolence and vanity, to name but four 'vices'.

Classical authors commented widely on stammering. For Aristotle, stammering was caused when the tongue was not 'obedient to the will',[26] while Demosthenes, who suffered badly from the condition, practised speaking with pebbles in his mouth, anticipating later contraptions, such as Itard's early nineteenth-century fork-like instrument placed under the tongue.[27] At the time of the publication of Hunt's thesis, mutilation of the mouth and tongue was common practice in the attempted cure of stammering and he successfully argues the barbarity and ineffectiveness of these methods.[28] Perhaps the most significant factor about his position is that, in the manner of his father before him, Hunt refutes the notion that stammering is an organic disease; it is rather 'the loss of habit (always unconscious) of articulation'. The cure thus requires teaching 'the patient to speak consciously, as other men speak unconsciously'.[29] Hunt's therapeutic method required the repetition of exercises in speaking and in making the stammering subject hyperconscious of vocalization and

articulation, both of which, he writes, 'acquired in infancy, the mode and cause of their production is unknown even to many adults'.

In the manner of writing on insanity contemporary with his work, there is a strong element of moral management running through Hunt's book. He believes that 'discipline of the vocal and articulating organs, under an experienced instructor, is the only means of overcoming impediments of speech'.[30] The stammerer is characterized as physically weak, in children sometimes stunted, and as someone whose physical strength is invariably drained by his defective condition. He is also susceptible to quacks who, according to Hunt, travel 'from place to place, drum the stutterers together like the recruiting officers, see them perhaps once or twice, sell them some bottles [of gargle] for good payment . . . and then depart for other towns'.[31] It is owing to such widespread charlatanism, together with the profound loneliness and isolation of the stammerer, who 'desire[s] to attach himself to somebody he trusts',[32] that Hunt recommends a residential course of treatment at his practice in which the patient becomes part of a family and undergoes therapy in a group situation. In a section of his book on cruelty to children who stammer, for example, Hunt powerfully communicates as especially psychologically damaging to a child sufferer the invisible and chameleon nature of the condition: 'if he were blind he would not expect to see. But when he knows there is no deformity, that his organs are just as perfect as other people's, the very seeming causelessness of the malady makes it utterly intolerable.'[33]

Carroll felt considerable empathy with others who stammered. On several occasions he arranged appointments with Hunt, and later with Rivers, for his sisters. As early as 11 April 1860, writing to his sister Mary from Wellington Square, Hastings, the home of his aunts, Carroll notes: 'I like Dr Hunt's system very much, and think I am benefitted by it.'[34] The following spring, he was again receiving speech therapy, staying with Hunt at Ore House and using that address for correspondence.[35] As early as 1862 he can be found recommending his speech therapist to acquaintances. Moreover, he worked with some undergraduates at Oxford who shared the same condition. For example, on 29 October 1862, Carroll records: 'Young of B.N.C. (who is a pupil of Dr Hunt's) came in the evening for our first hour's reading together' and he pronounces himself 'fortunate in having found one with whom I can carry on the system' (IV, 141). Henry Savill Young, an undergraduate at Brasenose, was one of a number of students

65 Lewis Carroll (C. L. Dodgson), *The Tennysons and the Marshalls*, 1857.

with whom Carroll was able to practise Hunt's system of readings. Later, on 16 March 1874, he writes to Rivers enlisting his help in treating another undergraduate, Walter Rees from Christ Church, who, he claims, 'is a very bad stammerer'. On this occasion, since the prospective patient is from a large family and 'very poor', Carroll works as an intermediary and attempts to secure discounted terms for his treatment.[36]

However, I want to dwell on an early occasion in 1857, the year during which Carroll first began therapy with Hunt, and in which he took this remarkably haunting photograph. To do so is to bring together, by way of the photographic medium, those visual and verbal spaces I have been exploring. The photograph, entitled *The Tennysons and the Marshalls* (illus. 65), shows the poet Alfred Tennyson and his five-year-old son Hallam in the company of the Leeds industrialist James Marshall and his family at Monk Coniston Park, Ambleside.[37] It is an early image, taken a year after Carroll acquired his camera, and it represents a format that he will go

on to largely abandon, the group portrait that as we have found will be replaced with the portrait of a single child. Carroll abandoned it in part because he was most interested in a portion of the visual field depicted here, namely the infant Hallam Tennyson nestled in his father's lap. The photograph is one of several of the earliest photographs that Carroll took of Tennyson.

Compositionally, in terms of the arresting gaze of the poet, the image splits into two: the left-hand side occupied by Tennyson and his young son is much more striking than the right, which seems to be striving to mimic the traditional grouping of an eighteenth-century portrait. The left side is what Carroll will increasingly come to realize (and here it is already manifest in advance, very subtly, hidden almost), namely intimacy between a man and a child. Significantly, it is a male child here, rare in Carroll's photography that comprises several portraits of fathers and daughters. Christened 'Hallam' after his father's beloved Cambridge undergraduate Arthur Hallam, who had died suddenly in his early twenties and for whom Tennyson had composed the series of elegies that became *In Memoriam*, published seven years before in 1850, the child is cradled in the poet's arms. In the manner of all photographic subjects, Hallam Tennyson suggests the future in the imminence of his arrested development. But the child's photograph also functions as a memorial to a dead adult and, in so doing, demonstrates in a rather overdetermined way that which all photographs of children are capable of doing.

But while the process of naming a loved one after another can encapsulate such a movement, a photograph is able to perform that temporal shift in a way more arresting than naming alone can. The child Hallam, in the photographic present, is the future in addition to his signalling the past. It is as if the poet's son Hallam anticipates that which the older Hallam will become (but reciprocally that which he has already been), namely devoted to Tennyson as a friend. The child Hallam, who will himself be the close partner and biographer of his father, functions here as a kind of predictor of the future in the present. Such an investment in the photographed child involves a conception of the present as always confirming the past as prophetic. It is the issue of memory, released through naming here, that compounds the relationship of the photograph to temporality and allows us to muse upon the peculiar nature of prophecy of which Walter Benjamin has written so compellingly.[38]

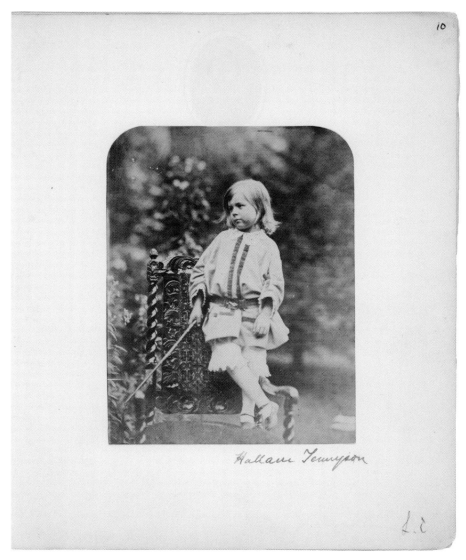

66 Lewis Carroll (C. L. Dodgson), *Hallam Tennyson*, 28 September 1857,
albumen print.

But there is a further subtle connection with stammering here. Carroll shows empathy with the Tennyson boys, Hallam (1852–1928; illus. 66) and Lionel (1854–84), after the event of the photographic sitting that produced this image. Indeed, we find out in letters of the 1870s that Carroll has remembered that the younger of Tennyson's sons, Lionel, stammers. It is most probable that Carroll discovered Lionel's stammer on the occasion of his visit to the Lake District when he took this photograph of him aged three (illus. 67) with his brother and the twelve-year-old Julia Marshall. It was a day that Carroll marked in his diary with one of his famous white stones. But, whatever the date at which he first realized the child's stammer, Carroll kept it in mind, writing from Christ Church on 19 June 1872 to recommend a speech therapist for Tennyson's son:

> If Lionel is, as I understand, still suffering, as I have done for most of my life, from that most annoying malady, I do most strongly advise that he should go over to Sheffield and hear Dr Lewin. One lecture will in all probability be all that he will need, and he can then complete the cure for himself.[39]

Tennyson writes back on 23 June declining Carroll's suggestion on the grounds that his son's stammer is much 'ameliorated' and 'will possibly pass or nearly pass away with advancing life'.[40] And although one detects more than a grain of irritation in Tennyson's reply, Carroll's memory of the boy's speech impediment not only indicates the extent to which the stammer affected his initial meeting with the child, but hints at that more fundamental connection between infancy and hesitancy.

In Carroll's empathy for a child who stammers, stammering provides a kind of perpetual, if unwelcome, connection for the adult to his own child self, the self as frightened, disempowered, vulnerable. More emphatically, such a connection to the child through imperfect speech (in which the speech impediment comes to stand in for the speech of childhood) suggests a way of preserving, halting that imperfect speech, that state of disequilibrium prior to its translation into sense.

The connection of the photograph to stammering further works in a way similar to naming. The photograph cannot speak the name of the absent loved one but it can otherwise commemorate that individual by triggering a temporal flight. By definition, the silent visual medium of photography

Miss Marshall with Hallam & Lionel Tennyson

L C., taken Sept 28th 1857

Julia Marshall, daughter of James Marshall, owner of Tent Lodge, Coniston

67 Lewis Carroll (C. L. Dodgson), *Hallam and Lionel Tennyson with Julia Marshall,*
28 September 1857, albumen print.

cannot figure forth a stammering subject but perhaps photography can come closer to doing so than any other visual medium. This is the case, not only through a temporal connection – the act of stammering occupying a temporal trajectory in the anticipation, the forward movement of that which will be said but reciprocally has already been uttered – but one of a sense of disempowerment I touched upon earlier.

A similar temporal dimension resonates in both photography and stammering. In the photograph (see illus. 66), the child Hallam Tennyson recalls his namesake long since dead, such that retrospection becomes simultaneously its opposite, a looking forward. The photograph also tells us of that 'equivalence' death in the future[41] by performing an odd aesthetic resurrection, in showing forth the child Hallam who has been to the future and back, so to speak, and whose death, yet to come, we viewers have already witnessed. In Carroll's anxiety about 'seeing difficult words' before he 'comes' to them, he is similarly projected, or takes flight, into a future that is simultaneously a past in which he has already stumbled over words. The act of stammering, like that of photographing, is then to anticipate, in the present, future hesitation as having already occurred.

6

7 Lushington Road, Eastbourne

Work is hard to keep up, by the sea, when it is all voluntary. I must try for
better habits (17 August 1882, VI, 461).

O RE HOUSE, WHERE LEWIS CARROLL attended speech therapy with
James Hunt, was one of a number of Victorian villas that once lined
the Ridge on the outskirts of Hastings. More recently known as
Hastings Cottage, and derelict for a number of years, it was demolished
in April 2010 in spite of local residents' attempts to save it. At Eastbourne,
however, 7 Lushington Road is very much intact and bears a blue plaque
marking Carroll's regular summer residence from July 1877 until 1896
(illus. 68). Built of blonde brick, the mid-Victorian semi looks out onto a
quiet tree-lined road conveniently located for the station. Carroll generally
occupied a bedroom and a first-floor sitting room[1] and, since the build-
ing was of a modest size, when guests came to stay he enjoyed the run of
virtually the whole house. By all accounts, Carroll felt at home in what he
referred to as his 'headquarters' during the 'long vacations' he spent there.
The landlady Caroline Dyer,[2] and her postman husband, Benjamin, held
the lease on the property until 1896 when they moved to 2 Bedford Well
Road. At that point, for the last two summers of his life, Carroll moved his
tenancy along with them.[3]

7 Lushington Road is now somewhat ironically a dental practice, ironic
because it has often been claimed that while in Eastbourne Carroll paid
unusually frequent visits to the dentist. The dentist in question, Jack H.
Whatford, had his practice at 6 Seaside Road and during 1881, for example,
Carroll made eight visits to Whatford's surgery, recording on 26 August 'he
is doing a quantity of stopping for me' (VII, 358–9). While critics may have
exaggerated his concern for his teeth, it is clear, though, that for Carroll
dental treatment attached to Eastbourne just as speech therapy belonged
to its neighbouring Hastings. Each town provided a therapeutic context

68 Plaque at 7 Lushington Road, Eastbourne.

discrete from Oxford life. At Eastbourne, Carroll dedicated a substantial portion of his day to mathematical writing and, in an attempt to make up for what he routinely felt a dereliction of clerical duty, he sometimes preached at Christ Church, the Victorian Gothic church at the eastern end of Seaside Road. As a break from academic and clerical work, however, the coastal town afforded a legitimate context for leisure pursuits (some of them trivial and childish) that Carroll cherished. He took pleasure in many forms of entertainment geared to the juvenile holidaymaker and increasingly part and parcel of the Victorian seaside holiday.[4] He also enjoyed spending time with children without experiencing the levels of guilt he felt when, during term, he escaped college for the theatre in London. Moreover, while young actresses were especially associated with Carroll's time in Eastbourne – he invited them to stay at his lodgings, sometimes procured openings for them and, on occasion, paid for their voice training – the girl child more generally populates Carroll's diaries and letters of the period.[5]

Carroll never took his camera to Eastbourne and the majority of his visits to the upmarket Sussex resort coincided with the period in which he was apparently no longer taking photographs. An entry in his diary for 15 July 1880 records what appear to have been the last photographs taken

with his own camera. However, contrary to popular opinion, Carroll did not suddenly 'give up' photography at that point. In fact, the last eighteen years of Carroll's life remained very much 'photographic' ones, although his relationship to the medium altered in significant ways. Up until 1897 Carroll continued to oversee photographs at professional studios both in Eastbourne and London. On occasion, he arranged to hire a camera to take models such as those the artist Gertrude Thomson arranged to sit for him. In addition, Carroll's correspondence for this period records receipt of *cartes de visite* from friends and associates and, during these years, he maintained his long-established habit of showing his photographs to visitors.

Yet while such practices testify to a continued practical and conceptual commitment to photography, critics have been more interested in trying to determine precisely why Carroll stopped taking photographs than in addressing those various other ways in which he invested in the photographic medium at this time. He may indeed have found it tricky at 48 to shift to a new process, and gossip had come to a head in 1880 with the notorious 'Atty' Owen incident when Carroll had kissed, as she left his college rooms, the seventeen-year-old daughter of his colleague Sidney Owen, believing her to be a minor.[6] However, such explanations do not amount to a rationale for Carroll's abandoning photography. In fact, there is every indication that he intended to continue photographing as evident in his comments, subsequent to 1880, on the merits of potential photographic subjects.[7] When, on 22 July 1880, his rooms at Mrs Dyer's became vacant, before taking the train to the seaside, Carroll simply packed up his photographic equipment to store in his studio as he had done the previous three summers.

During the last seventeen years of his life, in addition to albums displaying his prints, Carroll's archive of negatives remained essential in enabling him to order reprints from images he had taken between 1856 and 1880. Equally significant, though far from sufficiently acknowledged, is the extent to which during those years of not using his own camera, Carroll relied on the photography of others, both amateur and professional. Eastbourne was important in this regard. By the late 1870s the town could boast a wealth of photographic establishments and Carroll refers in his diary not only to his favourite, William Kent's, with studios in Gildridge Road and Terminus Road, but to other professional studios in the town.[8]

As well as continuing to acquire photographs in various ways at a remove from taking them himself, Carroll continued to enjoy sketching children and securing drawings and paintings of them from artists and collectors. Moreover, once he had resigned his Oxford Mathematical Lectureship at the end of 1881, Carroll was also in a position to indulge to the full his lifelong fascination for 'theatre' in its broadest terms. At Eastbourne he watched performances, not only at the Devonshire Park Theatre, but at venues as diverse as the skating rink and swimming pool. The beach, by comparison, with its wonderfully substantial bathing machines, occupied a 'theatrical' space of sorts, an interactive one in which Carroll felt free to strike up acquaintances with potential photographic subjects. In all of these contexts, the act of watching child 'performers' continued in complex ways to stand in for photographing them.[9]

Eastbourne figured 'photographically' for Carroll in multiple ways. Those summers he spent there highlight a shift of emphasis from Carroll as primarily a producer of photographs to his important role as a consumer of them. Moreover, since in the 1880s and '90s his pleasure in popular seaside entertainments connected with that he took in using professional photographers, I consider the significance of live performance to Carroll's continuing investment in photography. As photographs petrify their human subjects they also capture the promise of their re-vivification in a compelling correspondence between the stasis of the image and the animation of theatrical spectacle. While London boasted Lulu's acrobatics, inciting Carroll to enquire in 1871 about a camera able to capture children 'quickly', Eastbourne offered Louie Webb's and Laura Saigeman's swimming entertainments. Most recognizably Carroll's fascination for theatrical spectacle came into its own when, in 1886, he oversaw Henry Savile Clarke's *Alice in Wonderland: A Musical Dream Play, in Two Acts for Children and Others*, which opened at the Prince of Wales Theatre in December of that year.[10] In staging *Alice* not only did Carroll realize his long-held ambition to produce a play, but he made pictures move, releasing, as it were, the incipient energy caught in the still photograph.

Before choosing Eastbourne as his primary seaside location, Carroll visited the town with his friend Edward Sampson between 3 and 7 April 1877 to look at lodgings. Staying firstly at the Burlington Hotel and then at Grosvenor House, he spent the morning of the final day on the Promenade, concluding it to be 'certainly a good seaside place' (VII, 28). In

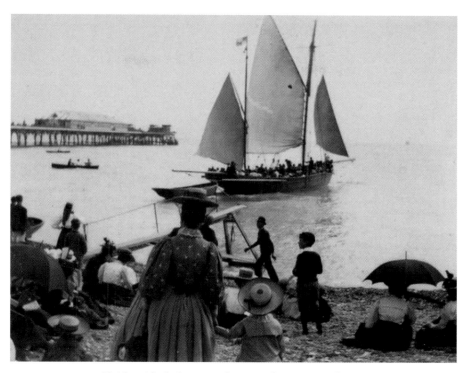

69 Unidentified photographer, *Eastbourne Beach*, 1891.

contrast to its neighbouring Seaford, which Carroll recorded as 'dull to the
last degree' (VII, 51), the new resort of Eastbourne held many attractions
that he would go on to appreciate over the consecutive summers he spent
there (illus. 69). From 1849 Eastbourne had been developed as a 'high class
resort' financed by the Duke of Devonshire and the town flourished with
the 'national building boom of the late 1870s and early 1880s'.[11] In add-
ition to a fine beach and good sea air, Eastbourne boasted a thoroughly
modern sewerage system; as fundamental proof of its genteel status the
resort had brand new, state-of-the-art drains. As William Abbotts Smith
and Charles Hayman had earlier indicated in their *Eastbourne, and the
Advantages which it Possesses for Invalids: With General Remarks upon
Sea-Bathing, Sea-Air, and Exercise* (1861), annual mortality rates in the
town, of thirteen per thousand of the population, compared with a rate of
34 in Manchester and 27 in London, made Eastbourne 'the most healthy
town in the kingdom'.[12] Aside from considerable investment in sanitation,
however, Eastbourne enjoyed the natural advantages of being built on a

substratum of sandstone preventing build-up of stagnant water. The town also boasted an inexhaustible supply of excellent drinking water from a 'celebrated well'.[13] Furthermore, unlike resorts such as Torquay that had suffered outbreaks of typhus, and largely free of the diphtheria that at times dogged nearby Brighton, Eastbourne's reputation for civic cleanliness appealed to Carroll's fear of infection. He also believed in the salubrious effects of Eastbourne's sea air upon a range of disorders including ague and bronchial conditions from which he suffered. The Devonshire Park Baths, filled directly from the sea, provided separate tepid bathing facilities for men and women. Although Carroll appears not to have taken up swimming or warm sea-water baths, he recommended to others the health benefits of both.

Like all nineteenth-century seaside towns Eastbourne had become a natural haunt of photographers but it also encouraged optical instruments for viewing, most obviously opera glasses, which were widely available in local shops in the town. Freed from the intended context of an auditorium, and ideal for bringing objects nearer, opera glasses were regularly trained upon the various states of undress encountered on the shoreline. Contemporary caricatures of the peeping Tom highlight the role of optical instruments in facilitating acts of voyeurism on the beach. While clichés about compromising viewing habits depended upon the visibility of usually hidden flesh, the nude bathing of earlier periods was no longer common in Britain. Yet, magnified by opera glasses, a heavy costume, once wet, did not necessarily ensure the coverage it promised in its dry state. At the seaside, children also benefited from relaxed rules regarding formal dress, casting aside gloves and other restrictive garments for fisherman's jerseys, knickerbockers and tunics. As a result, their bodies were also more visible.

THE PERSISTENT LENS

In Eastbourne, with an eye on subjects to photograph, Carroll acknowledged – sometimes to children themselves – the possibility of visual exploitation on the beach. Writing on his birthday, 27 January 1882, to the nine-year-old Edith Blakemore, expressing concern regarding her father's health and recommending the benefits of Eastbourne air, Carroll notes: 'Then sometimes I shall have the pleasure of seeing you, with my opera

glass, at the other end of the beach: and I shall be able to say "there's Edith: I can see *her*: but I shall go home again if she looks this way, for fear of her seeing *me*".[14]

Comically voicing to a child an encounter in which he is fearful, or shy, of being seen as he looks at her, here, as elsewhere in his letters, Carroll employs an optical instrument as a protective as well as an enabling device. He openly discloses a wish to 'look' at the child without himself being seen, thereby articulating his mediated view as one natural to a shy observer. At the same time, as Carroll outlines his 'pleasure of seeing' Edith Blakemore with his 'opera glass', he stresses protection rather than exploitation of the object brought close by the lens. As on other occasions, Carroll plays with the inequity of the power relation between adult and child by attributing to a minor the power of the look: he 'shall go home again' if the child spoils, by acknowledging it, *his* act of looking.

Photographs work analogously by highlighting physical transformation. Carroll's letter of 10 February 1882 to Florence Balfour ('Birdie'), for example, acknowledging receipt of a photograph of herself aged sixteen she had sent to him, expresses shock at how much she has changed:

> As are the feelings of an old lady who, after feeding her canary and going out for a walk, finds the cage entirely filled, on her return, with a live turkey – or of the old gentleman who, after chaining up a small terrier overnight, finds a hippopotamus raging around the kennel in the morning – such are my feelings when, trying to recall the memory of a small child who used to wade in the sea at Sandown, I meet with the astonishing photograph of the same microcosm suddenly expanded into a tall young person, whom I should be too shy to look at, even with a telescope which would no doubt be necessary to get any distinct idea of her smile, or at any rate, to satisfy oneself whether she has eyebrows or not![15]

Both microscope and telescope are complicit in the visual intrigue Carroll here creates. Like a microcosm revealed by a powerful magnifying lens, the mature 'child' of the photograph is 'astonishing' in her manifestly 'expanded dimensions'. At the same time, Carroll must employ a telescope not only to detect 'any distinct idea' of Florence Balfour's 'smile' but to identify, from a distance, her expanded form. The photograph of the mature 'Birdie' de-familiarizes the child of Carroll's memory and the comic similes

of a 'turkey' replacing a domestic bird and a hippo a small dog convey the visual shock of the photograph against calm reflection. But, he claims, the result upon him of such transformation is correspondingly to induce shyness or, to put it differently, a fear of looking.

There are a number of occasions in his letters when Carroll dwells upon the capacity of a photograph to make him stop short, to disrupt his capacity to think, by drawing attention to the process of memory itself. As I have indicated elsewhere, alarm at the physical growth and transformation of 'child friends' is a response he frequently explores in his letters and diaries.[16] At times, and this one included, that surprise is especially conveyed by the capacity of photographs to induce misrecognition. That challenge to memory highlights the larger place photography occupies in processes of recollection. But both of the above examples from his letters also form part of that larger ruse Carroll resorts to throughout his life. By openly acknowledging, in comic terms, its extremity, by stressing his shyness in 'look[ing] at' a grown up child, a young woman, he plays down his interest in looking at, and picturing, children photographically. Such questions as to the propriety of looking at women and minors are thrown into bold relief at the beach – a treasure trove for artists and photographers – that turns acts of looking, and attempting to cover them up, into new arts.

∾ THE BATHING MACHINE ∾

The introduction of bathing machines at seaside resorts represented in part an attempt to temper voyeurism at the beach.[17] As a contemporary contraption synonymous with the seaside the bathing machine appealed to Carroll's imagination. Not only did it present a quirky and picturesque structure, it also facilitated the quick-change and, in so doing, betokened a type of theatrical metamorphosis. A fully dressed person entered one end of a box on wheels and, as if by magic, emerged from the other transformed into bathing attire to descend directly into the sea. In the period, dress for bathing took many forms, ranging from the scanty to the quite elaborate, and the 'machine' provided a place in which to change discreetly. As the haunt of the quick-change artist, a bathing machine invited fantasies of physical transformation. As a solid structure implanted on the shoreline, it also bore an uncanny resemblance to a giant camera. Rather

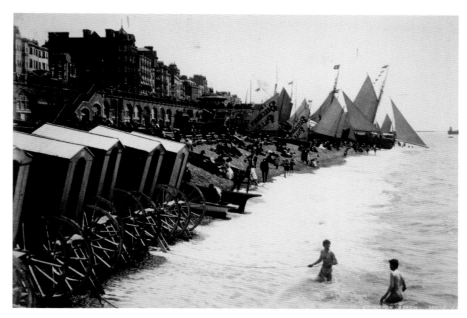

70 Unidentified photographer, *Brighton Beach,
Both Sides of West Street, with Bathing Machines.*

like a camera, though by different means, a bathing machine turned out people differently.

The very name 'bathing machine' also lent to the portable changing room a technological dimension. Yet its claim to mechanize bathing amounted to little more than the rather basic attribute of wheels that allowed a horse to pull the contraption up and down the beach (illus. 70). Not surprisingly, *Punch* had a field day mocking the many varieties of odd-looking bathing machines, including the more sophisticated varieties that came to replace those drawn by horses. In 1888 William Fagg of Folkestone patented a device mounted on a railway gauge of 3–4 metres running down to the sea. Fagg's contraption, 'raised and lowered by a cable attached to a stationary steam engine', had 'two carriages each containing nine dressing rooms'. By all accounts the carriages were luxurious. In addition to a lavatory they were equipped with 'looking-glasses, clothes pegs, hat racks, wash basins and even showers'.[18]

At Eastbourne, meanwhile, Hounsom's bathing machines (illus. 71) operated on the beach during those summers Carroll was resident. Tens of specimens of the machine with their characteristic striped paint are

71 Hounsom's bathing machine, Eastbourne.

visible in contemporary photographs. In this anonymous amateur photograph (illus. 72), for example, machines crowd the beach leaving little room for bathers themselves. They were a draw for children: on one occasion at Sandown on the Isle of Wight Carroll rescued a child from punishment after she had broken the windows of a bathing machine in protest at the owner's cruelty to his horse. At the beginning of his first summer in Eastbourne, by comparison, Carroll used a bathing machine to shelter a woman who had suffered a seizure on the beach (VII, 55).

By the 1880s, in some quarters bathing machines had become much less salubrious. For many they were prominent eyesores, as evident in a scathing 1885 article by a 'A Lady Bather' in the *Pall Mall Gazette*.[19] Claiming they have been forgotten by modern civilization, a 'standing reproach to Darwinian theory – the "survival of the *un*fittest"' – the author deplores the sight of rows of white or green 'ramshackle, springless cupboards on wheels':

> Suppose you get up the rickety steps without breaking your shins, you
> find yourself on a slippery inclined plane, messy and soaking from alien
> feet; a sudden tug hurls you on to a sort of sinking knifeboard – your only

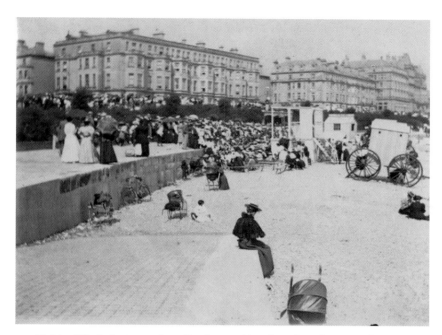

72 Unidentified photographer, *Eastbourne Beach with Bathing Machines*, 1891.

seat – and you hold on there, unless jolted off, till a wave splashing under the door and drenching your stockings, sets your boots swimming, and warns you to prepare quickly for the delights of the bath.[20]

In practice, as this witty piece confirms, though shielding bathers from the sun and prying eyes, bathing machines did little to aid swimming. Many who used them strayed no further than those ropes attached to them aiding entry to the water.

Yet in the absence of such vilified facilities, equally subject to ridicule was the prospect of changing on the beach. An illustration that appeared in *The Graphic* in September of the same year plays upon the odd appearance to the casual stroller of the makeshift changing tent (illus. 73).[21] With the helpfully unequivocal title 'The British Bather: How to Bathe in a Resort where there are no Bathing Machines', the series of images shows a bearded 'professor' prodding with his umbrella an odd-looking draped object on the sand. His bemusement at finding the 'weird, shapeless object' to be a young woman in the process of changing for a swim highlights the extent to which the lack of a purpose-built changing

73 W. Ralston, 'The British Bather: How to bathe in a Resort where there are no Bathing Machines', from *The Graphic*, September 1885.

Professor Anthony, while taking a stroll during his vacation, is struck by a weird, shapeless object on the beach

Still puzzled, he prods it with his umbrella, in the hope of determining its character

DRAWN BY W. RALSTON

The Puzzled PROFESSOR

His naturalist's instincts are aroused, and he inspects it closely

Tableau! It wakes into life in a manner most bewildering and discomfiting to the curious Professor

FROM SKETCHES BY E. BEANE

cubicle caused its own, very different, problems from those voiced in the *Pall Mall Gazette.*

But while the beach provided for a variety of aspiring bathers, Eastbourne, like other resorts, also boasted choreographed swimming extravaganzas for its visitors. These combined athleticism with scanty costumes. On 2 September 1885 Carroll entrusts the following to his diary: 'Went to Miss L. Saigeman's swimming entertainment, a very pretty performance. This is the first year gentlemen have been admitted' (VIII, 235). Fully aware that the spectacle was not formerly open to men, Carroll is happy to have experienced it. He records another visit on 24 August of the following summer to see Miss Saigeman and some of her pupils perform (VIII, 289). On 7 October 1887 the actress Isa Bowman accompanied him to a performance by Saigeman (VIII, 367).

Laura Saigeman, the resident swimming instructor at Eastbourne's Devonshire Park Baths, was also one of a number of late nineteenth-century female natationists, or 'naiads', gaining a name for themselves in competitive swimming as well as performing in such 'entertainments'. Along with Agnes and Elizabeth Beckwith (who performed in a family group created by their father), the Wallenda sisters (who performed at the Alhambra in 1898) and 'Lurline', renowned for her exploits in a crystal aquarium at the Oxford Music Hall and whom Carroll saw at the Brighton Aquarium, Saigeman was admired both for her artistry and her physical appearance. As David Day has pointed out, female swimmers of the period taught swimming and lifesaving to secure a regular income, but they supplemented it by performing in tanks 'diving, and holding their breath underwater' and taking part in endurance events and competitions.[22]

The *American Gentleman's Newspaper* reprinted two accounts of a mile race at the Devonshire Baths, Eastbourne, on 31 October 1883 for £200 prize money, between 'Miss Laura Saigeman (Eastbourne) and Miss Teresa Johnson (Leeds)'.[23] The first, 'a gossipy account of the race from the London *Ashore and Afloat*' coverage, focuses on the swimmers' physical appearance:

> they cast off their outer garments, when the human form divine, very much so, stood out in bold relief, and a close observer must have been struck with the fine physique of the young competitors. There was little to choose in this respect; both would, no doubt, be accepted as models for an artist; and, as the visitors were chiefly ladies, of a rather ordinary

type, too, the swimmers' scantiness of attire – a slight modification of Eve's before the fall – was of little consequence. The young lady from the Yorkshire town wore a tight fitting 'combination' garment of the most abbreviated dimensions, while Miss Saigeman was lightly clad in similar costume of blue, which set off her points to the greatest advantage. It is quite evident to my mind that all ladies who desire good figures should learn to swim.[24]

As evident in this case, such female competitions gave their audience, as well as male reporters, opportunities to dwell upon the revealing nature of the swimmers' costumes displaying 'a slight modification of Eve's [attire] before the fall'. By the late 1880s, the time that Carroll saw the Beckwiths, they had allegedly been 'refined into an amusing and instructive swimming entertainment'. *The Graphic* records Agnes Beckwith displaying 'a line of beauty and the poetry of motion in such a graceful manner as to call forth repeated applause from the large company'. Her finale included the flourish of catching a bouquet, before promptly 'inhal[ing]' it and placing it 'in the sanctity of her somewhat décolleté costume.'

Pictured in this contemporary *carte de visite* (illus. 74), Agnes Beckwith emerges from the waves of a studio backdrop in tights and shoes with flowers, on this occasion, tucked into her satin costume at the hip. Presenting as physically strong, this contemporary Venus, regularly known as 'the Lambeth Naiad',[25] appears before distant boats substituting for the usual mythological shell. Agnes Beckwith carries her body confidently and, transposing her from a pool to the sea, the studio portrait portrays swimming as a natural occupation for a female subject. Emerging as she does, however, with one of her leather slippers obscured by the tufts of a rug that serves as a breaking wave, the effect is bizarre yet oddly harmonious. In addition to her open-water racing, Agnes Beckwith was celebrated for performing underwater in a plate-glass tank. There, in an elegantly decorated sub-aquatic environment, she transformed commonplace actions such as drinking milk and writing on a slate into spectacular gestures. Displaying her various feats with 'certainty and ease', the attraction of Beckwith's show lay also in the power of the fabricated scene to evoke 'the haunt of Undine or some equally historic water nymph'.[26]

In 1888, when the actress Isa Bowman visited him at Eastbourne, Carroll took her to Hastings to see the Beckwiths' 'excellent swimming-performance',

74 Unidentified photographer, *Agnes Beckwith*, 1880s, albumen *carte de visite*.

75 Unidentified photographer, *The West Pier*, Brighton, 1875, albumen print.

while on 29 August 1892 he took his niece Violet Dodgson to Hastings to see them. In August 1897 Carroll travelled by steamer from Eastbourne to Hastings specifically to take Edith Rix to see the Beckwiths perform. These were not the only swimming extravaganzas Carroll enjoyed: earlier, on 13 July 1887 en route to a dinner engagement with Henry Barclay and his wife, Lucinda, at Sussex Square, Brighton, he stopped off at the West Pier to see in one of the kiosks a performance by 'Miss Louey [*sic*] Webb, with Professor Reddish (a professor of swimming) lecturing':

> She performs in a tank, like those in the Aquarium, with the light behind (i.e. glass front and back), and the water just deep enough for her to stand with her head out. She did some sewing, writing on a slate, etc. under water: sometimes being under nearly a minute ... Miss Webb is 18, and, as she is beautifully formed, the exhibition is worth seeing if only as a picture (VIII, 347–8).

Carroll clearly enjoyed the magical, Houdini-like trickery of Louie Webb,[27] but, in claiming the event was 'worth seeing if only as a picture', he points to the strong pictorial qualities of the animated semi-subterranean scene. While it was not surprising to find such a preponderance of swimming entertainments at resorts such as Brighton and Eastbourne, Carroll is

76 W. H. Mason (?), *The Aquarium, Conservatory and Cascade*, Brighton, 1872 (?), albumen print.

77 Programme, Brighton Aquarium, week commencing 14 September 1885.

drawn to them – he saw this one four times within a short period in 1887 – not only for the beauty of the performers' bodies but for their physical virtuosity, and by a desire to record it. In addition to the West Pier (illus. 75), when in Brighton Carroll liked to visit the Aquarium, which held the world's finest collection of living marine specimens. It had opened in 1872 and, 'being distinguished among similar buildings in Europe by its size and importance,'[28] it drew many visitors. This photograph of the conservatory and cascade (illus. 76) shows the extent to which the building functioned as a concert hall decorated with plaster casts. In addition to 'the specimens of the tanks' that Carroll regularly enjoyed, he attended concerts, magic shows and, as this programme confirms (illus. 77), 'the Pedestal Lady'.

❧ Photographing on the Beach ❧

On 18 September 1877, during his first summer at Eastbourne, the beach provided Carroll with an unexpected photographic opportunity since he joined the Hull family precisely at the point at which they were being photographed, recording in his diary: 'I got one of Agnes done for me' (VII, 72). Given his status as a respected amateur photographer, Carroll's request appears not to have been considered odd by the family concerned. But the incident also highlights the relative novelty of having such photographs taken. Prior to the 1870s there was no regulation of photographers working the beach but by the last decades of the century, in the manner of hawkers of goods, photographers taking portraits had to apply for licences. At the time of Carroll's meeting with the Hulls there were five registered photographers providing services on the beach at Eastbourne. They each had allotted 'stands' along different parts of the seafront. Albert Owen had his stand near the pier; George Austen (Austin) near the Wish Tower; J. A. Waylett opposite Hartington Place; Charles Cain opposite Marine Parade; and John Heard opposite Royal Parade.

'Tintypes' or 'ferrotypes' – collodion positives on thin sheets of iron – were the most common form of beach photography. The tintype, developed from the ambrotype by Hamilton Smith of Ohio in 1856, was a relatively quick and simple process resulting in affordable images of portable size.[29] Introduced into the United Kingdom in the early 1870s, tintypes were, to begin with, very small, measuring about 15mm across for the 'Gem' and 35mm across for the 'Victoria'. Like an ambrotype, the tintype process relied upon the fact that a collodion negative appeared as a positive when viewed as a dark surface; the plates were thereby coated with black varnish. The tintype camera held a stack of sensitized tin plates raised in turn by a mechanical device as each photograph was taken. The exposed plate was then dropped through a slot in the base of the camera to a tank containing chemicals to develop and fix the photograph. While the image would normally appear reversed left to right, some cameras had mirrors to correct the lateral inversion of the tintype. A client received a docket to be redeemed at a later time, but the swift photographic process meant 'while you wait' services were also available for day-trippers.

In addition to obtaining images such as a tintype of Agnes Hull from a beach photographer, in the early 1880s Carroll was acquiring photographs

from less predictable Eastbourne sources, as is evident, for example, in the second paragraph of his diary entry for 6 August 1881: 'In the afternoon I went to the [Devonshire] Park. It was the last bicycle performance, and afterwards met the charming little "Henri" in the Park, who gave up his tour of selling photos and remained with me for some time (VII, 355). 'The charming "little Henri"' as Carroll calls him, and siblings, belonged to a troupe of French bicyclists to whom he refers by the unlikely name of 'French'. Carroll watched the children perform and subsequently bought photographs from them. His diary entry for the previous day (5 August) confirms that on that occasion, also at Devonshire Park, he had purchased photographs from the same child performer: 'saw the French's again, and bought more photos from "Henri", and one from "Marie"' (VII, 354). Yet, as his diary further discloses, Carroll had already purchased photographs of the children the previous day (4 August) after watching their performance for the first time. Freely available *cartes* had become the customary offshoot merchandise of a host of such seaside shows and Carroll bought them avidly, just as he had bought photographs as a tourist in Russia fourteen years earlier.

☙ OTHER PEOPLE'S PHOTOGRAPHS ❧

From his first summers in Eastbourne Carroll adopted the habit of recording as they developed his relationships with children. On 2 August 1877, for example, two days after first moving into 7 Lushington Road, he wrote in his diary: 'It is time to record the various beginnings (or pseudo-beginnings) of child friendships here' (VII, 52). Appearing to resume an ongoing dialogue with himself, he differentiates between 'beginnings' and 'pseudo-beginnings' only to conclude that counterfeit beginnings of friendships are nonetheless as worth recording as their counterparts. Certainly, since by the time he records them such 'beginnings' may already have proved to be 'pseudo', they appear to merit retrospective record precisely for the promise they originally suggested. Or else Carroll records such meetings in the hope a friendship may yet develop at a future date when he has all but forgotten the child in question. Equally, though, his distinction between starts and false starts raises a question of what for Carroll a 'real' beginning of a 'friendship' with a child might look like. There are years

following this one of 1877 when, on arriving in Eastbourne for the summer, he commits to his diary feelings of loneliness. For one reason and another few of the regular seasonal visitors he has befriended are present and he finds himself alone for long periods of time without much hope of striking up new accquaintances.[30] On other occasions, Carroll cannot believe his luck, such are the hordes of 'respectable' families holidaying at the beach.

From 1877 Carroll adopted his annual habit of listing children associated with the summer season at the Sussex resort: 'my child friends this year at Eastbourne have been'. Thus, for example, on 14 October 1880, the list appears as follows:

Ida, Elise, and Stella Balthasar
Mary Hawtrey
Maggie, Beatrice and Charlie Hare
Maggie Spearman
Annie and Agnes Macwilliams
Nellie, Katie, and Phyllis Godby
Lily Alice Godfrey
Helen Cowie
Fanny Wood (VII, 305).

While usefully preventing his confusing the Marys or Fannys of Eastbourne with those of Oxford, Carroll's list also reassuringly confirms that the seaside will continue to generate a regular supply of children. In turn, in a vital sense, such a record doubles as a wish list for photographs of those children named.

During his annual vacations in Eastbourne, Carroll's experience as a photographer allowed him to take, apparently without question, the children of friends and acquaintances to be photographed professionally. Prior to the 1880s Carroll had employed the services of photographic studios to print his negatives, but such professional work had then supplemented his own regular production of photographs. Once he was no longer taking photographs in his studio at Christ Church, however, Carroll incorporated into his summers professional photographic sittings for some of those children he befriended. In significant ways such visits to Eastbourne studios directly qualify a prevailing belief that photography became less important to him in the 1880s and '90s. The photographer he used most

frequently was William Hardy Kent (1819–1907), who had studios in Gildredge Road and Terminus Road. Having trained in the United States and run a successful studio in New York, and three in London (the first London studio opening in 1854), Kent opened his studio in Eastbourne in 1878. A highly experienced photographer, he 'had an intimate knowledge of the improvements successively introduced into photography' and in Eastbourne he had a separate studio for photographing children.[31]

During the summer of 1882 Carroll records in his diary a number of visits to Kent's to get various children photographed. On 25 July Carroll 'took Marion [Richards] and had her photographed at Kent's' (VII, 455). On 1 August, he notes, 'Mrs. Miller's sister brought May and Edith to see me and left them for me to get them photographed at Kent's'. While on 19 August, Carroll records taking 'Evie and Jessie [Hull] to Kent's, and had two photos done of each' (VII, 461), his diary entry for 4 September reads: 'Spent most of the morning on beach. Got Winnie Howes photographed – alone and with "Bibs"' (VII, 468). Four days later, on 8 September, Carroll's entry reads: 'Brought Jessie in, in morning. Took Alice [Amyatt] to Mr. Kent's at 2, and had two photos done: then Winnie Howes ditto in bathing-dress' (VII, 469–70). While, taken as a whole, these entries convey the frequency during 1882 of Carroll's visits to Kent's, the reference to 'bathing-dress', which almost slips by unnoticed, signals his wish to capture in photographs the seaside context.

In addition, though, the fact that Carroll transferred to William Kent, in particular, his agency in operating a camera begs a variety of questions. To what extent did Carroll retain control of the set-up and staging of images? Did he intervene in the production of photographic prints? Benefiting regularly from his services, what technical and aesthetic discussions did Carroll share with Kent? While Carroll's letters indicate his active role in matters of photographic costume, he allegedly favoured Kent in part because the photographer preferred not to touch up his prints.[32] It is worth dwelling upon such a preference. For, although by this time processes of correcting, or enhancing, photographs were quite sophisticated, in his own darkroom practices Carroll had rarely resorted to manual intervention. Generally speaking, he liked to allow physics and chemistry to work their magic unmolested. In privileging Kent's reluctance to touch up his work, therefore, Carroll implicitly welcomed photography's uninterrupted indexical connection to a sitter.

W. KENT 45, GILDREDGE ROAD,
AND 86, TERMINUS ROAD EASTBOURNE.

78 William Hardy Kent, *Edith Miller*,
1882, albumen *carte de visite*.

It is rare to find surviving examples of those photographs Carroll had made at Kent's. Yet those that exist testify to the high technical quality he associated with the studio. *Cartes de visite* of the children Edith Mary (1870–1929) and Marion 'May' Louisa Miller (1868–1946), now in the Rosenbach Collection, Philadelphia, also indicate the importance to Carroll during this period of preserving photographically those children he met at Eastbourne.[33] The *cartes*, of regular four by two inch dimensions, bear the imprint: 'W. Kent, 45, Gildredge Road and 86, Terminus Road Eastbourne'. In addition to the child's name, Carroll's inscription in violet ink on the reverse of each of them reads: 'rec.d Dec. 7/82'. Although it is difficult to date the images exactly, they may well originate from the aforementioned sitting of 1 August 1882.

The photograph of Edith Miller (illus. 78) captures her penetrating expression directed into the camera. As a result of vignetting that shades the

79 William Hardy Kent, *Louisa ('May') Miller*,
1882, albumen *carte de visite*.

margins of the picture, the lace collar she wears emerges prominently in the midst of a gradual fading of the subject. In its formal arrangement the photograph of her sister May (illus. 79) achieves a similar effect. Featuring an equally conspicuous filigree collar which emphasizes the child's facial features, the image arrests the twist of her body turned to semi-profile. The elder by two years, May Miller comports herself more confidently than her sister. Taken as a pair, however, the studio portraits stress sibling resemblance through the shared seriousness of the children's expressions. Photographic monochrome, exquisitely reproducing the relative tones of eye colour, confirms Edith's eyes as almost black, May's a light shade of blue or grey.

The time lag between the date of Carroll's receiving these prints and the original sitting at Kent's in August 1882 may well be explained by his letter to the girls' mother dated 15 August of that year in which he elaborates on the resulting prints, indicating his plan to order a further vignette:

W. KENT, 45, GILDREDGE ROAD,
AND 86, TERMINUS ROAD, EASTBOURNE.

80 William Hardy Kent, *Seaside*, 1882, albumen *carte de visite*.

I enclose for your acceptance copies of the 2 photographs. May seems to have come out well in both – Edith in neither. It would have perhaps been wiser to do them separately. I am having a vignette carte done of May (½ length) in the seaside one – this I will also send you.

As each child may like to give her dearest friend a group, I will send one for each – if each will say which one she prefers. (VII, 457)

It is apparent in this letter to Mrs Miller concerning the photographs, in which Carroll considers May 'to have come out well' and Edith not so, that the extant vignetted half-length images (Rosenbach) may have originated from a double portrait taken at the same sitting. Yet, in addition, Carroll's mention of 'the seaside' photograph refers to props or trappings not visible in the extant photographs in the Rosenbach. Having initially tried to conjure in my mind the photograph to which Carroll refers I have since located it. The 'seaside' photograph (illus. 80) is far from its companion images from that sitting, in the L. Tom Perry Special Collections at Brigham Young University, Utah.[34] Inscribed on the reverse in Carroll's handwriting: 'May and Edith Miller Aug./82' (illus. 81), the print shows the sisters against a painted backdrop of waves gently breaking on the shore.

81 William Hardy Kent, studio stamp with Carroll's inscription on reverse, 1 August 1882.

"Pretty little legs
 Paddling in the waters,
Knees, as smooth as eggs,
 Belonging to my daughters."

82 Lewis Carroll (C. L. Dodgson), *Honor, Evelyn and Olive Brooke,*
Going-a-shrimping, 13 July 1875, albumen print.

With their dresses pinned up for wading, their white knickerbockers visible, the girls pose bare legged and bare-footed in the fabricated shallows of a sandy beach. May stands on the left of the print and Edith sits in a leisurely attitude upon a barrel. Both look off-frame to their right in a striking portrait of sororal intimacy in which May rests her left arm lovingly upon her sister's shoulder.

The informality of Kent's fabricated seashore setting is in keeping with photographs Carroll had earlier attempted himself. In the album he presented to Henry Holiday, discussed in chapter Four, an image of Honor, Evelyn and Olive Brooke entitled *Going-a-shrimping* (illus. 82) depicts the sisters posed bare-legged accompanied by the following short rhyme:

Pretty little legs
Paddling in the waters,
Knees, as smooth as eggs,
Belonging to my daughters.

Distinct from Kent's painted backdrop of the sea, however, Carroll's plain backcloth makes no pretence at illusionism. Having set up his camera on location in Hampstead, it would have been difficult for Carroll to convey a sophisticated studio interior. Nonetheless, leaving the setting aside, Carroll fails to achieve the relaxed look in the faces of his sitters that Kent conveys in his photograph of the Miller children. Though the speaker of Carroll's *Going-a-shrimping* identifies the 'pretty little legs' and 'smooth' knees of his 'daughters', as the children look awkwardly into the camera they fail to perform that filial connection to the photographer expressed in the verse.

A photograph by Carroll taken two years earlier, however, *Xie Kitchin, 12 June 1873* (illus. 83), more closely anticipates the scene captured for him with greater technical sophistication by Kent. Inscribed on the verso with the phrase 'By The Sad Sea Wave', the photograph alludes to the ballad 'By the Sad Sea Waves' from the opera *The Brides of Venice* (1843) by Julius Benedict and J. L. Lambert, popularized in the 1850s by Jenny Lind.[35] The nine-year-old Xie Kitchin stands, her hair falling freely over her shoulders, with right arm crooked to present at an inclined angle the wooden spade she holds. Carroll captures the child, her dress hitched up for paddling, from a viewpoint that elongates her bare legs and feet, which, like her clothing, are bleached out by the summer light entering his studio. Xie

83 Lewis Carroll (C. L. Dodgson), *Xie Kitchin, 'By the Sad Sea Wave'*, 12 June 1873, albumen print.

Kitchin's serious expression is in keeping with the loss conveyed in the nostalgic sentiment of the song:

> By the sad sea waves, I listen while they moan
> A lament o'er graves of hope and pleasure gone.
> I am young, I was fair
> I had once not a care
> From the rising of the morn' to the setting of the sun.
> Yet I pine like a slave by the sad sea wave
> Come again, bright days of hope and pleasure gone!

Apart from the props of bucket and spade, however, the photograph lacks a simulated seaside setting: the pattern of Carroll's studio carpet and deep skirting board anchor the photograph unmistakably to its Christ Church context.

By comparison, the later 'sea-side' photograph, as Carroll refers to it in his letter to Mrs Miller, is especially important to my discussion, not only for what it discloses about Kent's studio and the nature of the scene staged, but owing to its migration far from its place of origin. In general terms, this latter point flags up the characteristic ways in which photographs, slim and light, travel easily and discreetly without much fuss. But in a more specific sense, the existence of this particular print from Kent's, otherwise only alluded to in Carroll's letter, also highlights the enduring importance to him of staging studio photographs of children. In addition, the disjunction between the original home of a treasured photographic memento, kept by Carroll in an album alongside others, and its subsequently orphaned state, points up the close relationship that existed for him between those photographs he took himself and those many others acquired from various sources that he owned.

In addition to the individual *cartes* and the 'seaside' group photograph of the Miller sisters, there exist in the Rosenbach Collection individual portraits of them in two oval frames hinged and covered in bright blue velvet (illus. 84). These small photographs give an immediate sense of having been cropped from a larger group photograph. And, in fact, the children wear the same dresses, identifiable by the protruding collars of their undershirts, as in Kent's 'seaside' photograph. While the print of Edith has not been inserted upright into the frame so that she appears tipped

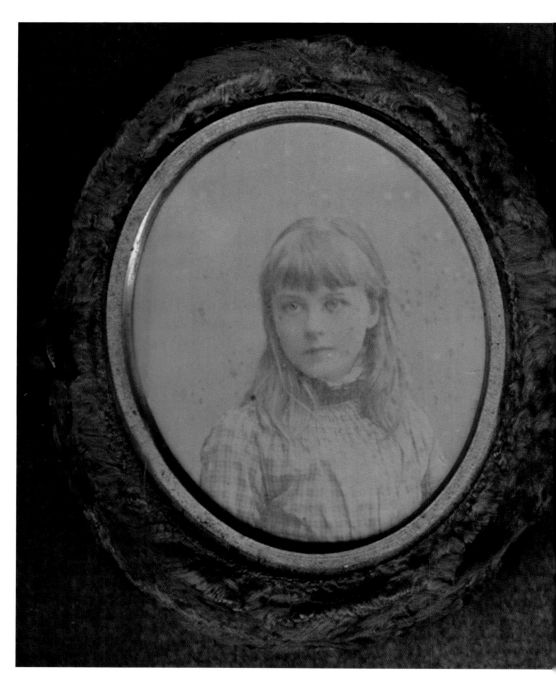

84 William Hardy Kent, *May and Edith Miller*, in oval hinged frames covered in blue velvet, 1882, albumen prints from larger double portrait (illus. 80).

to one side, May maintains her upright pose from the double portrait. However, on closer inspection, as if taking its cue from a spirit photograph, a haunting appendage has fixed itself in the portrait of Edith. The remnant of a ghostly arm – the aforementioned arm of May – confirms in no uncertain terms that these individually framed portraits are fragments of the 'sea-side' group (see illus. 80). It is unclear who cut and arranged the cameo portraits in the clasped frame. Nevertheless, when all of these surviving photographs of the Miller children superintended by Carroll in Eastbourne (but now in Philadelphia and Utah) are here reunited, they demonstrate just how much remains to be known about Carroll's similar studio acquisitions. Straying far from home, such photographs are split up from others taken at the same studio and, in this case, at the same sitting. Yet, reunited, so to speak, these particular *cartes* highlight the relationship of the event of a photographic sitting to its material outcomes. This is not simply a general point about the recent splitting up of nineteenth-century photographs as they become increasingly valuable to collectors, but also a reminder that during those years when Carroll was no longer 'taking' them, he continued to send photographs to friends and acquaintances, and to receive them. Indeed, photographs flew far and wide enclosed with letters to child and adult recipients alike.

On 20 March 2014 the *Brighton Argus* reported the sale the previous day of 'Lewis Carroll's Eastbourne holiday snap'.[36] The report was wrong on two counts. It was not a photograph by Carroll. Nor was it an authentic beach scene at Eastbourne. Instead, the *carte de visite* that fetched £5,250 at Bonhams, previously in Carroll's possession, shows the interior of Kent's studio recognizable from his 'seaside backdrop'. Inscribed on the back in Carroll's hand, 'For Miss Symonds, from C. L. Dodgson, "a memento of the beach at Eastbourne in the summer of 1883"', the *carte* shows a girl posed in the same fabricated waves with bucket and spade (illus. 85). Her identity is uncertain but she may be nine-year-old Eleanor Winifred ('Winnie') Howes, whom Carroll had had photographed on 4 and 8 September in 1882, on the latter date in bathing-dress. There is also a possibility she is eleven-year-old Clare Turton, known as 'Bibs', photographed at Kent's on 4 September 1882; or, indeed, Jessie Hull, who was eleven in 1882 and also taken by Carroll to be photographed at Kent's. However, since the inscription refers to 1883, and Carroll was thorough in dating professional *cartes* according to the time they were taken or received, it is equally possible this

photograph derives from a sitting at Kent's that remains undocumented in his diary.[37]

Regardless of the child's identity, however, her quizzical look, along with the compositional arrangement and props of bucket and spade, resemble the set-up of Carroll's *Sad Sea Wave*. There are clear differences created by the superior illusionism of the studio but the sentiment of Kent's photograph references earlier photographs by Carroll. Since few of Carroll's images of children in seaside costume have survived, however, it is impossible to tell in what ways, when commissioning photos from Kent, he worked with the professional photographer to contrive an aesthetic across the several 'seaside' images. Even so, the recently auctioned studio portrait forms an interesting companion image to that of Edith and May Miller taken against the same backdrop, at the same studio, during the same summer. More to the point, the fact that some misrecognized the photograph as one by Carroll confirms the importance of considering alongside his own work his use of photography, and especially his recourse to professional studios, to generate portraits for his own consumption. Implicit is a shift from Carroll as primarily a producer to Carroll as an equally avid consumer of photographs by others.

A letter from Carroll to May Miller from 7 Lushington Road, dated 26 August but without a year, provides a simple but profound meditation on professional photographic *cartes* of the type he had had taken in Eastbourne:

> Here is the photo. Looking at it, however, is not much of a substitute for the live May. I wish you would come back again: I need to point out how cruel it is of you to be away so many weeks while I am here, for no doubt you are already feeling a little ashamed of your heartless conduct. Nevertheless, I still am
>
> > Your loving friend,
> > C. L. Dodgson[38]

Carroll's attribution of heartlessness to a child is common in his letters, and a stance he adopts with varying degrees of comic irony. Here, though, his request for the child's return to Eastbourne is somewhat redundant since he proceeds to explain in the letter what he would wish to say to her in person. Yet, as he assigns a motive to the child's absence, a reader

85 William Hardy Kent, 'Child, Eastbourne', signed C. L. Dodgson, 1883,
albumen print, reproduced in *The Brighton Argus*, 20 March 2014.

86 J. Lucas, London, *Agnes Hull*, 1882, albumen print.

is as struck by Carroll's brief reflection upon the material object of a photograph as by his familiar tone of self-pity. For Carroll announces the presence of the photograph: 'here is the photograph' only to dismiss it as immediately deficient: a poor 'substitute for the live May'. Indeed, the resonance of the adjective 'live' indicates the peculiar and enduring power of photographs to remind Carroll of that animation they precisely cannot show to him. May Miller is away, her presence a memory, and the photograph thereby re-stages the difference between her past presence and her current absence. Yet Carroll's use of the definite article in referring to 'the photo' also suggests that, whether or not he is describing a recent image May Miller has sent to him, *she* will know the one to which he refers. It is tempting to assume it is indeed one of the above *cartes* from 1882. In larger terms, while the photograph triggers a desire for the child's return, in showing her as she was, Carroll knows only too well that it has also always predicted her future absence.

Carroll's response by letter to May Miller's photograph is by no means exceptional. In replying on 24 May 1882 to a letter from Agnes Hull, the child whose tintype he had requested from the beach photographer five years before, Carroll writes: 'Thank you, very much for the photograph: it is quite first-rate. But the letter I prize even more: the one is your *face* only – the other is *you*.'[39] Here, the value of the photograph is relative only to its ability to show the whole child. On this occasion, by substituting a part for the whole (Agnes Hull's face for her entire body), the photograph is inferior to the letter that, bearing the trace of a hand, confirms her presence to him. And yet, of course, it is not the case that a photograph showing more than the child's face would solve the problem.

There is an extant *carte de visite* of Agnes Hull taken around this time by the London studio of J. Lucas (illus. 86). Since Carroll's inscription in violet ink records his receipt of the print as September 1882, it is probably a different photograph of the child from the one to which he refers in his letter. Nonetheless, this photograph of Agnes Hull, previously in Carroll's possession, does more than simply put a name to a face. While he encouraged his child readers to send to him photographs of themselves, the close-up format of this *carte* by Lucas, distinct from several extant portraits he superintended at Kent's, allows me to differentiate between those photographs he had a hand in orchestrating and those he didn't. A fifteen-year-old Agnes Hull poses, her face close to the picture plane, eyes

looking upward. The formality of the image resembles others of children he kept such as those of Irene Barnes taken at Kent's. Yet, as indicated by two *cartes* (illus. 87 and 88) of the latter taken at Kent's on 18 August 1887 (VIII, 357), Carroll did not encourage such extreme close-up shots of those child subjects he took to Kent's studio.

Although in writing to Agnes Hull Carroll claims to prefer, over a head-shot, a complete child as embodied in the language of her letter, he was clearly aware that a photograph of a full-length figure might introduce its own problems. Writing on 13 December 1881 to F. H. Atkinson concerning a photograph of his daughter Atkinson had sent to him, Carroll explains:

> I have sent off the *Alice* for your child, by book-post, and am returning you, with this, the photograph of her. If you are kind enough to get a copy printed for me (which I should much like) would you have it done as a "cabinet" vignette? This is partly because I have no album to fit those new (and in my opinion ill-proportioned) long narrow pictures – and partly that I may have her *without her feet*! The artist has managed his lens badly, and has magnified them: no English child ever had such huge feet! I have so often photographed, and drawn children's feet (generally in their natural beauty, without the disfigurement of boots), that I speak from experience.[40]

This is a striking example of the types of exchange Carroll continues to enter into in the so-called 'post-photographic' years of his life. Since his experience as a photographer has taught him the merits of shading out unwanted portions of a print, he thereby claims it preferable to omit parts of the child's body than have them rendered out of proportion by the demands of the format or, as I'll show, by technical faults of particular lenses. In his customary fashion, he sends, via her father, an *Alice* book to the Alice in question. However, somewhat unusually, though, he sends it along with a photograph of the child previously given to him by her father. Although Carroll notes he is grateful to have seen the image, he finds it faulty and requests a superior one. While he claims not to have the correctly sized album to accommodate the 'long print', he proceeds to criticize the 'artist'[s]' control of his lens and the resulting expanded proportions of the child's feet. But precisely what is the matter for him with larger-than-life feet? In what way do they spoil the photograph? Spoil it, that is, to the

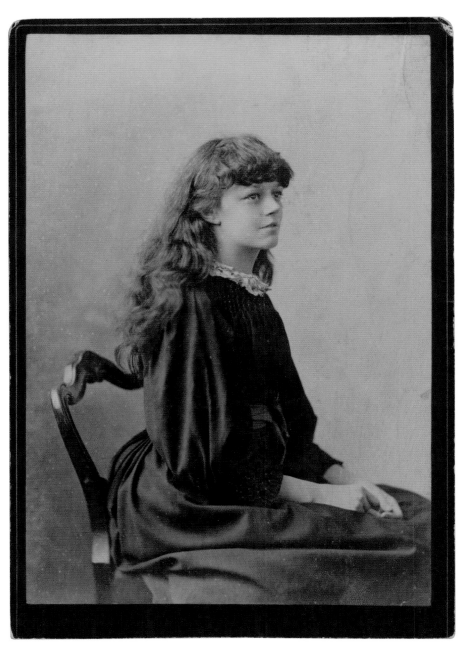

87 William Hardy Kent, *Irene Barnes*, 18 August 1887.

88 William Hardy Kent, *Irene Barnes*, 18 August 1887.

extent that Carroll would rather return it, at the risk of failing to secure a replacement print, than keep the inferior one. Why didn't Carroll simply crop the large feet from the print from Atkinson and settle for a self-edited version? Why did he prefer to return it to sender with specific instructions to the photographer on his desired image?

At one level, here writ large is the pedantic, overly fussy Carroll noticed by some of his colleagues at Christ Church and by the churchwarden of that other Christ Church in Eastbourne, who remembers having to have an extra-large hassock made for him.[41] But also apparent is Carroll's enduring interest in the mechanics and aesthetics of photography, and the continuing role performed by photographs in those ways in which he viewed children's bodies. As this correspondence demonstrates, even in the most casual associations and correspondences Carroll expresses preferences for particular types of photographs. These are not the responses of one who has 'given up' photography. Instead, they reveal one who, having delegated to others technical aspects of the medium, wishes to retain an element of control.

At this period, then, Carroll is still contemplating children's bodies according to their suitability for photography. Moreover, in so doing he appears somewhat unguarded in his remarks about potential child models. A diary entry for 16 March 1883 is especially telling in this respect. It records his view, disclosed elsewhere, that after a period of awkwardness girls alter physically for the better:

> Went up to Haverstock Road, to see (for first time) Mrs. May and her children (who sit as 'models' to Mr. Coleman and other artists, and one or two whom I have thought of having to photo) ... This time 'Nellie', the eldest, was home, and we soon became very good friends. She is pretty, and no doubt artists can make *very* pretty pictures of her, but I doubt her being a very good photographic subject: for a 'nude' study, I should guess her to be too fat at present, though she is 11½: in another year or two she might be more graceful (VII, 522–3).

Coming three years after he had reputedly given up the medium, Carroll's comment demonstrates that he is still thinking in terms of photographing child models and not simply drawing them. Furthermore, Carroll distinguishes between the technological methods of photography and the

painter's art according to their relative potential to embellish the truth. While 'no doubt' Carroll claims 'artists can make *very* pretty pictures of [the child]', the same is not true of photographers who are bound by indexicality to the reality of her physical form. He has not decided by this point, thereby, to actively refrain from taking photographs. Not only that, since Carroll is considering a 'nude' photograph and at the time of writing the age of consent was thirteen, 'a year or two' would put Nellie May on the cusp of majority.

It was not only in his first summers at Eastbourne, however, that Carroll expressed a continuing interest in photographs of children as 'nude studies', as he generally terms them. Indeed, as late as 2 July 1893 Carroll wrote the following letter to Charles B. Barber that demonstrates his continuing desire to acquire photographs:

> There is a lovely picture of a child, in the R. A., by a Mr. Reginald Barber. It is No. 985, called 'Nanetta, daughter of H. Klinker'. If he (Mr. R. Barber) is any relative of yours, I should be grateful if you would ascertain whether a photograph of her is procurable for love or money. Perhaps *you* may have photographed her, yourself? I still treasure those 2 little cartes you gave me, as two of the prettiest studies, of the nude figure, that I have ever seen done by an amateur photographer.[42]

On the one hand, the request indicates the extent to which photographs circulate between 'amateur' photographers, demonstrating that recourse to professional studios was only one means by which Carroll and his friends and acquaintances acquired prints. Indeed, a thriving network of amateur photographers meant that prints changed hands in circumstances, and at a rate, that chiefly went unrecorded. But, on the other, Carroll's letter to Barber signals a familiar trajectory in his relationship to other people's photographs of children. He sees a painting at the Royal Academy and, liking the appearance of the child model, wishes for a photograph of 'the original'; the hope of a photograph stands as a logical next step. Furthermore, in the context of Carroll's reference to those 'cartes' he had previously received from Barber, the child clothed as Nanetta at the RA migrates, in thought at least, to a nude form photographed.

It was also in this period, the early 1890s, that Carroll welcomed oppor-
tunities to draw the naked forms of life models that his friend the artist
Gertrude Thomson employed in her London studio.[43] On occasions she
arranged models especially for Carroll to draw. But when she did so the
pair did not maintain a rigid distinction between drawing and photo-
graphing the life model. Writing to Thomson on 28 July 1893 regarding the
inferiority of the dry-plate to the wet-plate process, Carroll adds:

> but, as a means of making *memoranda* of attitudes etc., it is invaluable.
> Every figure-artist ought to practice it. If *I* had a dry-plate camera, and
> time to work it, and could secure a child of a really *good* figure . . . I would
> put her into every pretty attitude I could think of, and could get, in a
> single morning, 50 or 100 such memoranda. Do try this, with the next
> pretty child you get as a model, and let me have some of the photos.[44]

His response with its italicized 'I' does not amount to a rejection of the
dry-plate process. Rather, Carroll recognizes its capacity to generate large
quantities of photographs of the same child. While his choice of the word
'memoranda' might imply artistic inferiority of the dry-plate to the wet-
plate process, as aids to memory such rapidly generated photographs
would satisfy a longing for multiple copies of an original.

On occasions when Thomson hired a model for Carroll to draw, cameras
were evidently present in addition to pencils and chalks. On 14 October
1893, for example, they both went to the home of Charles and Ethel Bell to
make sketches of their children.[45] As Carroll notes in his diary: '[Thomson]
made, and I *tried* to make, sketches of [ten-year-old] Iris and [six-year-old]
Cynthia, who were very willing and patient models, with lovely figures, and
yet more lovely innocence. It purifies one even to see such purity' (ix, 99).
Although there exist few details of the circumstances, Carroll famously
regretted this sitting after the girls' eight-year-old brother Clive inadvert-
ently entered the room as the children were posing for nude studies. But
Carroll's subsequent mortification at this incident begs the question as to
what precisely the boy has seen. Or, to put it differently, what does Carroll
believe the boy to have seen in stumbling upon the 'artists'? His extreme
concern regarding the incident chimes with other examples, including his

letter to the *St James's Gazette* (22 July 1885) regarding W. T. Stead's articles on child prostitution, 'The Maiden Tribute of Modern Babylon', published earlier that month in the *Pall Mall Gazette*. But there is a sense in which Carroll's concern over the incident takes an acute form owing to the likely presence of a camera on this occasion. When on this notorious occasion in 1893 Carroll and Thomson were intruded upon by Clive Bell as they 'drew' his sisters, the pair were most probably also photographing them.

The fact that sketching might easily morph into photographing is further apparent in Carroll's letter to Gertrude Thomson of 17 November 1897, in which he asks:

> Could you have a *camera*, as well as a model, on Saturday? Drawing takes *time*, of which we shall have little to spare. But the lens, with which you did the Bells, is a terribly *small* one: some of the photos are very much out of proportion. Could you *hire* one, for the day, with a better lens? Charge *me* with the costs involved.[46]

Here is concrete evidence for the persistence of Carroll's photographic activity into the late 1890s, photography specifically associated with the child. With time at a premium photography comes into its own. Not only that, but his comment about the lens, and his offer to pay Thomson for the hire of a 'better' one, directly references an earlier occasion on which cameras were present.

Following the occasion referred to above, having sketched Thomson's fifteen-year-old model Isy Watson, aged thirteen, on 20 November 1897, Carroll writes again to the artist the next day asking her to reimburse Watson for her train fare and also to keep an account 'against' him of

> the hire of that camera – and the *next* hiring of it, if you can get it again (with fuller instructions!) and do some pictures of Isy? In that case, could you do one as large as the enclosed, which I have just traced from a lovely photo of a girl (of about 15, I should think)? I should like her done, that way, very much. Hands behind the back is a very pretty arrangement, I think. The picture need not include the knees.[47]

Carroll's tracing has not come to light but his reference to it demonstrates the specificity of his compositional requests, including which parts

of the child's body to omit. In generating a template from a pre-existing photograph Carroll also indicates how the two mediums, photography and drawing, remain for him interdependent. Furthermore, his comment about 'fuller instructions' confirms that, on the previous occasion, he and Thomson had experienced some difficulty in operating the camera. These are not the expressions and instructions of one who has lost interest in the practice of taking photographs. Rather, they confirm Carroll's hand in operating a camera and his direct involvement in stage-managing sittings as late as the year before his death. While he may not have used his own camera after July 1880, in working via Thomson Carroll enjoyed, at the very least, the visual equivalent of an amanuensis.[48]

ALICE ON THE STAGE

In addition to references to hiring cameras and to professional photographs, such as those by Kent of Eastbourne, after 1880 Carroll's diaries record receipt of photographs from Henry Herschel Hay Cameron's studio in London.[49] These are specifically connected with the staging of *Alice in Wonderland: A Musical Dream Play, in Two Acts for Children and Others*. On 16 September 1887, having first called at his publisher Macmillan's 'and inscribed forty-one books to go to children who had acted in *Alice*', Carroll notes: 'Then to Mr. Cameron's photographic studio, and bought some lovely photos of Phoebe, Dorothy, etc., in costume' (VIII, 361–2).[50] Furthermore, in their metamorphosis from text to live performance the *Alice* books dovetail in various ways with Carroll's considerable investment in photographic agency.

When *Alice in Wonderland: A Musical Dream Play* opened on 23 December 1886 at the Prince of Wales Theatre in London, Carroll realized a long-held desire to stage his stories for children with children playing the parts. But the play also came to supplement for him that conceptual space I've been exploring long occupied by photography. Dramatized by Henry Savile Clarke, with music by Walter Slaughter, the production was originally planned to run for matinée performances until February 1887. However, its popularity was such that the run was extended to 18 March and its provincial tour, including to Brighton's Theatre Royal, had to be postponed, although, as Wakeling points out, 'the cast, crew, and scenery were

moved to Brighton for three special matinée performances on Thursday 3 March until Saturday 5 March', before returning for its run there on 11 July 1887 (VIII, 316). As early as 1867, in his visit to 'the Living Miniatures', Carroll had been considering turning *Alice's Adventures in Wonderland* into a pantomime and had given a copy of his 'juvenile entertainment' to Thomas Coe, the company's manager. Ten years later, in 1877, he had consulted Arthur Sullivan about writing songs for a musical production but the proposed collaboration did not come to fruition. When, however, as Carroll's diary of September 1886 records, he 'got an application from Mr H. Savile Clarke, for leave to make a two Act Operetta out of Alice and Looking-glass', he agreed on condition that 'neither in the libretto nor in any of the stage business, shall any coarseness, or anything suggestive of coarseness, be admitted'.[51]

As a playwright, drama critic and newspaper editor, Savile Clarke proved to be, in Carroll's opinion, a respectful and cooperative dramatist. Although Carroll had been reluctant to concede to Savile Clarke's proposal to conflate in a single production his two *Alice* books, on the basis that no 'genuine child enjoys mixtures', he eventually agreed to it and was, by all accounts, pleased with the result. Having been deeply involved in all aspects of the stage production, Carroll saw the play for the first time on 30 December, recording details of his response in his diary:

> The first Act ('Wonderland') goes well, specially the Mad Tea Party. Mr Sydney Harcourt is a capital 'Hatter,' and little Dorothy d'Alcourt (aged 6½) a delicious Dormouse. Phoebe Carlo is a splendid 'Alice.' Her song and dance, with the Cheshire Cat . . . was a gem (VIII, 311–12).

Reviews in the press were extremely complimentary and, though not all the speeches were verbatim, the 'operetta' was considered to have retained the singular spirit of the texts.[52]

Having rated highly Carrie Coote's performance in *Goody Two-Shoes*, Carroll earlier noted she would 'be just the child to act "Alice", if it is ever dramatized'. However, it was Phoebe Ellen Carlo (b. 1874) who, at twelve years of age and on Carroll's recommendation, took on the lead role in *Alice in Wonderland*. It is not surprising that Carroll suggested her for the part. Not only was she an experienced child actress but, in the three years prior to the production, he had got to know her and her family, and invited

234

her to spend time with him at Eastbourne. The daughter of William Carlo, a factory hand and packer from Lambeth, and Phoebe, née Rawlings, Phoebe Carlo had first caught Carroll's attention in 1883 when at the age of nine she sang in the pantomime *Whittington and his Cat* at the Avenue Theatre. In March of the same year he saw her perform a minor role in Henry Arthur Jones's *The Silver King* at the Princess's Theatre (VII, 525) and subsequently called at the child's home and, after meeting her and her mother, gained permission to take her to the Royal Academy for the day to see Holman Hunt's *Triumph of the Innocents*.

Up until this point, the trajectory of Carroll's acquaintance with the child follows the pattern established early in his life. However, it then differs since, from 1877, Carroll used his Eastbourne lodgings as a base to which to invite visitors including, on some occasions, minors and young women. On 11 July 1885 Carroll records in his diary: 'went to town by the 9 a.m. Called on Mrs Carlo, and talked over plan of having Phoebe down to Eastbourne' (VIII, 219). He subsequently travelled to London on 24 July to fetch the child by train to stay as his guest at Lushington Road. She was eleven years of age and allowed to go unchaperoned. Of the following day Carroll writes: 'Phoebe was ready dressed when I went to the sitting-room: so we began with an early walk. Most of the day we spent on the beach, to her great delight: and as she was too tired for Devonshire Park in the evening I took May Miller instead' (VIII, 227). As was common when Carroll had child guests in Eastbourne, the days comprised a mixture of walks, the beach, theatrical entertainments and, on Sunday, a morning service at Christ Church, in Seaside Road. During Phoebe Carlo's visit, on 27 July, Carroll arranged for her to go with May and Edith Miller to the Devonshire Park Baths and to the beach in the afternoon. However, as he proceeds to explain in his diary entry for the following day, her visit had to be cut short owing to an acting commitment at the Princess's Theatre in London (VIII, 228). Having 'sat' for a professional photograph at Kent's, Carlo returned to London to appear in *Hoodman Blind* and Carroll went to see her perform on 29 August, noting 'as the little boy "Kit", [she] is charming' (VIII, 234).

When the following year she was cast as Alice, Phoebe Carlo impressed Carroll especially for her considerable feat of memorizing and delivering 215 speeches. He was also effusive in his praise of the Dormouse played by Dorothy D'Alcourt (VIII, 312). The success of animal characters such as the Dormouse was in large part owing to the costumes by M. L. Besche, which,

89 Herbert Rose Barraud, *Phoebe Carlo as 'Alice' and Dorothy D'Alcourt as 'the Dormouse', The Theatre*, published by Carson & Comerford, 1 April 1887, carbon print.

as his surviving designs indicate, realized very closely Tenniel's illustrations. Carroll was specific about the ways in which children should wear animal heads, always in such a way so as to reveal at least part of their faces. For Anne Varty, Carroll's direction in this regard reveals 'a departure from the traditional use of "skins" for children playing the parts of animals or monsters' and an important element of his anthropomorphism.[53]

A cabinet photograph by Herbert Rose Barraud (1845–1896) of Phoebe Carlo as Alice and Dorothy D'Alcourt as the Dormouse (illus. 89) appeared in *The Theatre*. Known for his cabinet portraits of eminent Victorians and actors, Barraud portrays the two characters against an elaborate theatrical set. D'Alcourt nestles against the seated figure of Carlo who, in a pale satin fur-trimmed dress, leaning against an ivy-clad tree, gazes directly out of the image. The Dormouse's body is, by comparison, turned to profile and she holds Alice's hand in her right hand, while resting her left one just above the elder girl's wrist. In Barraud's photograph, contrary to Carroll's stipulation for staging, the animal head does not reveal any portion of D'Alcourt's face, though her tiny human proportions are evident in the positioning of her feet and the smallness of her hands against those of Carlo.

In staging *Alice*, both at the Prince of Wales Theatre in 1886, and in the West End revivals of his *Musical Dream Play* in 1888, Carroll referred to the theatrical scenes as pictures, just as he did dreamscapes. But the dramatic spectacle also evoked afresh some of the metaphysical qualities of photography that for him perpetually attached to the medium. These included the rootedness of the medium in magic that he had from the first found compelling. Contemporary accounts of the first production suggest that the ethereal nature of photography, its ghostly potential to manifest the invisible, resonated in the physical staging of Carroll's play. Indeed, the drama not only relied upon the illusionism of the more familiar 'illuminated gauzes to effect transitions into the depths of the enchanted wood' but employed "dissolving view effects" to elide scenic shifts'.[54] Varty reminds us that 'the use of gauzes' would have been familiar 'from the "transformation" scenes of pantomimes' and in Carroll's play they are used to convey the woodland or 'enchanted' landscape in which the action is set, but 'dissolving views' are ones Carroll specifically associated with photographic effects and his lifelong enjoyment of the magic lantern.

Such visual effects enhance the dream scenario with which *Alice in Wonderland* opens and closes. As the audience is transported by fairies to

the realm of Alice's dream, the setting of the drama situates itself, as critics have noted, within the tradition of Shakespeare's *A Midsummer Night's Dream*. Yet, in a far cry from Shakespeare's pastoral, the subsequent oddity of the intersplicing of characters from *Looking-Glass* – Tweedledum and Tweedledee, for example – combines the grace of the miniature performer with the resilience of the wind-up toy considered earlier.

Carroll published his well-known letter on stage children, 'Children in Theatres', in the *St James's Gazette* on 19 July 1887. In it he cited a joyful trip to Brighton Pier as evidence with which to defend child protection while rejecting the absolute prohibition on children under the age of ten acting in theatres.[55] He recounts the outing with three actresses – Phoebe Carlo, her sister Elizabeth and Dorothy D'Alcourt – from the cast of the first *Alice* then playing on tour at the Theatre Royal. Although acknowledging the labour and strain child actors might be subject to, Carroll was not alone in the period in claiming, as he did, that an affinity with acting was a 'natural' attribute of childhood, and that

> a taste for *acting* is one of the strongest passions of human nature, that stage-children show it nearly from infancy, and that, instead of being, as these good ladies imagine, miserable drudges who ought to be celebrated in a new 'Cry of the Children', they simply *rejoice* in their work, 'even as a giant rejoiceth to run his course' (VIII, 352).

But whereas Carroll composed his 'Brighton Pier Letter' specifically in relation to Phoebe Carlo's working practices, and her ability to triumph over them, by 1888, echoing his altered reaction to Connie Gilchrist's performance, he found her acting skills to have changed significantly. Claiming that his chief reason for having gone to *A Midsummer Night's Dream* at the Devonshire Park Theatre was to see Phoebe Carlo in the role of 'Titania', Carroll concludes: 'she spoke too quick, and with little expression: I think the part is beyond her powers' (VIII, 417).

It perhaps comes as little surprise that when, on 25 October 1887, Carroll consulted Savile Clark regarding a revival of his musical play, he had a new actress in mind for the part of Alice, namely Isa Bowman, who had played an Oyster Ghost in the original production. In the manner of Carlo she too had become an acquaintance, and then a 'friend', though he became more involved with the development of her career. I will not

dwell upon her story, however, since it has been well documented, including in 'her' memoir, the record that Carroll kept of her visit to Eastbourne. But, true to the pattern of his 'child-friends' more generally, Isa Bowman eclipsed the 'first' of Carroll's stage Alices and become known eventually as the 'real' stage Alice.[56]

In April 1887, three months before the 'Brighton Pier' letter, Carroll had published an article '"Alice" on the Stage' in *The Theatre*.[57] Having approached the editor Clement Scott, who had expressed an interest in a piece on *Alice in Wonderland*, Carroll's resulting account stresses the oral beginnings of the tale as told to children. While he openly romanticizes the origins of *Alice*, in larger terms, Carroll focuses upon the creative act of writing as a virtually automatic one:

> Every ... idea and nearly every word of the dialogue ... *came of itself*. Sometimes an idea comes at night, when I have had to get up to strike a light to note it down – sometimes when out on a lonely winter walk, when I have had to stop, and with half-frozen fingers jot down a few words which should keep the new-born idea from perishing ... I cannot set invention going like a clock, by any voluntary winding up ... *Alice* and *Looking-Glass* are made up almost wholly of bits and scraps, single ideas which came of themselves.[58]

Readers have cited the 'bits and scraps' but they have tended not to notice the powerful presence here of 'single ideas which came of themselves'. Yet Carroll's account sets the creative process against a clockwork model of invention that requires winding. He identifies an automatic kind of writing that, like the latent photographic image, may emerge as if involuntarily, or at least independent of an operator's intentions.

In Carroll's last 'post-photographic' years, the staging of Alice was highly significant to him. During that time, in addition to continuing to consume photographs, he recognized an essence of photographic agency in the types of visual metamorphosis that theatre and other forms of popular spectacle continued to offer to him. By animating his *Alice* books Carroll breathed new life into the form of the *tableau vivant*. Indeed, in powerful and often subtle senses, photography continued to equal staging for Carroll and staging, reciprocally, photography. Recognizing the intimate connection between still and moving pictures, he celebrated the

metaphysical force of photography in the forward and backward rush of time implicit in the petrified image. This is not to say that he anticipated 'moving' pictures in the precise form they would subsequently take of continuous projected cinematic frames. Or, that in the last two decades of his life, he ceased to enjoy 'still' pictures. Yet in wider cultural terms in this later period, Carroll's desire to capture movement was played out in technological advancements towards cinema.

Postscript

A Postscript is a very useful invention: but it is *not* meant (as so many ladies suppose) to contain the real *gist* of the letter: it serves rather to throw into the shade any little matter we do *not* wish to make a fuss about.[1]

Carroll missed by only eight years James Williamson's film of 'Professor' Reddish – the entertainer and swimming instructor whose South Coast shows he had enjoyed – performing his bicycle stunt off the end of Brighton's West Pier (illus. 90).[2] He would have been mesmerized by it, however, and by cinema more generally, just as he was haunted when he heard the phonograph for the first time. Entitled *Flying the Foam and Some Fancy Diving*, the short 35mm film from 1906 shows the 'Professor' riding off the pier followed by reverse motion shots of him and male divers plunging into the sea. As deployed, reverse motion gets to the heart of an impulse extremely attractive to Carroll, namely, the ability to view repeatedly performances of this type. The sequence turned around in this way, the bicycle and rider emerge, flinging out water droplets, only to roll off the end of the pier a second time, resurfacing miraculously in a wonderfully elaborate *fort/da*. Aside from the stunt itself, the fixed camera lens reveals the enthralled crowd gathered on the pier, that unique architectural structure exemplifying the separation from working life of the Victorian seaside holiday.

In the manner of the child's *fort/da* game described by Freud, early cinema, as exemplified by Williamson of the Brighton School, also articulates an important aspect of Carroll's relationship to photographs as I have been exploring it. In Freud's well-known account of 'Little Hans', the baby

90 Unidentified photographer, *Professor Reddish with his Bicycle*,
West Pier, Brighton, 1900, sepia-toned print.

throws the spool of string out of the cot and then pulls it back again, to mimic the absence and return, the loss and restoration, of the figure of his mother.[3] Testing the object's reappearance, by staging the trauma of its loss and controlling its return, the child inaugurates an act of faith. While the mechanism of *fort/da* has influenced understanding of the temporal pull of narrative cinema – and for Tom Gunning, in particular, what he calls the 'early cinema of attractions'[4] – it also elucidates Carroll's enduring attachment to photographs as bound up with an habitual impulse to acquire them.

Prior to the invention of cinema, a magical property of photography as Carroll and other Victorians experienced it was its ability to suggest, in an arrested form, potential metamorphosis. By miraculously rolling into one image different temporal moments, a photograph captured the capacity for conceptual and physical change. Such potential was especially vivid in a photographic image of a child who theoretically had most of her life still before her. Like many of his contemporaries, Carroll thereby found photographic likenesses of children compelling partly because they generated such an acute sense of time. By holding fast infant subjects in a present immediately past, thereby highlighting the anterior future tense, such photographs offered a particularly resonant presentiment of what Barthes later recognized as the 'death[s] in the future' of all photographic subjects. From its inception there emerged in these terms a natural affinity between photography and the figure of the child. It is therefore no coincidence that, towards the end of the nineteenth century, emergent cinema, like photography before it, took up figures of children as some of its most consummate subjects.[5]

Yet, in Carroll's enduring desire for them, it is not only photographs that stage loss and return. So, too, do letters. When the latter contains the former it provides the perfect combined form. With the temporal movement of *fort/da* – Barthes' 'death in the future' and Benjamin's 'spark of contingency' – packed into a single image, a photograph of a child both rehearses her absence and restores the child to him. The act of letter writing offers similar reassurance in the anticipation of a reply. Not only did Carroll's letters to children make up a significant proportion of his prolific output but he spent a great deal of time in crafting them to appeal to child recipients. Furthermore, so concerned was he at Christ Church with the safe keeping of the mail that – in a letter to Arthur Acland signed 'yours

hydrophobically' – he sketched a design for a basket with waterproof covers to prevent letters from getting wet on the way to the postbox.[6]

As I have shown, Carroll's investment in photographs of children extended far beyond those photographs he took himself to a range of professional *cartes de visite*. Yet he was equally glad to receive amateur photographs of children such as the ones sent to him by Edward Draper with which I began. The photographs he acquired from different sources, together with many he took himself, connected intimately to places, whether in the form of a modest day return to London, his annual three-month stay in Eastbourne or the once-in-a-lifetime trip to Russia. Carroll's attachment to photographs, which began in the 1850s, remained a complex one. It found fresh modes of expression up until the end of his life.

References

INTRODUCTION

1 Edward Wakeling, ed., *Lewis Carroll's Diaries: The Private Journals of Lewis Carroll*, 10 vols (Clifford, Herefordshire, 2003), vol. VII, p. 19. Hereafter cited in text as volume number, followed by page reference.

2 The photograph, previously unpublished, is in the David Bickersteth Magee (1905–1977) Collection of Victorian and Edwardian Manuscripts, 1812–1952, L. Tom Perry Special Collections, Brigham Young University, Utah.

3 The *carte de visite* is inscribed 'Dolly Draper from Lewis Carroll, Feb 5, 1877'. The date is uncertain. The Gernsheim Collection at the Harry Ransom Humanities Research Center, University of Texas, dates the self-portrait to 1872 while the Rosenbach Collection, at the Rosenbach Museum and Library, Philadelphia, dates the photograph 1875. Both hold copies. Edward Wakeling lists the image as '1875?'

4 The letter (Collection of Jon Lindseth) is reproduced in Wakeling, ed., *Diaries*, VII, pp. 29–30.

5 Carroll registered his photographs but, as Wakeling points out, he appears not to have done so entirely systematically until 1875 when, in a diary entry for 7/8 August, he began a numbering system tracing back his photographs to 1856. See Roger Taylor and Edward Wakeling, eds, *Lewis Carroll, Photographer: The Princeton University Library Albums* (Princeton, NJ, 2002), p. 125.

6 *Alice in Wonderland: A Musical Dream Play for Children and Others*, dramatized by Henry Savile Clarke with music by Walter Slaughter, opened at the Prince of Wales Theatre, London, in December 1886.

7 In addition to its portability, the camera enabled Carroll to take a range of negatives from whole plate to quarter plate; Roger Taylor, '"All in the Golden Afternoon": The Photographs of Charles Lutwidge Dodgson', in *Lewis Carroll, Photographer*, p. 27.

8 Frederick Scott Archer's process producing highly detailed negatives on glass could be used, as Carroll used it, to make albumen prints or 'when placed against a black background' to generate 'direct positive photographs known as either glass collodion positives or ambrotypes'. See *'From Today Painting is Dead': The Beginnings of Photography*, exh. cat., Victoria & Albert Museum, London (London, 1972), p. 31.

9 Taylor and Wakeling, eds, *Lewis Carroll, Photographer*, p. 123.

10 The first and only time that Carroll exhibited his photographs was at the

Fifth Annual Exhibition of the Photographic Society at the South Kensington Museum in 1858. They were 'Little Red Riding Hood' (exhibit 174), a portrait of Agnes Grace Weld, the daughter of Emily Tennyson's sister, taken on 18 August 1857, and three unidentified portraits; *Exhibition of Photographs and Daguerreotypes at the South Kensington Museum* (London, 1858).

11 While the diary entry for 15 July 1880 is Carroll's last reference to taking a photograph in his studio, it is important to note that he did not record an intention to give up photography.

12 In *Camera Lucida: Reflections on Photography* (New York, 1981), p. 11, Barthes briefly alludes to cameras as 'clocks for seeing' and, as I'll show, for Carroll the measuring of time and the making of photographs connect in overt and subtle ways.

13 The photograph, previously unpublished, is in the David Bickersteth Magee (1905–1977) Collection of Victorian and Edwardian Manuscripts, 1812–1952, L. Tom Perry Special Collections, Brigham Young University, Utah.

14 Geoffrey Batchen, 'Snapshots: Art History and the Ethnographic Turn', *Photographies*, I/2 (2008), pp. 121–42.

15 Once he had established his reputation as a popular children's author and required child sitters for photography, Carroll was able to draw on capital he had built up in the form of his books for children. Gifts of *Alice* books often served as currency with which to barter for photographic sessions. Likewise, in the case of a child he had little chance of photographing, Carroll might send her one of his books in the hope of receiving in return a professional *carte de visite* of her.

1
'The [Glass] House': Christ Church, Oxford

1 On 17 March 1872 Carroll recorded in his diary: 'Yesterday I took my first photo in the new studio, Julia Arnold: I had her and Ethel with me for about three hours' (VI, 203).

2 Letter to Mary MacDonald, *The Letters of Lewis Carroll*, ed. Morton N. Cohen, 2 vols (London, 1979), vol. I, p. 176.

3 Alice and Ida Mason were aged seven and five, respectively, Carry Mason's dates are unknown; Julia Arnold was eleven, her sister Ethel seven; Xie Kitchin was nine and her brother George Herbert was eight; the dates of Lily Bruce, Miss Ward and Miss Jones are all unknown; Margaret and Frederica Morell were five and six, respectively; Isabel Fane's dates are unknown; Beatrice Hatch was seven and her sister Ethel four. Maud and Isabel Standen were

sixteen and fourteen, respectively, while their sister Helen was nine.

4 Henry George Liddell succeeded Thomas Gaisford as Dean of Christ Church in June 1855. Previously Head of Westminster School, Liddell was a Liberal who, in partnership with Robert Scott, had published a highly significant Greek lexicon, a standard work for many years. He married Lorina Reeve in 1846 and they had seven children (six surviving infancy) growing up at the Deanery.

5 Diary entry for 24 April 1873, *Lewis Carroll's Diaries: The Private Journals of Charles Lutwidge Dodgson*, ed. Edward Wakeling (Luton, 2001), vol. VI, p. 274.

6 Sir Brooke Boothby, *Sorrows Sacred to the Memory of Penelope* (London, 1796).

7 See Anne Higonnet, *Picturing Innocence: The History and Crisis of Ideal Childhood* (London, 1998), p. 29.

8 See Roger Taylor, '"All in the Golden Afternoon": The Photographs of Charles Lutwidge Dodgson', in *Lewis Carroll, Photographer: The Princeton University Library Albums*, ed. Roger Taylor and Edward Wakeling (Princeton, NJ, 2002), pp. 61–4.

9 In 1842, the year of publication of Tennyson's *Poems*, the Percy Society reprinted Richard Johnson's ballad 'A Song of a Beggar and a King' (1612). In 1857 the Pre-Raphaelite painter William Holman Hunt had illustrated Tennyson's poem in *The Moxon* edition of his work, showing the king about to crown his 'beggar queen'.

10 Although there existed a certain degree of interchangeability between all of Carroll's child models, critics remain preoccupied by his relationship with Alice Liddell. In part, one can see why. Of the four missing volumes of his diaries, two relate to the period (April 1858 and May 1862) in which Carroll was most involved with the Liddell family. Speculation about what might be contained in these diaries is to some extent responsible for the continuing fascination. Carroll's first biographer, his nephew Stuart Collingwood, had them in his possession when writing his 'Life' but they disappeared subsequently. Largely owing to these missing diaries and to the enduring power of the image of 'Alice', a popular story has endured. Carroll had wanted to marry Alice Liddell and had been 'disappointed' in love. Yet for this story to prevail readers must largely ignore the wealth of photographs that Carroll took and purchased of other girls, together with those ways in which photography was integral to his daily life in more hesitant but all-pervasive ways than has been acknowledged.

11 James Henry Leigh Hunt, 'Deaths of Little Children', *The Indicator* (5 April 1820), p. 160.

12 Ibid.

13 Ibid., pp. 160–61.

14 See, for example, Karoline Leach, *In the Shadow of the Dreamchild: A New*

Understanding of Lewis Carroll (London, 1999), pp. 50–53. Leach counters the importance to Carroll of Alice Liddell, providing an unlikely, albeit interesting, argument that he was interested in Lorina Liddell senior rather than her daughter. In order to make this claim Leach requires the absent diaries, together with those ten pages cut from the extant ones, to contain a level of discursive detail simply absent from the existing volumes. For Leach, as for many earlier commentators, Carroll's interest in photographing girls is simply the realization of a 'natural' connection between the medium and eminently photographable objects: end of story.

15 Lindsay Smith, *The Politics of Focus: Women, Children and Nineteenth-century Photography* (Manchester, 1998), pp. 95–110.

16 Susan Sontag, *On Photography* (London, 1977); Roland Barthes, *Camera Lucida: Reflections on Photography* (New York, 1981).

17 Walter Benjamin, 'A Small History of Photography', in *One Way Street and Other Writings*, trans. Edmund Jephcott and Kingsley Shorter (London, 1985), pp. 240–57 [p. 243].

18 Ibid.

19 In 1976 the photograph of Alice was removed from its position on the last page of the manuscript to reveal Carroll's drawing beneath it. See Morton N. Cohen, 'Alice Under Ground', *New York Times Book Review*, LXXXII (9 October 1977).

20 In a letter to Alice (Liddell) Hargreaves, 7 March 1885, thanking her for her permission to publish the manuscript, Carroll writes: 'My own wishes would be distinctly *against* reproducing the photograph' (Cohen, ed., *The Letters of Lewis Carroll*, vol. I, p. 561).

21 Benjamin, *A Small History*, p. 247.

22 Barthes, *Camera Lucida*.

23 Roland Barthes, *A Lover's Discourse: Fragments*, trans. Richard Howard (New York, 1984), p. 14.

24 U. C. Knoepflmacher, *Ventures into Childland: Victorians, Fairy Tales and Femininity* (Chicago, 1998); James Kincaid, *Child Loving: The Erotic Child and Victorian Culture* (London, 1992); Catherine Robson, *Men in Wonderland: The Lost Girlhood of the Victorian Gentleman* (Princeton, NJ, 2001).

25 Smith, *The Politics of Focus*, pp. 95–110.

26 See Carol Mavor, *Pleasures Taken: Performances of Sexuality and Loss in Victorian Photographs* (Durham, NC, 1995). For a discussion of Carroll's attitude to issues of consent, see Smith, *The Politics of Focus*, pp. 97–101.

27 Letter to Anne Isabella Thackeray, 23 January 1872, *The Letters of Lewis Carroll*, ed. Cohen, vol. I, p. 171.

28 'A Photographer's Day Out', *South Shields Amateur Magazine* (1860); reprinted

in Helmut Gernsheim, *Lewis Carroll, Photographer* (London, 1949), pp. 116–20.

29 Ibid., p. 116.

30 Ibid., pp. 117–18.

31 Gernsheim, *Lewis Carroll, Photographer*, p. 50.

32 *Irene MacDonald Autographed*, 1863 (Gernsheim Collection, Harry Ransom Humanities Research Center, University of Texas), reproduced in Gernsheim, *Lewis Carroll, Photographer*, pl. 17.

33 'Photography Extraordinary', *Misch-Masch*, no. 13 (3 November 1855), repr. in Gernsheim, *Lewis Carroll, Photographer*, pp. 106–8 [p. 106].

34 Ibid., p. 106.

35 Ibid., p. 108.

36 Ibid.

37 Thomas De Quincey, *Suspiria de Profundis: Being a Sequel to the Confessions of an English Opium Eater* (1847), repr. in *Confessions of an English Opium Eater and Other Writings*, ed. Grevel Lindop (Oxford, 1998), pp. 87–181.

38 Ibid., p. 88.

39 Ibid., p. 142.

40 'Photography Extraordinary', p. 108.

41 'A Photographer's Day Out', p. 120.

42 Ibid.

43 Emmanuel Levinas, 'Reality and its Shadow', *Les Temps modernes*, XXXVIII (1948), pp. 771–89; repr. in *Collected Philosophical Papers*, ed. Alphonso Lingis (Dordrecht, 1987), pp. 1–13.

44 'Hiawatha's Photographing', *Train*, IV (December 1857), pp. 332–5; repr. in Lewis Carroll, *Jabberwocky and Other Nonsense: Collected Poems*, ed. Gillian Beer (London, 2012), pp. 129–33.

2

CARROLL ON THE TRAIN

1 Charles L. Dodgson, *Euclid and his Modern Rivals*, intro. by H.S.M. Coxeter (London, 1973), p. 119.

2 John Ruskin, *Fors Clavigera*, Letter 79, 18 June 1877, *The Complete Works of John Ruskin* (Library Edition), ed. E. T. Cook and Alexander Wedderburn, 39 vols (London, 1903–12), vol. XXIX, p. 119.

3 Michael Freeman, *Railways and the Victorian Imagination* (New Haven, CT, and London, 1999), p. 1.

4 Carroll, *Diaries*, IV, 336. The first underground railway, the Metropolitan line between Paddington and Farringdon Street, opened in January 1863.

5 Wolfgang Schivelbusch, *The Railway Journey: The Industrialization of Time and Space in the 19th Century* (Berkeley, CA, 1986), p. 41.

6 Morton N. Cohen, ed., *The Letters of Lewis Carroll*, 2 vols (London, 1979), I, p. 128.

7 Ibid., pp. 131–2.

8 *Through the Looking-Glass, and What Alice Found There* (1872), ed. Hugh Haughton (London, 1998).

9 Ibid.

10 Ibid.

11 Ibid.

12 *Lewis Carroll's La Guida di Bragia: A Ballad Opera for the Marionette Theatre*, intro. Peter L. Heath (Lewis Carroll Society of North America, 2007).

13 Lewis Carroll, *Alice's Adventures in Wonderland and Through the Looking-Glass*, ed. Hugh Haughton (London, 1998), p. 336.

14 Cited in Schivelbusch, *The Railway Journey*, p. 39.

15 *Through the Looking-Glass*, p. 148.

16 Cohen, ed., *Letters of Lewis Carroll*, I, p. 19.

17 *Through the Looking-Glass*, p. 152.

18 Cohen, ed., *Letters of Lewis Carroll*, I, p. 146.

19 Ibid.

20 Ibid., p. 147.

21 A second letter to Edith Jebb, written two weeks later on 1 February 1870, which begins 'my poor dear puzzled Child' and continues 'I won't write you such a hard letter another time', confirms the extent to which his earlier one had confused her; Cohen, ed., *Letters of Lewis Carroll*, I, p. 147.

22 Robert Simpson, *Sir John Tenniel: Aspects of his Work* (Cranbury, NJ, 1994), p. 38.

23 David Norman Smith, *The Railway and its Passengers A Social History* (Newton Abbot, 1988), p. 19.

24 Donald Thomas, *Lewis Carroll: A Portrait with a Background* (London, 1996), p. 277.

25 Margaret Bradley reported that Carroll 'doubtless concluded me to be a very stupid girl, for he took no further notice of me' (Cohen, ed., *Letters of Lewis Carroll*, II, p. 1147).

26 Abraham Solomon, *First Class – The Meeting: 'And at first meeting loved'* (Ottawa, National Gallery of Canada); *Second Class – Parting: 'Thus part we rich in sorrow parting poor'* (Canberra, National Gallery of Australia).

27 See *Art Journal*, 1 June 1854; *Punch*, XXVI (1854), p. 247.

28 Augustus Egg, *Travelling Companions* (Birmingham Museum and Art Gallery).

29 'Left Oxford by the 8.25 for Birmingham, and so home by Derby and York.

We had to wait an hour at Normanton, when I brought out my *in statu quo* chess-board, and had a game with one of my travelling companions' (v, 189).

30 Walter Benjamin, 'A Small History of Photography', in *One Way Street and Other Writings* (London, 1985); Heinrich Schwarz, *Art and Photography: Forerunners and Influences* (Chicago, IL, 1985); Roland Barthes, *Camera Lucida: Reflections on Photography* (New York, 1981).

31 Mary Price, *The Photograph: A Strange Confined Space* (Stanford, CA, 1994), p. 92.

32 Ibid.

33 *All the Year Round*, v, no. 125 (14 September 1861), pp. 589–93.

34 '"In the Natural Course of Physical Things": Ghosts and Science in Charles Dickens's *All the Year Round*', in *Science in the Nineteenth Century Media*, ed. Louise Henson, Geoffrey Cantor et al. (Aldershot, 2004).

35 Thomas Frank Heaphy, *A Wonderful Ghost Story; Being Mr. H's Own Narrative; a Recital of Facts with Unpublished Letters from Charles Dickens Respecting it* (London, 1882).

36 Ibid., p. 36.

37 Ibid.

38 Nicholas Faith, *The World the Railways Made* (London, 1994), p. 36.

39 Cohen, ed., *Letters of Lewis Carroll*, I, p. 104.

40 Carroll creates a version of Heaphy's ghostly train encounter in the second chapter of *Sylvie and Bruno* (London, 1889).

41 Thomas De Quincey, 'The English Mail-Coach, or the Glory of Motion', in *Confessions of an English Opium Eater and Other Writings*, ed. Grevel Lindop (Oxford, 1998), p. 183.

42 Freeman, *Railways and the Victorian Imagination*, p. 82.

43 De Quincey, 'The English Mail-coach', p. 186.

44 Ibid., p. 193.

45 Ibid., p. 194. For Dionysius Lardner by comparison: 'It is impossible to regard the vast buildings and their dependencies, which constitute a chief terminal of a great line of railways without feelings of inexpressible astonishment at the magnitude of the capital and the boldness of the enterprise . . . Nothing in the history of the past affords any parallel to such spectacle'.

46 De Quincey, 'The English Mail-coach', p. 194.

47 William Powell Frith, *The Railway Station* (Egham, Royal Holloway, University of London).

48 Jack Simmons, ed., *The Railway Traveller's Handy Book of Hints, Suggestions and Advice* (1862; repr. Bath, 1974), pp. 69–70.

49 Isa Bowman, *The Story of Lewis Carroll* (1889); repr. as *Lewis Carroll as I Knew Him* (London, 1972), p. 37.

50 Jeffrey Richards and John M. MacKenzie, *The Railway Station: A Social History* (Oxford, 1986), p. 298.

51 Ibid.

52 According to Richards and MacKenzie: 'the earliest surviving copy [of *Bradshaw*] is 1839 but dedicated research suggests the first timetable was actually issued in 1838' (*The Railway Station*, p. 96).

53 The railways revealed differences in time between different parts of the country and standardization was consequentially known as 'railway time'. Christ Church clock kept local time.

54 Lewis Carroll, 'The Two Clocks', *The Rectory Umbrella*, first published 1898, reproduced in Edward Wakeling, ed., *Lewis Carroll's Diaries: The Private Journals of Lewis Carroll*, 10 vols (Clifford, Herefordshire, 2003): 'Now observe: the one which loses a minute a day has to lose twelve hours, or seven hundred and twenty minutes before it is right again, consequently it is only right once in two years, whereas the other is evidently right as often as the time it points to comes round, which happens twice a day' (I, 36).

55 Richards and MacKenzie, *The Railway Station*, p. 96.

56 Freeman, *Railways and the Victorian Imagination*, p. 68.

57 John Pendleton, *Our Railways* (London, 1896), p. 97.

58 *Punch*, XX (1851), p. 225.

59 *Lewis Carroll's La Guida di Bragia*.

60 Freeman, *Railways and the Victorian Imagination*, p. 68.

61 *Lewis Carroll's La Guida di Bragia*, p. vii.

62 Ibid., p. x.

63 Ibid., p. 31.

64 Ibid., p. 34.

65 Ibid., p. x.

66 Ibid., p. 34.

67 Ibid., p. 39.

68 Wakeling, ed., *Lewis Carroll's Diaries*, vol. I, pp. 18–19. Carroll continued to be fascinated by 'rules' and puzzles derived from the railway. Thus, for example, in 'A Tangled Tale': Problem – (1) 'Two travellers, starting at the same time, went opposite ways round a circular railway', first published in *The Queen*, CLXX/4430, pp. 37–40, p. 66.

69 Lewis Carroll, *Phantasmogoria* (London, 1869).

70 Cohen, *Letters*, I, p. 305.

71 Ibid., pp. 194–5.

72 Cited in Cohen, ed., *Letters of Lewis Carroll*, I, p. 137 n. 1.

73 Ibid.

74 Thomas, *Lewis Carroll*, p. 199.

75 Cohen, ed., *Letters of Lewis Carroll*, I, p. 75.

76 J.M.W. Turner, *Rain, Steam and Speed: The Great Western Railway* (London, National Gallery), exhibited at the Royal Academy, 1844.

77 *Through the Looking-Glass*, p. 146.

78 *Alice's Adventures in Wonderland*, p. 20.

79 Lynne Truss, *Tennyson's Gift* (London, 1996).

80 Cohen, ed., *Letters of Lewis Carroll*, I, p. 66. It is in this letter that, after 'a mutual exhibition of photographs with Cameron', Carroll expresses his and her wish to photograph, in their own terms, each other's subjects: '*she* wished she could have had some of *my* subjects to take *out* of focus – and I expressed an analogous wish with regard to some of *her* subjects'.

81 Ibid., p. 67.

82 Ibid., p. 139.

83 Ibid., p. 140.

84 Ibid.

85 Lewis Carroll, *Symbolic Logic* (London, 1897), ed. Edmund C. Berkeley (New York, 1958), chap. 15, p. 101.

86 Edward Hyams, trans. and ed., *Taine's Notes on England* (London, 1957).

87 Cohen, ed., *Letters of Lewis Carroll*, I, pp. 75–6.

88 Ibid., p. 76.

89 Sigmund Freud, *The Psychopathology of Everyday Life*, vol. VI of *The Standard Edition of the Complete Psychological Works of Sigmund Freud*, ed. and trans. James Strachey (London, 1953), p. 273.

90 Sigmund Freud, *New Introductory Lectures on Psycho-analysis and Other Works*, vol. XXII of *The Standard Edition of the Complete Psychological Works of Sigmund Freud*, ed. and trans. James Strachey (London, 1964), p. 105.

91 Anna Freud, 'About Losing and Being Lost', *Indications for Child Analysis and Other Papers, 1945–1956* (London, 1969), pp. 302–16 [p. 303].

92 Ibid.

93 Ibid.

94 Deborah P. Britzman, *Lost Subjects, Contested Objects: Towards a Psychoanalytic Inquiry of Learning* (New York, 1998), p. 132.

95 Cohen, ed., *Letters of Lewis Carroll*, I, p. 76.

96 For the fate of Carroll's photograph albums, see Roger Taylor and Edward Wakeling, eds, *Lewis Carroll, Photographer: The Princeton University Library Albums* (Princeton, NJ, 2002), pp. 123–5.

97 Lindsay Smith, *The Politics of Focus: Women, Children and Nineteenth-century Photography* (Manchester, 1998), pp. 95–110.

98 *Dymphna Ellis and Her Sisters*, Joseph Brabant Collection, Thomas Fisher Rare Book Library, University of Toronto.

99 John Everett Millais, *Spring*, 'Apple Blossoms', 1859 (Port Sunlight, Lady Lever Art Gallery).

100 Cohen, ed., *Letters of Lewis Carroll*, I, p. 114.

101 William Holman Hunt, *The Awakening Conscience*, 1853–4 (London, Tate Gallery).

102 *Alice's Adventures in Wonderland*, p. 19.

103 Ibid., p. 31.

104 J. Prytherch, 'Modern Obliviousness as Exemplified in the Railway Lost Property Office', *Railway Magazine*, 2 (1898), pp. 258–65.

3

THE PLAY HOUSE: CARROLL AT THE THEATRE IN LONDON

1 Carolyn Steedman, *Strange Dislocations: Childhood and the Idea of Human Interiority, 1780–1930* (Cambridge, MA, 1995), p. viii.

2 Ibid.

3 Ibid., p. 150.

4 Henri Bergson, *Laughter: An Essay on the Meaning of Comedy*, trans. Cloudesley Brereton and Fred Rothwell (Copenhagen and Los Angeles, 1999), pp. 60–61. First English translation (London, 1911).

5 Richard Foulkes, *Lewis Carroll and the Victorian Stage: Theatricals in a Quiet Life* (Aldershot, 2005).

6 Donald Thomas, *Lewis Carroll: A Portrait with a Background* (London, 1996), p. 265. In the 1860s, when not staying with friends, Carroll stayed at Old Hummums Hotel in Covent Garden; from 1868, after a brief period of staying at the Trafalgar Hotel in Spring Gardens, behind Whitehall, he began staying instead at the United Hotel in Charles Street.

7 Ibid.

8 See, for example, Stewart Dodgson Collingwood, *The Life and Letters of Lewis Carroll* (London, 1898); Florence Becker Lennon, *Lewis Carroll* (London, 1947); Derek Hudson, *Lewis Carroll* (London, 1976); Morton N. Cohen, *Lewis Carroll, A Biography* (New York, 1995); Karoline Leach, *In the Shadow of the Dreamchild: A New Understanding of Lewis Carroll* (London, 1999); Jenny Woolf, *The Mystery of Lewis Carroll: Understanding the Author of Wonderland* (London, 2010).

9 See, for example, diary entries for 1863 and 1864.

10 In 1871, for example, Carroll notes in his diary 'went up to town, left my luggage at King's Cross and went to the MacDonalds [at The Retreat on the Thames], where I arrived just after the play had begun. It was one of Mrs.

MacDonald's dramas, *Snowdrop*, and was acted by the children, and two or three friends. The stage was out in the garden, with curtains next the audience (100 poor people from Marylebone – Ruskin's tenants: and a few friends), but no back-ground, and no means of getting the actors unseen to the stage, which rather spoiled the effect. However, it was capitally done, Lily being the best of all: she has a real genius for acting' (VI, 161–2). *Snowdrop*, one of Louisa MacDonald's plays, was published in *Chamber Dramas* in 1870 along with others such as *Cinderella* and *Beauty and the Beast*.

11 Morton N. Cohen, ed., *The Letters of Lewis Carroll*, 2 vols (London, 1979), vol. I, p. 270.

12 William Raeper, *George MacDonald* (Tring, 1987), p. 169.

13 As Kenneth Douglas Brown, *The British Toy Business* (London, 1996), p. 22, notes: 'Cremer was licensed as a toy seller in the Soho Bazaar and was also known for selling wax dolls. Although a trader rather than a manufacturer some early wax and bisque shouldered dolls had a purple oval stamp with Cremer Soho Bazaar on their bodies. Cremer's great granddaughter Vera Cremer ran "Dolls in Wonderland" in Brighton in the 1970s and then took her collection to the US.' It seems difficult to believe the association of Cremer with Wonderland might be coincidental, confirming instead Carroll's interest in Cremer's toys.

14 Thomas, *Lewis Carroll*, p. 190.

15 Thomas Coe advertised his lessons in 'elocution to clergymen, Orators, Ladies and Others' (*Era Almanac Advertiser*, 1868, n.p.) He lived with his common-law wife, Ellen Blanch Hanson, and two children. Carroll was sufficiently impressed by his professionalism to contemplate studying elocution with him (Wakeling).

16 *The Era*, XXIX (30 December 1866), pp. 10–11. Although there existed other all-child performing troupes, the Living Miniatures appear to have been somewhat atypical of the period for, as Anne Varty, *Children and Theatre in Victorian Britain: 'All Work, No Play'* (London, 2008), has pointed out: 'a far greater majority were employed as dancers or as supernumeraries in pantomime'. Exploring nineteenth-century working conditions and legislation, Varty reveals the difficulties in promoting a model of exploitation above all else. Marah Gubar, 'The Drama of Precocity: Child Performers on the Victorian Stage', in *The Nineteenth-century Child and Consumer Culture*, ed. Dennis Denisoff (Aldershot, 2008), pp. 63–78, claims that criticism has 'downplayed the numbers of highly skilled parts for children beyond the anonymous and undemanding roles of supernumeraries'. She maintains that 'minors in an all-child cast would have been more likely to have their needs met than ones in a minority in an adult cast.'

17 *Sporting Gazette* [London], no. 219 (5 January 1867), p. 16.

18 The Act for the Prevention of Cruelty to Children passed in 1889 prohibited the employment of children under the age of seven in the theatre and regulated the employment of children between the ages of seven and ten.

19 Tracy Davis, 'The Actress in Victorian Pornography', *Theatre Journal*, XLI (October 1989), p. 294.

20 Ibid.

21 Ibid.

22 Carroll's eventual choice of the word 'through' rather than 'behind' the Looking-Glass for his second *Alice* book transfers the emphasis from a specifically located vantage point to the process of traversing a surface. Frankie Morris points out how Alice's passage 'through the looking glass of the chimney combined elements of a transformation scene and of a harlequinade'; see 'Alice and King Chess', *Jabberwocky*, XII/4 (1983), pp. 76–8. On the relation of the lens to the mirror, see Joanna O'Leary, 'Where "things go the other way": The Stereochemistry of Lewis Carroll's Looking-Glass World', *Victorian Network*, II/1 (Summer 2010), p. 74.

23 Cohen, ed., *Letters of Lewis Carroll*, I, p. 101.

24 Marah Gubar, 'The Drama of Precocity: Child Performers on the Victorian Stage', in *The Nineteenth-century Child and Consumer Culture*, ed. Dennis Denisoff (Aldershot, 2008), pp. 63–78 [p. 66].

25 Ibid., p. 76.

26 Ibid.

27 Nina Auerbach, *Romantic Imprisonment: Women and Other Classified Outcasts* (New York, 1985), pp. 156–7.

28 Charles Baudelaire, 'Morale du joujou', first published in *Monde Litteraire*, 17 April 1853, before being included in *L'Art romantique*. This version, 'Philosophy of Toys', in *The Painter of Modern Life and Other Essays*, trans. and ed. Jonathan Mayne (London, 1964), pp. 197–203 [p. 198].

29 Ibid.

30 Ibid., p. 199.

31 See Douglas R. Nickel, *Dreaming in Pictures: The Photography of Lewis Carroll* (San Francisco, CA, 2004).

32 Susan Stewart, *On Longing: Narratives of the Miniature, the Gigantic, the Souvenir, the Collection* (Durham, NC, and London, 1993), p. 57.

33 Ibid.,

34 Ibid., p. 56.

35 Ibid., p. 57.

36 Ethel M. Arnold, 'Social Life in Oxford', *Harper's New Monthly Magazine*, LXXXI (July 1890), pp. 246–56.

37 Susan Stewart, *Nonsense: Aspects of Intertextuality in Folklore and Literature* (Baltimore, MD, and London, 1978), p. 70.

38 Stewart, *On Longing*, p. 57.

39 Lindsay Smith, *The Politics of Focus: Women, Children and Nineteenth-century Photography* (Manchester, 1998), p. 106.

40 *Catalogue of the Furniture, Personal Effects, and the Interesting and Valuable Library of Books of the Late Rev. C. L. Dodgson ... Sold at Auction* (1898). In his diaries, Carroll uses a concept of duplication when comparing children. On 5 May 1867, seeing a pretty child he would like to photograph whose name he does not know, Carroll refers to her as a 'Second Edition of Edith' (V, 234). In a diary entry for 15 December 1868, he writes: 'I was much pleased with the two little girls, Mary and cousin, aged 9 and 6; the elder is a pretty miniature likeness of Leila' (VI, 67).

41 'I used, as a child, to stare at it intently almost every day; and, if my hand were not stiff, I could make a sketch of that little waxen image now'; George Augustus Sala, *London up to Date* (London, 1894), p. 234.

42 Leslie Daiken, *Children's Toys throughout the Ages* (London, 1963), p. 170.

43 Cited in ibid., p. 171.

44 George Augustus Sala, *Gaslight and Daylight* (London, 1859), p. 200.

45 Colin Campbell, *The Romantic Ethic and the Spirit of Modern Consumerism* (Oxford, 1989).

46 Ibid.

47 Baudelaire, *Philosophy of Toys*, p. 197.

48 Ibid., p. 198.

49 Ibid.

50 Ibid., p. 199.

51 Ibid.

52 Wakeling suggests, based on the fact that a German toy theatre survives, that Carroll may have had two theatres: 'beginning with a German toy theatre, improved upon it by making marionettes to be moved by threads from above in place of the cut-out "penny-plain, tuppence coloured" cardboard figures with their ugly stands and wires' (I, 19). For a discussion of boyhood and the 'cardboard and paste' toy theatre in the period see Liz Farr, 'Paper Dreams and Romantic Projections: The Nineteenth-century Toy Theater, Boyhood and Aesthetic Play', in *The Nineteenth-century Child and Consumer Culture*, ed. Denisoff, pp. 43–62. Regarding the troupe of marionettes and the theatre he constructed on 11 April 1855, Carroll writes: 'As our own family are all home now, and likewise the Webster boys, we got up an entertainment for the assembled party with the Marionette Theatre. I chose the Tragedy of King John, which went off very successfully ... [A Christmas book for children that

would sell well. Practical hints for constructing Marionettes and a theatre (we have managed to get up the whole thing with about 20 figures, for a very few shillings) – this might be followed by several plays for representation by Marionettes or by children. All existing plays for such objects seem to me to have one of two faults – either (1. they are meant for the real theatre, and are therefore not fitted for children, or (2. they are overpoweringly dull – no idea of fun in them'] (I, 81–2).

53 John McCormick, *The Victorian Marionette Theatre* (Iowa City, IA, 2004), p. 20.

54 Ibid. p. 12.

55 Ibid., p. 53.

56 After visiting the Exhibition of British Artists in London on 22 April 1857, Carroll noted: 'I took hasty sketches on the margin of the Catalogue of several of the pictures, chiefly for the arrangement of hands, to help in grouping for photographs' (III, 51).

57 Robin Bernstein, *Racial Innocence: Performing American Childhood from Slavery to Civil Rights* (New York, 2011), p. 203.

58 Evelyn M. Hatch, ed., *A Selection from the Letters of Lewis Carroll to his Child-friends* (London, 1933).

59 Cohen, ed., *Letters of Lewis Carroll*, I, pp. 196–7.

60 Bergson, *Laughter: An Essay on the Meaning of Comedy*, p. 64.

61 Ibid., p. 65.

62 Ibid. A key example in Bergson's discussion of 'the illusion of life and the distinct impression of a mechanical arrangement in repetition' is the Jack in the Box: 'the image of the spring . . . which is bent, released and bent again' (p. 66).

63 *John Bull*, 11 March 1871, p. 158.

64 Sigmund Freud, *The Interpretation of Dreams*, vol. IV of *The Standard Edition of the Complete Psychological Works of Sigmund Freud*, ed. and trans. James Strachey (London, 1953), p. 515.

65 Ibid.

66 Ibid., pp. 516–17.

67 Jennifer Forrest, 'Aerial Misses and Spectating Messieurs: The Paradox of the Lady Acrobat in the French Fin de Siècle', in *Peripheries of Nineteenth-century French Studies: Views from the Edge*, ed. Timothy B. Raser (Cranbury, NJ, 2002).

68 Ibid., p. 147.

69 Ibid.

70 Ibid.

71 *Sporting Times*, 11 March 1871, p. 76. There emerges a curious unacknowledged 'photographic' connection between Carroll and Lulu when the latter later adopted the position of an ethnographic photographer. In 1885

the former 'Lulu' served as official photographer to his father on an expedition across the Kalahari Desert. His photographs were subsequently exhibited in London and appeared in Farini's book *Through the Kalahari Desert* (London, 1886).

72 Davis, 'The Actress in Victorian Pornography', pp. 294–315.

73 Thomas, *Lewis Carroll*, p. 268.

74 Varty, *Children and Theatre in Victorian Britain*, p. 48.

75 Edward Stirling, *Old Drury Lane: Fifty Years' Recollections* (London, 1881), p. 254.

76 Ibid.

77 Jeffrey Stern, ed., *Lewis Carroll, Bibliophile* (Luton, 1997), p. 92.

78 Varty, *Children and Theatre in Victorian Britain*, p. 53.

79 Cohen, ed., *Letters of Lewis Carroll*, I, p. 303.

80 Ibid., p. 307.

81 Ibid.

82 Wakeling lists as 'not located' Carroll's photograph of Arthur Hatch as 'Cupid' taken between 19–30 April 1872 (*Lewis Carroll Photographer*, p. 266). Cohen, however, reproduces the photograph in *Letters of Lewis Carroll*, I, facing p. 252.

4

Carroll in Russia: Shopping for Photographs and Icons

1 Album A (II) is one of the larger of twelve known surviving albums by Carroll and one of four in the Morris L. Parrish Collection, Princeton University. Originally containing 136 photographs, mounted four on a page, this album along with the other three at Princeton is reproduced in Roger Taylor and Edward Wakeling, eds, *Lewis Carroll, Photographer: The Princeton Library Albums* (Princeton, NJ, 2002).

2 From 1863 until 1871 Carroll rented a studio in Badcock's Yard, Oxford. Only a third of the photographs he took there appear to have survived; of all the photographs registered taken in that studio, however, only three refer to ethnic costumes: Ella 'Monier-Williams in New Zealand Dress' (1–8 July 1866) and, following the Russian trip, 'Julia Arnold in Chinese dress', in 'standing' and 'seated' versions (5 June 1871). From 1872 to 1880 there is evidence of close to 60 'costume' photographs of children.

3 On 18 March 1856, Carroll purchased for £15 his first camera from Ottewill in London, known for its folding designs and excellent workmanship (II, 53–4).

4 Charles Lutwidge Dodgson, the *Russian Journal*, Morris L. Parrish Collection, Princeton, published in Edward Wakeling, ed., *Lewis Carroll's Diaries: The*

Private Journals of Charles Lutwidge Dodgson, vol. V (Luton, 1999), pp. 255–369. All subsequent references appear as page numbers in parentheses in the text.

5 Henry Parry Liddon, Diary published as *The Russian Journal*, II: *A Record Kept by Henry Parry Liddon of a Tour Taken with C. L. Dodgson in the Summer of 1867*, ed. Morton N. Cohen, Carroll Studies No. 3 (New York, 1979).

6 See, for example, Morton Cohen who, in *Lewis Carroll, A Biography* (New York, 1995), p. 273, claims: 'What with his many occupations memories of the journey abroad quickly receded. Nowhere does he reflect upon it.'

7 See Carol Mavor, *Pleasures Taken: Performances of Sexuality and Loss in Victorian Photographs* (Durham, NC, 1995) and Lindsay Smith, *The Politics of Focus: Women, Children and Nineteenth-century Photography* (Manchester, 1998).

8 See Liddon, *The Russian Journal*, II, ed. Cohen: 'In 1866, the Association published the first of a series of occasional papers on reunion . . . The first was written by William Stubbs, the Archbishop of Canterbury's Librarian and bears the title: "The Apostolical Succession in the Church of England: A Letter to a Russian Friend".' Involved 'in negotiations between East and West on Christian unity', Liddon travelled with letters of introduction to a range of Russian dignitaries such as Bishop Leonide, the Suffragan of Moscow (Cohen, *Lewis Carroll*, p. 268).

9 Albert Schmidt, 'Architecture in Nineteenth-century Russia: The Enduring Classic', in *Art and Culture in Nineteenth-century Russia*, ed. Theofanis George Stavrou (Bloomington, IN, 1983), p. 178.

10 Sidney Monas, 'St Petersburg and Moscow as Cultural Symbols', in *Art and Culture in Nineteenth-century Russia,* ed. Stavrou, p. 29.

11 Tom Taylor, *The Serf, or Love Levels All* (London, 1867). According to Richard Foulkes: 'during the score or so years in which Carroll patronised it the Olympic had passed through different phases: the heyday of burlesque with the tour de force performances of Robson, the plays of house dramatist Tom Taylor and the acting of the Terry sisters'; Foulkes, *Lewis Carroll and the Victorian Stage: Theatricals in a Quiet Life* (Aldershot, 2005), p. 155.

12 There are nine photographs by the London Stereoscopic Company of Kate Terry in her role in *The Serf* (Guy Little Theatre Collection, V&A).

13 Taylor, *The Serf*, p. 25.

14 Ibid., p. 28.

15 Liddon, *Russian Journal,* II, p. 28.

16 Taylor, *The Serf*, p. 5.

17 Leigh Hunt, 'Of the Sight of Shops' (First Paper), *The Indicator and the Companion: A Miscellany for the Fields and the Fireside* (London, 1833). When Carroll's journal omits to mention 'shopping', entries supplied by Liddon's

diary for the same days detail its presence as a quotidian activity. On 18 July Liddon remarks, 'spent the greater part of the morning in going about to shops for photographs for Dodgson' (*Russian Journal*, II, p. 268).

18 Charles Piazzi Smyth, *Three Cities in Russia* (London, 1862), p. 308.
19 J. G. Köhl, *Panorama of St Petersburg* (London, 1852), p. 17.
20 *Illustratsiya,* no. 52 (8 January 1859), p. 30, cited in Elena Barkhatova, *Russian XIX Century Photographers: William Carrick's Scenes of Russian Life* (St Petersburg, 2010), p. 42.
21 Working closely with his assistant John MacGregor to record the street life of St Petersburg, Carrick used the 'fast-working' Dahlmeyer portrait lens.
22 Felicity Asbee, 'William Carrick: A Scots Photographer in St Petersburg (1827–1878)', *History of Photography*, II/3 (1978), pp. 207–22 [pp. 207–8].
23 Ibid., p. 208.
24 Liddon, *Russian Journal*, II, p. 32.
25 Asbee, 'William Carrick', p. 211.
26 Henry Mayhew, *London Labour and the London Poor: A Cyclopaedia of the Condition and Earnings of those that will Work, those that cannot Work and those that will not Work* (London, 1851–61). Mayhew's book grew out of articles he published in the *Morning Chronicle*; John Thomson and Adolphe Smith, *Street Life in London* (London, 1877), serialized in parts for 1s 6d each.
27 Julie Lawson, 'William Carrick: His Photography', in Felicity Ashbee and Julie Lawson, *William Carrick, 1827–1878* (Edinburgh, 1987), p. 12.
28 Barkhatova, *Russian XIX Century Photographers*, p. 47.
29 Between 1859 and 1864 the French photographer Laurent had a studio at 5 Bolshaya Konyushennaya Street. In 1863, as Elena Barkhatova indicates, Laurent's 'Russian National Types' were available in *carte de visite* format at '50 silver kopecks per hundred' at the S. Dufour Bookstore in St Petersburg; *Russian XIX Century Photographers,* p. 45.
30 Charles Dickens Jr, *Dickens's Dictionary of London: An Unconventional Handbook* (London, 1888), p. 233.
31 Köhl refers to the derogatory term 'black people' used to 'designate' members of the peasantry. He points out that 'tshornoi narod . . . means literally black people', but that '"tshornoi" is often used synonymously with *dirty* . . . the expression may be taken to mean "dirty people", in short "the unwashed"'; Köhl, *Panorama of St Petersburg*, p. 73.
32 Anticipating photographic portraits, icons 'return the gaze of the viewer – the eyes make direct contact, so setting up a dialogue' and functioning like 'gateways . . . to the other world'; Robin Milner-Gulland, *The Russians* (Oxford, 1997), p. 178.
33 But for Carroll the act of securing photographs holds greater significance

than it does for Liddon. Even on the return leg of his trip when, while staying in Paris, he has the opportunity to make several visits to the International Exhibition, Carroll prioritizes hunting down photographs, such that his intention of spending 10 September at the Exhibition is thwarted by wandering and 'buying photographs till it was too late to go to the Exhibition' (V, 365).

34 The icon *Theotokos of Kazan* was allegedly discovered in 1579 underground in the city of Kazan by a young girl to whom its whereabouts had been revealed by the Virgin Mary.

35 Köhl, *Panorama of St Petersburg*, p. 63.

36 Ibid.

37 Milner-Gulland, *The Russians*, p. 178.

38 The Greek word 'eikon' is a term for any image. In its Russian form 'icona' or 'obraz' and in Orthodox use it designates a representation of holy persons or events. Reference to the Mandylion was first recorded in the fourth century and Scholasticus, writing around AD 600, referred to the existence of the image in the ancient city of Edessa. It was then allegedly moved to Constantinople in the tenth century.

39 Geoffrey Batchen, *Burning with Desire: The Conception of Photography* (Cambridge, MA, 1997), p. 68.

40 Julia Kristeva, *Crisis of the European Subject*, trans. Susan Fairfield (New York, 2000), p. 134.

41 Ibid., p. 153.

42 Ibid.

43 Ibid., p. 154.

44 Liz James and Antony Eastwood, eds, *Icon and Image: The Power of Images in Byzantium* (Aldershot, 2003), p. 20.

45 A concept of intercession is fundamental to the workings of the icon. See Marina Warner, *Alone of All Her Sex: The Myth and Cult of the Virgin Mary* (New York, 1983), p. 286: 'The theology of the Virgin's intercession maintains very strictly that the Virgin does not have the power to grant any boon by herself but only intercedes with her son who as God is the only source of her salvation.' However, as Kristeva indicates, 'God is threefold in Orthodoxy, but not in the same way as in Catholicism: the Holy Spirit proceeds from the Father *through* the Son for the Orthodox (per filium), the Holy Spirit proceeds from the Father *and* from the Son for the Catholics (filioque)'; Kristeva, *Crisis of the European Subject*, p. 138.

46 A Hodegetria-style icon known as 'Virgin Trichorousa' or 'Our Lady with Three Hands'. The third hand represents the severed and later healed hand of John of Damascus, who defended the icon against iconoclasts.

47 As discussed in Chapter One, as early as 3 November 1855 in 'Photography Extraordinary', *Misch-Masch*, no. 13, Carroll had explored a concept of photographic imprinting as applied to the human mind.

48 See Lindsay Smith, 'The Nineteenth-century Photographic Likeness and the Body of the Child', in *Children and Sexuality: From the Greeks to the First World War*, ed. George Rousseau (Basingstoke, 2007), pp. 210–37.

49 Susan Stewart, *On Longing: Narratives of the Miniature, the Gigantic, the Souvenir, the Collection* (Durham, NC, and London, 1993), p. xii.

50 Ibid., p. 135. Carroll is interested in what Stuart calls the souvenir's capacity to 'contract the world in order to expand the personal' (p. xii).

51 Kristeva, *Crisis of the European Subject*, p. 154.

52 Ibid., p. 148.

53 Vera Shevzov, 'Miracle-working Icons, Laity and Authority in the Russian Orthodox Church, 1861–1917', *Russian Review*, LVIII/1 (January 1999), pp. 26–48 [p. 34].

54 Cohen, *Lewis Carroll*, p. 267.

55 S. Frederick Starr, 'Russian Art and Society, 1800–1850', in *Art and Culture in Nineteenth-century Russia*, ed. Stavrou, pp. 87–112 [p. 92].

56 See Jeffrey Stern, ed. *Lewis Carroll, Bibliophile* (Luton, 1997), p. 92.

57 Liddon, *Russian Journal*, II, p. 22.

58 The first production Carroll saw was John Maddison Morton's pantomime *Aladdin and his Wonderful Lamp* at the Princess's in 1857; later in January 1875 he saw E. L. Blanchard's pantomime version.

59 Cohen, ed., *Letters of Lewis Carroll*, I, pp. 106–7.

60 When tea was first imported to Britain from China by the East India Company in the 1650s, it was an expensive luxury. Widely available in the mid-nineteenth century and sold from chests, it was – along with porcelain, textiles and lacquerware – a major commodity in Anglo-Chinese commerce. Carroll shared contemporary interest in photographic images of China. The following year John Thomson published his lavish book *Illustrations of China and its People* (London, 1874).

61 The Holiday Album in the Morris L. Parrish Collection, Princeton, contains 24 photographs, many with quotations, all taken during Carroll's visit in July 1875.

62 As Marta Weiss points out, Henry Holiday had studied at Heatherley's and was very interested in the history of dress. See 'Lewis Carroll's Holiday Album', *The PhotoHistorian*, 157 (Winter 2008/Spring 2009), pp. 5–9 [p. 9].

63 Bret Harte's poem, published in the *Overland Monthly Magazine* (September 1870) and intended as a satire on the prejudice against Chinese immigrant workers in San Francisco, was widely quoted as both condemning and

justifying violence towards immigrant workers.

64 Entitled 'Song' and beginning 'Maid of Athens, ere we part', Byron's poem
 was written in 1810 allegedly for Teresa Macri, the twelve-year-old daughter
 of the British Consul in Athens. The last line of each stanza, 'my life, I love
 you', appeared in Greek. There is not space to unpack in relation to Byron's
 philhellenism the associations of what had become by the 1870s a very
 well-known poem. However, after the War of Independence, as David Roessel
 indicates, there occurs a 'conflation' of Byron's expression of 'love' for the
 'maid' 'with his commitment to a feminised Greece'; Roessel, *In Byron's
 Shadow: Modern Greece in the English and American Imagination* (Oxford,
 2002), p. 78.

65 It is distinct, too, from Liddon's frequent note: 'we got our photographs',
 Russian Journal, II, p. 32.

66 Cited in Cohen, *Lewis Carroll*, p. 378.

67 On 30 August 1868, on his journey home and a week after recording the
 'beautiful' studio photograph, Carroll notes 'the playground of the girls' school
 adjoined to St Dorothy's Church' in Breslau as 'a very tempting field for a
 photographic camera' (V, 353). Such reflection on a missed opportunity relates
 to other references to girls in the Russian journal not immediately identifiable
 as 'photographic', but frequently accompanied by a wish to capture a likeness.
 See, for example, Carroll's entries for 13 July (V, 258); 21 July (V, 274) and
 16 August (V, 332–3).

68 While Wakeling preserves the words in the facsimile reprint, he does not
 gloss the Cyrillic. In a footnote to the 26 August entry in his edition of the
 Diaries, Wakeling notes that 'Prince Golicen? has not been identified' (V, 519).
 However, the name is 'Golitsin', one of Russia's major aristocratic families, and
 he may have been the Russian general and statesman Grigory Sergeyevich
 Golitsin (1838–1907), who trained at the General Staff Academy of Petersburg.

69 This interpretation is somewhat borne out by the fact that the word
 'артистический' is not the most usual word for 'artistic', which is 'искусство'.
 The translation calls attention to how little remains known about Carroll's
 investment in other people's photographs, both home and abroad. I am
 grateful to Mary Caruthers for advice on the translation.

70 Roland Barthes, *Camera Lucida: Reflections on Photography* (New York, 1981).

71 As Liz James writes in the context of Byzantine icons: 'A portrait was a
 memory, it was not the portrayed but it was a recollection and a means of
 recollection of them'; James, 'Art and Lies: Text, Image and Imagination in the
 Medieval World', in *Icon and Image*, ed. James and Eastwood, pp. 59–71 [p. 67].

72 Milner-Gulland, *The Russians*, p. 177.

73 Cited in Wakeling, ed. *Lewis Carroll's Diaries*, V, 287.

74 Cited ibid., v, 289.

75 Alice Emily Donkin used Carroll's *Xie Kitchin as 'Dane'* for her painting *Waiting to Skate*, which hung above Carroll's mantelpiece in his sitting room at Christ Church.

76 Kristeva, *Crisis of the European Subject*, p. 148.

77 Prayers and expressions of guilt and self-doubt are present throughout Carroll's diaries, but they intensify and increase in frequency in the 1860s. While Wakeling notes 'there is no clear . . . reason' to account for the increase, it coincides with Carroll's considerable involvement in photography and visits to theatrical entertainments in London.

78 James, *Icon and Image*, ed. James and Eastwood, p. 65.

5
Ore House, Hastings: Stammering, Speech Therapy and the Voice of Infancy

1 See Morton N. Cohen, ed., *The Letters of Lewis Carroll*, 2 vols (London, 1979), I, p. 207.

2 Gilles Deleuze, *Critique et clinique* (Paris, 1993), p. 109.

3 Ibid.

4 Ibid.

5 May Barber (Mrs H. T. Stretton), 'More Recollections of Lewis Carroll – II', *The Listener* (6 February 1958), p. 239.

6 Cohen, ed., *Letters of Lewis Carroll*, II, p. 1154.

7 Ibid.

8 Walter Benjamin, 'A Small History of Photography', *One Way Street and Other Writings*, trans. Edmund Jephcott and Kingsley Shorter (London, 1985), pp. 240–57.

9 Lindsay Smith, 'Infantia', *New Formations*, 42 (Winter 2001), pp. 85–98.

10 Ibid., p. 88.

11 Adam Phillips, *The Beast in the Nursery* (London, 1998), p. 47.

12 Ibid.

13 Maurice Merleau-Ponty, *Consciousness and the Acquisition of Language*, trans. Hugh Silverman (Evanston, IL, 1973). p. 23.

14 Ibid.

15 Ibid., pp. 23–4.

16 Ibid., p. 24.

17 Cohen, ed., *Letters of Lewis Carroll*, I, p. 194.

18 Ibid., p. 202.

19 Ibid.

20 Ibid., p. 207.

21 Ibid., p. 240.

22 Ibid.

23 Gertrude Thomson, 'Lewis Carroll: A Sketch by an Artist-friend', in *Lewis Carroll, Interviews and Recollections,* ed. Morton Cohen (Ames, IA, 1989), p. 235.

24 James Hunt, *Stammering and Stuttering, Their Nature and Treatment*, 5th edn (London, 1863).

25 Ibid., p. 92.

26 Ibid., p. 48.

27 Ibid., p. 64.

28 Ibid., p. 140.

29 Ibid., p. 175.

30 Ibid., p. 150.

31 Ibid., p. 172.

32 Ibid., p. 182.

33 Ibid., p. 197.

34 Cohen, ed., *Letters of Lewis Carroll*, I, p. 42.

35 Ibid., p. 50.

36 Ibid., p. 210.

37 Taken on 29 September 1857, indoors, at the home of Mr and Mrs James Marshall, it shows the couple and their daughter Julia, together with Alfred and Hallam Tennyson. Carroll took nine other negatives at the house during his visit during 28 and 29 September. Six of them are in the Morris L. Parrish Collection, Princeton.

38 Benjamin, 'A Small History of Photography', p. 243.

39 Cohen, ed., *Letters of Lewis Carroll*, I, p. 178.

40 Ibid.

41 Roland Barthes, *Camera Lucida: Reflections on Photography* (New York, 1981), p. 96.

6

7 LUSHINGTON ROAD, EASTBOURNE

1 Carroll notes an exception to this habit on 28 June 1887: 'I have *three* rooms at Mrs. Dyer's this time, the first floor sitting-room, and the two top bedrooms, of which I make the back one my "working" room' (VIII, 345).

2 The relationship appears to have been a considerate and trusting one.

Anticipating his arrival, Carroll corresponded with her about ordering in provisions and she, in turn, appreciated his ensuring she did not lose income by encouraging her to rent out his regular rooms when duties in Oxford delayed him. Writing to Mrs Dyer prior to one of his summer visits, Carroll explains how she need not take trouble to get in the customary marmalade since he has secured a superior brand to bring with him from Oxford. In *Alice's Adventures in Wonderland*, Alice's relationship to a jar of marmalade she takes from a shelf, and contemplates what to do with as she falls down the rabbit hole, becomes newly resonant in the context of Carroll's domestic arrangements with his Eastbourne landlady. On another occasion, in April 1888, he sent Mrs Dyer a ferrometer to install that used iron sulphate to purify the sewage from water closets (VIII, 245). At a later date still, Carroll wrote to her proposing 'to send a man from Oxford' to inspect her drains. These latter details are usually cited as evidence of Carroll's awkward and overly insistent nature, but they also reveal that he was on sufficiently good terms with his landlady for such demands apparently not to cause a rift.

3 Although Bedford Well Road was further from the sea than Lushington Road, as Carroll notes in his diary on 2 August 1896: 'I find that I am 9 minutes from church, 12 from Pier, 11 from Post office, 11 from Station, and 18 from Devonshire Park' (IX, 272).

4 Carroll had spent regular time at the seaside since his stay at Whitby during the long vacation of 1854 when, while working for his final examination, he lodged at East View Terrace to work with Bartholomew Price. He frequently took his sisters to Whitby and, prior to settling on Eastbourne, had favoured Sandown on the Isle of Wight.

5 The actresses most frequently associated with Carroll's time at Eastbourne included Phoebe Carlo, Dorothy D'Alcourt, Isa Bowman, Nellie Bowman, Violet and Irene Barnes, Violet Gordon, Dot Hetherington and Lottie Rix.

6 Carroll kissed Alexandra 'Atty' Owen, daughter of Sidney James Owen, Tutor in Law and Modern History at Christ Church, and Mary Owen, née Sewell, a barrister, allegedly believing her not to 'look fourteen' when in fact she turned out to be seventeen (VII, 240). The parents were angered by the incident and by Carroll's mock apology. Prior to 1880 Carroll had commented on the relative attractiveness of children, especially with regard to photographing them, but in these later years, especially at Eastbourne, he appears more willing to drop his guard when describing them, less worried, it seems, about potential censure. The dominant critical view is that as Carroll grew older he was able to take more risks, countering suspicions of impropriety on his part by portraying himself as an old fogey don. Whatever the circumstances of the meetings themselves, Carroll's recording of encounters with numerous

children in Eastbourne is extremely insistent.

7 See Carroll, *Diaries*, vii, 240. Edward Wakeling notes that Carroll gave up because photography had become too bothersome for him and studios were plentiful (vii, 255). Yet since studios had been plentiful from the 1860s, this fact in itself seems an unlikely reason for Carroll to stop taking photographs. There was, however, as Wakeling points out, the added coincidence during this period of Carroll's concern over the storage of negatives owing to damp. When he moved a number of negatives in 1880 he also erased some because, he notes, their burgeoning numbers had become too great to manage.

8 When Carroll was resident in Eastbourne many photographers had professional studios in the town. These included William Atkinson; George Austin; Eugene Bampton; Frederick Bourne; Herbert Briggs; David Downey; William H. Kent; G. and R. Lavis; Thomas Gowland; William Hicks; Alfred Isard; Charles Long; Robert Morton Day; Thomas Rowe; William Stanley and Rudolph Vieler. (On 15 November 1886 he refers in his diary to a photograph from Lavis.) During this period Carroll was also having drawings photographed by Henry Peach Robinson's studio. See, in particular, the entry for 25 May 1882 (vii, 428).

9 At the same time such performances visually situate children in ways evoking earlier pleasures such as those of toys and marionettes in which motion is a key component. On his first summer in Eastbourne in 1877, for example, Carroll records buying 'a mechanical bear' costing one and a half guineas (vii, 53).

10 *Alice in Wonderland, a Dream Play for Children and Others*, dramatized by Henry Savile Clarke with music by Walter Slaughter, and incidental dances arranged by Mdlle Rosa, was produced under the direction of M. Marius. Carroll simultaneously involved himself in debates over legislation for child actors.

11 Sue Farrant, 'London by the Sea: Resort Development on the South Coast 1880–1939', *Journal of Contemporary History*, xxii/1 (1987), pp. 137–62 [p. 147].

12 William Abbotts Smith and Charles Hayman, *Eastbourne, and the Advantages which it Possesses for Invalids: With General Remarks Upon Sea-Bathing, Sea-Air, and Exercise* (London, 1861), p. 13.

13 Ibid., pp. 26–7.

14 Morton N. Cohen, ed., *The Letters of Lewis Carroll*, 2 vols (London, 1979), vol. i, p. 451.

15 Ibid., p. 454.

16 See Lindsay Smith, *The Politics of Focus: Women, Children and Nineteenth-century Photography* (Manchester, 1998), especially chapter 5.

17 While bathing machines date back to the eighteenth century, nude bathing was fairly common until the nineteenth. Benjamin Beale of Margate developed one of the earliest in the first half of that century and, by 1791, with the opening of the Sea Bathing Hospital there, the coastal town became one of the pre-eminent places for sea bathing. Guides, or 'dippers', attended bathers using the machines and one of the most celebrated, Martha Gunn (1776–1815), worked at Brighton.

18 See Fred Gray, *Designing the Seaside: Architecture, Society and Nature* (London, 2006), p. 157.

19 *Pall Mall Gazette*, Issue 6291, 13 May 1885, p. 19.

20 Ibid.

21 *The Graphic*, Issue 1346, 14 September 1895.

22 David Day, '"A Modern Naiad": Nineteenth-century Female Professional Natationists', *Women and Leisure, 1890–1839: Women's History Network Conference, Midlands Region, 2008*, pp. 1–2.

23 'Swimming: The Ladies Championship', *American Gentleman's Newspaper* (1883), p. 505.

24 Ibid.

25 *The Penny Illustrated Paper*, 27 July 1878, p. 61.

26 Ibid.

27 See Fred Gray, *Walking on Water: The West Pier Story* (Brighton, 1998), p. 32.

28 Harold Clunn, *Famous South Coast Resorts: Past and Present* (London, 1929), p. 44.

29 See Corina E. Rogge, 'The Varnished Truth: The Recipes and Realities of Tintype Coatings', *Journal of Cultural Heritage*, XV/1 (January–February 2014), pp. 57–63.

30 Carroll also documents what he regards as a number of difficult relationships that begin in Eastbourne, including with Agnes and Jessie Hull, whom he meets on his first summer there on 20 August 1877. Carroll's diary entry for 30 October 1882 reads: 'Received notes from Agnes and Jessie, to thank me for photos of drawings by Mr Coleman, which I had sent them by Theo. Both begin "my dear" (instead of "dearest") and are "affectionate" (instead of "loving"). The love of children is a fleeting thing!' (VII, 485–6). Writing to Mrs V. Blakemore, 2 October 1877, he notes: 'No summer that I have ever spent has given me so many child-friends as this, and I am very glad to think that I can now (a thing I despaired of for many weeks) include Edith in the list' (Cohen, ed., *Letters of Lewis Carroll*, I, pp. 285–6).

31 William Hardy Kent had studios at 45 Gildredge Road (1878–82), 86 Terminus Road (1882–4) and 104 Terminus Road (1884–93). Kent was born in London in 1819 to American parents. He spent the early part of his career in New

Bedford, Massachusetts, and began to study photography in 1845, opening his first studio in New York in 1848. Arriving in England in 1854, he opened three photographic studios: one at 147 Oxford Street (1854–64), where he was succeeded by John Beararni [John Beer]; one at 52 St George's Place, Knightsbridge; and the third at 86 Regent Street. He became bankrupt on 24 April 1883 with a bill of sale dated 31 August 1883 to J. T. Bowers in Brighton (indemnity). Kent subsequently went into partnership in Eastbourne with Seymour Lacy, who ran the business between 1894 and 1924, with branches in Brighton, Hastings, Newcastle and Harrogate. Married twice with five sons and five daughters, Kent retired from business in 1899. He died at his home in Eastbourne on 29 September 1907 and was buried at Ocklynge Cemetery on 2 October 1907. See 'Obituary', *The Times*, 1 October 1907, p. 10. See also *Eastbourne Gazette*, 2 October 1907. Kent wrote on technical aspects of photography in *Humphrey's Journal of the Daguerreotype and Photographic Arts*. See: 'The Camera', *Humphrey's Journal*, XII (15 December 1860), pp. 243–4; 'Gleanings Arranged from an Amateur's Scrap-book for the Aid of Beginners', *Humphrey's Journal*, XII (15 January 1861), pp. 273–4; 'Hints to Authors', *Humphrey's Journal*, XII (1861), pp. 306–7; 'Gleanings Arranged from an Amateur's Scrap-book for the Aid of Beginners', *Humphrey's Journal*, XIII (1 November 1861), pp. 194–6.

32 Irene Barnes (later Vanbrugh, the actress), who stayed with Carroll at Eastbourne, refers in her reminiscences to Carroll's preference: 'He liked to have photographs of his child friends, but disliked the way negatives were touched up. So he used to take them to a special photographer at Eastbourne who didn't do this, and he was quite pleased with the result in my case'; Irene Vanbrugh, *To Tell My Story* (London, 1948), p. 19.

33 Carroll first met Edith and May Miller on the beach on 6 August 1881, recording the occasion in his diary. The first encounter with the Millers is bound up with photographs from professional studios and occurred during the period when Carroll was still intending to take photographs himself and meeting children with their potential as photographic subjects in mind.

34 The David Bickersteth Magee (1905–1977) Collection of Victorian and Edwardian Manuscripts, 1812–1952, L. Tom Perry Special Collections, Brigham Young University, Utah.

35 Lewis Carroll, *By the Sad Sea Wave*, 12 June 1873 (Akehurst Bureau).

36 *Brighton Argus*, 20 March 2014.

37 There is, however, a facial resemblance to Agnes Hull as seen in the photograph from the studio of J. Lucas in Carroll's possession (illus. 86).

38 Morton Cohen, *Letters*, II, 636, suggests the photograph may date from 1886 but, as he notes, 'the year is a guess' based on the assumption 'that having met May

at Eastbourne for five successive years, [he] would notice her absence in 1886'.

39 Cohen, ed., *Letters of Lewis Carroll*, I, p. 460.

40 Ibid., p. 447.

41 Unpublished letter from Stanley Godman, Lewes. He notes that James Attlee, who was churchwarden in Lewis Carroll's time, remembered him as 'very irritable'.

42 Reproduced in Edward Wakeling, ed., *Lewis Carroll's Diaries: The Private Journals of Lewis Carroll*, 10 vols (Clifford, Herefordshire, 2003), IX, p. 79.

43 Gertrude Thomson (1850–1929), artist and illustrator, became good friends with Carroll after they met in 1879. He commissioned her to illustrate for him, resulting in the cover for *The Nursery Alice* (1889) and her signature fairy drawings for *The Three Sunsets* (1898). His practice of drawing from the 'child' life model frequently involved photography, conceptually if not practically. See Morton N. Cohen, *Lewis Carroll, A Biography* (New York, 1995), p. 173.

44 Letter dated 28 July 1893, reproduced in Cohen, *Lewis Carroll, A Biography*, p. 173.

45 Charles Bell was correspondent for *The Times* in Egypt from 1865 to 1890 and subsequently assistant manager of *The Times*, 1890–1908. They had six children: Moberly, Hilda, Enid, Iris, Clive and Cynthia.

46 Cohen, ed., *Letters of Lewis Carroll*, II, p. 1146.

47 Ibid., p. 1147.

48 Ibid., p. 1135.

49 Henry Herschel Hay Cameron (1852–1911), youngest son of Julia Margaret Cameron, had studios at Mortimer Street, and Cleveland Street in London. One of those images to which Carroll refers survives (Fresno) – a cabinet with the label 'the Cameron Studio', 70 Mortimer Street, Regent Street – in which Phoebe Carlo, dressed as a boy, and Dorothy D'Alcourt, who played the Dormouse in *Alice*, sit on the floor playing cat's cradle.

50 Again, for 16 January 1888, Carroll records: 'To London at 1.43. Called at "Cameron" studio, and got some photos of Phoebe etc., and a pretty "study" of Mr Comyns Carr's little girl Dolly' (VIII, 375). It is evident from an accompanying reference to 'the album [Cameron] is to get for [him]' (VIII, 365–6) that Carroll was collecting and arranging such *cartes*. Not only do these visits show him still connected to eminent professional studios in London but, gesturing backwards to Carroll's acquaintance with Julia Margaret Cameron's work, they focus the importance to the 1880s of the stage version of *Alice* and those child actors it involved.

51 Cohen, ed., *Letters of Lewis Carroll*, II, p. 637.

52 For the reviewer in *The Theatre* (1 January 1887): 'Mr Savile Clarke has achieved a wonderful and surprising success; he has given the little folk this

winter a genuine children's pantomime and founded it upon that marvellous and delightful book, of which no one ever grows weary'. The reviewer in *Fun* (5 January 1887) meanwhile claims: 'There is only one play in London for children, and this is it . . . Miss Phoebe Carlo is just the Alice of our hearts'.

53 Anne Varty, *Children and Theatre in Victorian Britain: 'All Work, No Play'* (London, 2007), p. 103.

54 Ibid., p. 107.

55 'Children in Theatres', *St James's Gazette*, 16 July 1887; known by Carroll as his 'Brighton Pier Letter'.

56 The revival of Alice with Isa Bowman in the title-role took place at the Globe Theatre on 26 December 1888. See Isa Bowman, *The Story of Lewis Carroll* (London, 1899); repr. as *Lewis Carroll as I Knew Him* (London, 1972).

59 'Alice on the Stage', *The Theatre*, 1 April 1887.

58 Cohen, *Lewis Carroll, A Biography*, p. 437.

POSTSCRIPT

1 Lewis Carroll, *Eight or Nine Wise Words about Letter-writing* (1890) was first published as a miniature pamphlet to fit in the envelope of Carroll's *Wonderland Postage-stamp Case*.

2 John Williamson (1855–1933) made his 35mm, 97 feet, black and white film (BFI) of a popular stunt in 1906. Local photographer George Ruff photographed Professor Reddish on 17 June 1904.

3 Sigmund Freud, *Two Case Histories: 'Little Hans' and 'The Rat Man'*, vol. X of *The Standard Edition of the Complete Psychological Works of Sigmund Freud*, ed. and trans. James Strachey (London, 1955).

4 Tom Gunning, '"Now You See It, Now You Don't": The Temporality of the Cinema of Attractions', in *Silent Film*, ed. Richard Abel (London, 1996), pp. 71–84.

5 See Vicky Lebeau, *Childhood and Cinema* (London, 2008).

6 Letter to Arthur Acland, 1881, in *Letters of Lewis Carroll*, ed. Cohen, I, p. 407.

Bibliography

Works by Lewis Carroll

La Guida di Bragia, A Ballad Opera for the Marionette Theatre, intro. Peter L. Heath
 (Lewis Carroll Society of North America, 2007)
The Rectory Umbrella (1850–53) *and Mischmasch* (1855–62), (London, 1932)
'Photography Extraordinary', *Mischmasch*, no. 13 (3 November 1855), repr. in
 Helmut Gernsheim, *Lewis Carroll Photographer*, pp. 106–8
'A Photographer's Day Out', *South Shields Amateur Magazine* (1860); repr. in Helmut
 Gernsheim, *Lewis Carroll Photographer* (London, 1949), pp. 116–20
Alice's Adventures in Wonderland (London, 1865)
Phantasmagoria (London, 1869)
Through the Looking-Glass, and What Alice Found There (London, 1872)
The Hunting of the Snark (London, 1876)
Euclid and his Modern Rivals [1879], intro. by H.S.M. Coxeter (London, 1973)
The Pillow Problems (London, 1885)
A Tangled Tale (London, 1885)
Alice's Adventures Underground (London, 1886)
Sylvie and Bruno (London, 1889)
Sylvie and Bruno Concluded (London, 1889)
The Nursery Alice (London, 1889)
Eight or Nine Wise Words about Letter Writing (London, 1890)
The Game of Logic (London, 1896)
Symbolic Logic Part I Elementary (London, 1897)
Lewis Carroll's Diaries: The Private Journals of Charles Lutwidge Dodgson, ed. Edward
 Wakeling, 10 vols (Luton and Clifford, Herefordshire, 1993–2008)
The Letters of Lewis Carroll, ed. Morton N. Cohen, 2 vols (London, 1979)

Other Works

Arnold, Ethel M., 'Social Life in Oxford', *Harper's New Monthly Magazine*, LXXXI
 (July 1890), pp. 246–56
Asbee, Felicity, 'William Carrick: A Scots Photographer in St Petersburg,
 1827–1878', *History of Photography*, II/3 (1978), pp. 207–22

Auerbach, Nina, *Romantic Imprisonment: Women and Other Classified Outcasts* (New York, 1985)

Barber, May (Mrs H. T. Stretton), 'More Recollections of Lewis Carroll – II', *The Listener* (6 February 1958)

Barthes, Roland, *Camera Lucida: Reflections on Photography* (New York, 1981)

Batchen, Geoffrey, *Burning with Desire: The Conception of Photography* (Cambridge, 1999)

—, 'Snapshots: Art History and the Ethnographic Turn', *Photographies*, I/2 (2008), pp. 121–42

Baudelaire, Charles, 'Morale du Joujou' ('Philosophy of Toys'), trans. and ed. Jonathan Mayne, *The Painter of Modern Life and Other Essays* (London, 1964), pp. 197–203

Becker Lennon, Florence, *Lewis Carroll* (London, 1947)

Benjamin, Walter, 'A Small History of Photography', *One Way Street and Other Writings*, trans. Edmund Jephcott and Kingsley Shorter (London, 1985)

Bergson, Henri, *Laughter, An Essay on the Meaning of Comedy*, trans. Cloudesley Brereton and Fred Rothwell (Copenhagen and Los Angeles, 1999)

Bernstein, Robin, *Racial Innocence: Performing American Childhood from Slavery to Civil Rights* (New York, 2011)

Blake, Kathleen, *Play, Games and Sport: The Literary Works of Lewis Carroll* (Ithaca, NJ, and London, 1974)

—, 'Three Alices, Three Carrolls', *English Language Notes*, 20 (1982), pp. 131–8

Bloom, Harold, *Modern Literary Views on Lewis Carroll* (New York, 1987)

Bowman, Isa, *The Story of Lewis Carroll* (London, 1899); repr. as *Lewis Carroll as I Knew Him* (London, 1972)

Britzman, Deborah P., *Lost Subjects, Contested Objects: Towards a Psychoanalytic Inquiry of Learning* (New York, 1998)

Brown, Kenneth Douglas, *The British Toy Business: A History since 1700* (London, 1996)

Campbell, Colin, *The Romantic Ethic and the Spirit of Modern Consumerism* (Oxford, 1989)

Cohen, Morton N., 'Alice Under Ground', *New York Times Book Review*, LXXXII (9 October 1977)

—, *Lewis Carroll: A Biography* (New York, 1995)

—, *Lewis Carroll: Interviews and Recollections* (London, 1989)

—, 'Lewis Carroll and Victorian Morality', *Tennessee Studies in Literature*, 27 (1984), pp. 3–19

Collingwood, Stewart Dodgson, *The Life and Letters of Lewis Carroll* (London, 1898)

Daiken, Leslie, *Children's Toys Throughout the Ages* (London, 1963)

Davis, Tracy, 'The Actress in Victorian Pornography', *Theatre Journal*, XLI (October 1989), pp. 294–315

De Quincey, Thomas, *Suspiria de Profundis: Being a Sequel to the Confessions of an English Opium Eater* (1847), repr. in *Confessions of an English Opium Eater and Other Writings*, ed. Grevel Lindop (Oxford, 1998),

Deleuze, Gilles, *Critique et Clinique* (Paris, 1993)

—, 'He Stuttered', in *Essays Critical and Clinical*, trans. Daniel W. Smith and Michael A. Greco (London, 1998), pp. 107–14

Denisoff, Dennis, ed., *The Nineteenth-century Child and Consumer Culture* (Aldershot, 2008)

Dickens, Charles, Jr, *Dickens's Dictionary of London: An Unconventional Handbook* (London, 1888)

Empson, William, 'Alice in Wonderland: The Child as Swain', *Art and Psychoanalysis*, ed. William Phillips (Cleveland, OH, 1963), pp. 185–217

Faith, Nicholas, *The World the Railways Made* (London, 1994)

Farr, Liz, 'Pater Dreams and Romantic Projections: The Nineteenth-century Toy Theater, Boyhood and Aesthetic Play', in *The Nineteenth-century Child and Consumer Culture*, ed. Dennis Denisoff (Aldershot, 2008), pp. 43–62

Ford, Colin, *Lewis Carroll Photographer* (Bradford, 1987)

Forrest, Jennifer, 'Aerial Misses and Spectating Messieurs: The Paradox of the Lady Acrobat in the French Fin de Siècle', in *Peripheries of Nineteenth-century French Studies: Views from the Edge*, ed. Timothy B. Raser (Newark, NJ, 2002)

Foulkes, Richard, *Lewis Carroll and the Victorian Stage: Theatricals in a Quiet Life* (Aldershot, 2005)

Fraser, Antonia, *A History of Toys* (London, 1966)

Freeman, Michael, *Railways and the Victorian Imagination* (New Haven, CT, and London, 1999)

Freud, Anna, 'About Losing and Being Lost', *Indications for Child Analysis and Other Papers, 1945–1956* (London, 1969), pp. 302–16

Freud, Sigmund, *New Introductory Lectures on Psycho-analysis and Other Works*, vol. XXII of *The Standard Edition of the Complete Psychological Works of Sigmund Freud*, ed. and trans. James Strachey (London, 1964)

—, *The Psychopathology of Everyday Life*, vol. VI of *The Standard Edition of the Complete Psychological Works of Sigmund Freud*, ed. and trans. James Strachey (London, 1953)

Gardner, Martin, *The Annotated Alice* (London, 1970)

Gattegno, Jean, *Lewis Carroll: A Life* (Paris, 1974)

Gernsheim, Helmut, *Lewis Carroll Photographer* (London, 1949)

Gubar, Marah, 'The Drama of Precocity: Child Performers on the Victorian Stage', in *The Nineteenth-century Child and Consumer Culture*, ed. Dennis Denisoff (Aldershot, 2008), pp. 63–78

Guiliano, Edward, *Lewis Carroll Observed: A Collection of Unpublished Photographs, Drawings, Poetry and New Essays* (New York, 1976)

Hatch, Evelyn M., ed., *A Selection from the Letters of Lewis Carroll to his Child-friends* (London, 1933)

Haughton, Hugh, ed. *Lewis Carroll: Alice's Adventures in Wonderland and Through the Looking-Glass* (London, 1998)

Heaphy, Thomas Frank, *A Wonderful Ghost Story; Being Mr. H's Own Narrative; a Recital of Facts with Unpublished Letters from Charles Dickens Respecting it* (London, 1882)

Henson, Louise, '"In the Natural Course of Physical Things": Ghosts and Science in Charles Dickens's *All the Year Round*', in *Science in the Nineteenth Century Media*, ed. Louise Henson, Geoffrey Cantor et al. (Aldershot, 2004)

Higonnet, Anne, *Lewis Carroll* (London, 2008)

—, *Picturing Innocence: The History and Crisis of Ideal Childhood* (London, 1998)

Hinde, Thomas, *Lewis Carroll: Looking-Glass Letters* (London, 1991)

Hudson, Derek, *Lewis Carroll* (London, 1976)

Hunt, James, *Stammering and Stuttering, Their Nature and Treatment*, 5th edn (London, 1863)

Hunt, James Leigh, 'Of the Sight of Shops' (First Paper)', in *The Indicator and the Companion: A Miscellany for the Fields and the Fireside* (London, 1833)

Hyams, Edward, trans. and ed., *Taine's Notes on England* (London, 1957)

James, Liz, and Antony Eastwood, eds, *Icon and Image: The Power of Images in Byzantium* (Aldershot, 2003)

Kincaid, James, *Child Loving: The Erotic Child and Victorian Culture* (London, 1992)

Kleist, Heinrich von, 'Uber das Marionettentheater' (On the Marionette Theatre), in *Selected Writings*, ed. and trans. David Constantine (London, 1997), pp. 411–16

Knoepflmacher, U. C., *Ventures into Childland: Victorians, Fairy Tales and Femininity* (Chicago, IL, 1998)

Köhl, J. G., *Panorama of St Petersburg* (London, 1852)

Kristeva, Julia, *Crisis of the European Subject*, trans. Susan Fairfield (New York, 2000)

Lawson, Julie, 'William Carrick: His Photography', in Felicity Ashbee and Julie Lawson, *William Carrick, 1827–1878* (Edinburgh, 1987)

Lebeau, Vicky, *Childhood and Cinema* (London, 2008)

Leach, Karoline, *In the Shadow of the Dreamchild: A New Understanding of Lewis Carroll* (London, 1999)

Lecercle, Jean-Jacques, *Philosophy through the Looking-Glass, Language, Nonsense, Desire* (London, 1985)

—, *Philosophy of Nonsense: The Intuitions of Victorian Nonsense Literature* (London, 1994)

Liddon, Henry Parry, Diary, published as *The Russian Journal – II, A Record Kept by*

Henry Parry Liddon of a Tour Taken with C. L. Dodgson in the Summer of 1867,
ed. Morton N. Cohen, Carroll Studies No. 3 (New York, 1979)

Levinas, Emmanuel, 'Reality and its Shadow', *Les Temps modernes*, XXXVIII
(1948), pp. 771–89; repr. in *Collected Philosophical Papers*, ed. Alphonso Lingis
(Dordrecht, 1987), pp. 1–13

Lovett, C. C., *Alice on the Stage: A History of the Early Theatrical Productions of Alice
in Wonderland* (Westport, CT, 1990)

McCormick, John, *The Victorian Marionette Theatre* (Iowa City, IA, 2004)

Mavor, Carol, *Pleasures Taken: Performances of Sexuality and Loss in Victorian
Photographs* (Durham, NC, 1995)

Mayhew, Henry, *London Labour and the London Poor: A Cyclopaedia of the Condition
and Earnings of those that will Work, those that cannot Work and those that will
not Work* (London, 1851–61)

Meisel, Martin, *Realizations, Narrative, Pictorial and Theatrical Arts in
Nineteenth-century England* (Princeton, NJ, 1983)

Merleau-Ponty, Maurice, *Consciousness and the Acquisition of Language*, trans. Hugh
Silverman (Evanston, IL, 1973)

Milner-Gulland, Robin, *The Russians* (Oxford, 1997)

Monas, Sidney, 'St Petersburg and Moscow as Cultural Symbols', in *Art and
Culture in Nineteenth-century Russia*, ed. Theofanis George Stavrou
(Bloomington, IN, 1983)

Morris, Frankie, 'Alice and King Chess', *Jabberwocky*, XII/4 (1983), pp. 76–8

Nead, Lynda, *Victorian Babylon: People, Streets and Images in Nineteenth-century
London* (New Haven, CT, and New York, 1999)

Nickel, Douglas, *Dreaming in Pictures: The Photography of Lewis Carroll*
(San Francisco and New York, 2002)

O'Leary, Joanna, 'Where "Things Go the Other Way": The Stereochemistry of Lewis
Carroll's Looking-glass World', *Victorian Network*, II/1 (Summer 2010), pp. 70–87

Ovenden, Graham, *The Illustrators of Alice* (London, 1971)

Phillips, Adam, *The Beast in the Nursery* (London, 1998)

Phillips, Robert, ed., *Aspects of Alice: Lewis Carroll's Dreamchild as Seen through the
Critics' Looking-Glasses* (London, 1972)

Price, Mary, *The Photograph: A Strange Confined Space* (Stanford, CA, 1994)

Prytherch, J., 'Modern Obliviousness as Exemplified in the Railway Lost Property
Office', *Railway Magazine*, 2 (1898), pp. 258–65

Raeper, William, *George MacDonald* (Tring, 1987)

Rapaport, Herman, 'The Disarticulated Image: Gazing in Wonderland', *Enclitic*,
VI/2 (1982), pp. 57–77

Richards, Jeffrey, and John M. MacKenzie, *The Railway Station: A Social History*
(Oxford, 1986)

Robson, Catherine, *Men in Wonderland: The Lost Girlhood of the Victorian Gentleman* (Princeton, NJ, 2001)

Rose, Jacqueline, *The Case of Peter Pan, Or, the Impossibility of Children's Fiction* (London, 1984)

Ruskin, John, *The Complete Works of John Ruskin* (Library Edition), ed. E. T. Cook and Alexander Wedderburn, 39 vols (London, 1903–12)

Sala, George Augustus, *London up to Date* (London, 1894)

—, *Gaslight and Daylight* (London, 1859)

Schivelbusch, Wolfgang, *The Railway Journey: The Industrialization of Time and Space in the 19th Century* (Berkeley, CA, 1986)

Schmidt, Albert, 'Architecture in Nineteenth-century Russia: The Enduring Classic', in *Art and Culture in Nineteenth-century Russia*, ed. Theofanis George Stavrou (Bloomington, IN, 1983)

Schwarz, Heinrich, *Art and Photography: Forerunners and Influences* (Chicago, IL, 1985)

Sewell, Elizabeth, *The Field of Nonsense* (London, 1952)

Shevzov, Vera, 'Miracle-working Icons, Laity and Authority in the Russian Orthodox Church, 1861–1917', *Russian Review*, LVIII/1 (January 1999), pp. 26–48

Simmons, Jack, ed., *The Railway Traveller's Handy Book of Hints, Suggestions and Advice* (1862; repr. Bath, 1974)

Simpson, Robert, *Sir John Tenniel: Aspects of his Work* (Cranbury, NJ, 1994)

Smith, David Norman, *The Railway and its Passengers: A Social History* (Newton Abbot, 1988)

Smith, Lindsay, 'Infantia', *New Formations*, 42 (Winter 2001), pp. 85–98

—, *The Politics of Focus: Women, Children and Nineteenth-century Photography* (Manchester, 1998)

—, *Victorian Photography, Painting and Poetry: The Enigma of Visibility in Ruskin, Morris and the Pre-Raphaelites* (Cambridge, 1995)

Smyth, Charles Piazzi, *Three Cities in Russia* (London, 1862)

Sontag, Susan, *On Photography* (Harmondsworth, 1979)

Stern, Jeffrey, ed., *Lewis Carroll, Bibliophile* (Luton, 1997)

Starr, S. Frederick, 'Russian Art and Society, 1800–1850', in *Art and Culture in Nineteenth-century Russia*, ed. Theofanis George Stavrou (Bloomington, IN, 1983), pp. 87–112

Steedman, Carolyn, *Strange Dislocations: Childhood and the Idea of Human Interiority, 1780–1930* (Cambridge, 1995)

Stevenson, Robert Louis, 'A Chapter on Dreams', *Scribner's Magazine* (3 January 1888), pp. 122–8

Stewart, Susan, *Nonsense: Aspects of Intertextuality in Folklore and Literature* (Baltimore, MD, and London, 1978)

—, *On Longing: Narratives of the Miniature, the Gigantic, the Souvenir, the Collection* (Durham, NC, and London, 1993)

Stirling, Edward, *Old Drury Lane: Fifty Years' Recollections* (London, 1881)

Taylor, Roger, '"All in the Golden Afternoon": The Photographs of Charles Lutwidge Dodgson', in *Lewis Carroll, Photographer: The Princeton University Library Albums*, ed. Roger Taylor and Edward Wakeling (Princeton, NJ, 2002), pp. 1–120

—, and Edward Wakeling, eds, *Lewis Carroll, Photographer: The Princeton Library Albums* (Princeton, NJ, 2002)

Taylor, Tom, *The Serf, or Love Levels All* (London, 1867)

Thomas, Donald, *Lewis Carroll: A Portrait with Background* (London, 1996)

Thomson, Gertrude, 'Lewis Carroll: A Sketch by an Artist-friend', in *Lewis Carroll, Interviews and Recollections*, ed. Morton Cohen (Aimes, IA, 1989)

Truss, Lynne, *Tennyson's Gift* (London, 1996)

Varty, Anne, *Children and Theatre in Britain: 'All Work, No Play'* (London, 2007)

Warner, Marina, *Alone of All Her Sex: The Myth and Cult of the Virgin Mary* (New York, 1983)

Winchester, Simon, *The Alice behind Wonderland* (Oxford, 2011)

Woolf, Jenny, *The Mystery of Lewis Carroll* (London, 2010)

Acknowledgements

My interest in Lewis Carroll's photography goes back to 1989 when I spent a memorable period poring over his albums and loose prints at the Harry Ransom Humanities Research Center at the University of Texas at Austin. Since that time I have been continually drawn back to Carroll in the context of nineteenth-century photography. I am grateful to Roy Flukinger and staff at HRHRC for fuelling my original fascination and, more recently, to Linda Briscoe Myers for supporting that fascination in its ongoing form. While completing this project I have benefited from the expertise and advice of a number of other curators, archivists and librarians and I would like to acknowledge the help of Raven Amiro, Cindy Brightenburg, Charles Greene, Sarah Gibbings, Sriba Kwadjovie, Alexandra Loske, AnnaLee Pauls, Anne Totten and Jobi Zink.

I owe a special debt of gratitude to Marcia Pointon for her long-standing interest in my work and for suggesting that I send the typescript to Reaktion Books. I thank Michael Leaman at Reaktion for his subsequent enthusiasm and insight while Alia Zapparova, Martha Jay and Vivian Constantinopoulos made the final stages of work a pleasure.

This book has benefited enormously from a publication grant from the Marc Fitch Fund to support the reproduction of images. I am most grateful to Director Christopher Catling and the Council of the Fund for the receipt of an award.

Family, friends and colleagues, always generous with their time, have in various ways encouraged and supported me. I thank in particular Isobel Armstrong, Patrizia Di Bello, Rachel Bowlby, Margaret Healy, Vicky Lebeau, Marcia Pointon, Vincent Quinn, Alan Sinfield, Jenny Taylor and Norman Vance. To Kerrie Smith I am especially grateful for help with the images. My loving and enduring thanks go to my husband David and our children Joe and Lily Rogers.

Invitations to speak at a number of institutions, including the ICA, Birkbeck College, the University of Oxford and Tate Britain, have allowed me to test my ideas. I am grateful to their audiences, together with my students at the University of Sussex, for their enthusiastic engagement. Earlier versions of chapters Four and Five appeared in *Art History* and the *Journal of Visual Culture*, for which Marquard Smith and Sam Bibby were respectively much valued readers.

Photo Acknowledgements

The author and publishers wish to express their thanks to the below sources of illustrative material and/or permission to reproduce it:

Photos author: 28, 34, 56, 68, 69, 72, 77; Birmingham Museum and Art Gallery: 26; photo courtesy the *Brighton Argus*: 85; the British Library, London: 27; Joseph Brabant Collection, the Thomas Fisher Rare Book Library, University of Toronto: 33; The James Gray Collection, the Photographic Archive of the Regency Society: 70, 75, 76, 90; © Hamilton Kerr Institute, Cambridge, photo Chris Titmus: 38; London Transport Museum Collection: 20; Peter Jackson Collection, Look and Learn Picture Library: 35; Los Angeles County Museum of Art: 83; Metropolitan Museum of Art, New York: 8, 11, 37, 43, 47; National Gallery of Canada, Ottawa: 23; National Portrait Gallery, London: 7, 9, 89; © National Railway Museum and Science and Society Picture Library: 24, 25; Oast House Archive: 63; Morris L. Parrish Collection, Department of Rare Books and Special Collections, Princeton University, Princeton, New Jersey: 6, 14, 16, 40, 42, 46, 50, 54, 55, 57, 58, 59, 60, 61, 62, 65, 82; David Bickersteth Magee Collection, L. Tom Perry Special Collections, Brigham Young University, Provo, Utah: 1, 2, 4, 80, 81, 86, 87, 88; photo © Andy Potter: 71; Gernsheim Collection, Harry Ransom Center, University of Texas at Austin: 5, 10, 15, 17, 18, 19, 29, 30, 31, 32, 64, 66, 67; Rosenbach Museum and Art Gallery, Philadelphia: 3, 78, 79, 84; San Francisco Museum of Art: 41; Scottish National Portrait Gallery, Edinburgh: 52, 53; Guy Little Collection, Victoria and Albert Museum, London: 36, 44, 45, 48, 49, 51; Victoria and Albert Museum, London: 12, 39.

Index